bombShells

Also by Steve Sullivan

Va Va Voom!: Bombshells, Pin-Ups,
Sexpots, and Glamour Girls

Pop Memories: The History of American
Popular Music, 1890–1954

Glamour
Girls of
a Lifetime

bomb*Shells*

Steve Sullivan

St. Martin's Griffin

New York

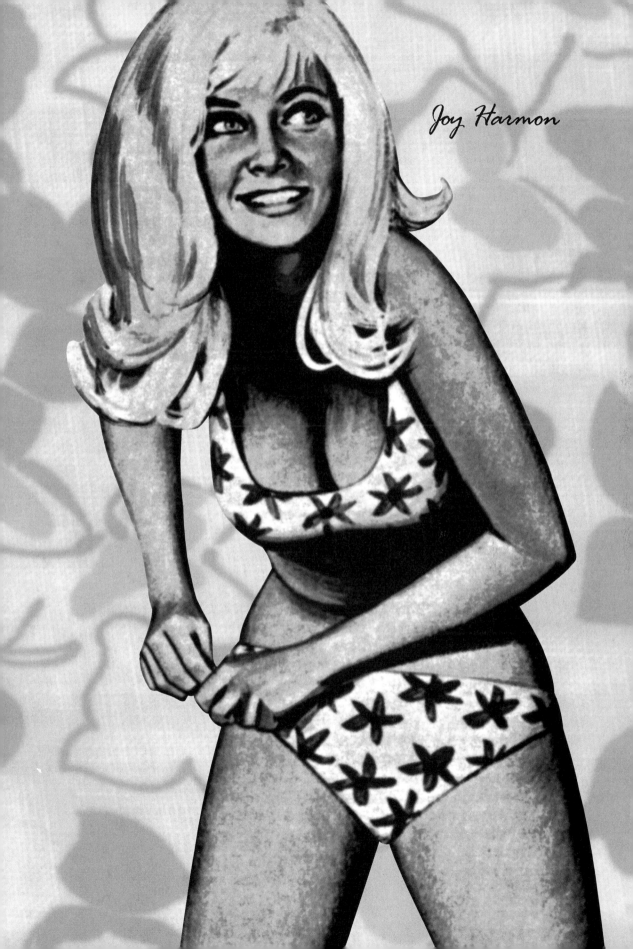

Joy Harmon

All photos of Maria Stinger copyright © Bunny Yeager; photos of
Dixie Evans on pages 20 and 35 courtesy of Dixie Evans and Exotic
World; photos of Jennie Lee on pages 69 and 81 courtesy of Exotic
World; photos of Cynthia Myers on page 94 and in the color insert
copyright © Playboy Enterprises, Inc. Used by permission.

Book design and composition by Margo A. Mooney

Library of Congress Cataloging-in-Publication Data

Sullivan, Steve.
 Bombshells: glamour girls of a lifetime/Steve Sullivan. —1st ed.
 p. cm.
 ISBN 0–312–16790–3
 1. Actresses—United States—Biography. 2. Models (Persons)—
 United States—Biography. 3. Glamour photography—Anecdotes.
 I. Title.
 PN2285.S86 1998
 792'.028'092273—dc21 98–4618
 [b]

First St. Martin's Griffin Edition: June 1998
10 9 8 7 6 5 4 3 2 1

Books are available in quantity for promotional or premium use.
Write to Director of Special Sales, St. Martin's Press, 175 Fifth
Avenue, New York, N.Y. 10010, for information on discounts
and terms, or call toll-free (800) 221-7945. In New York, call
(212) 674-5151 (ext. 645).

Contents

Dixie Evans

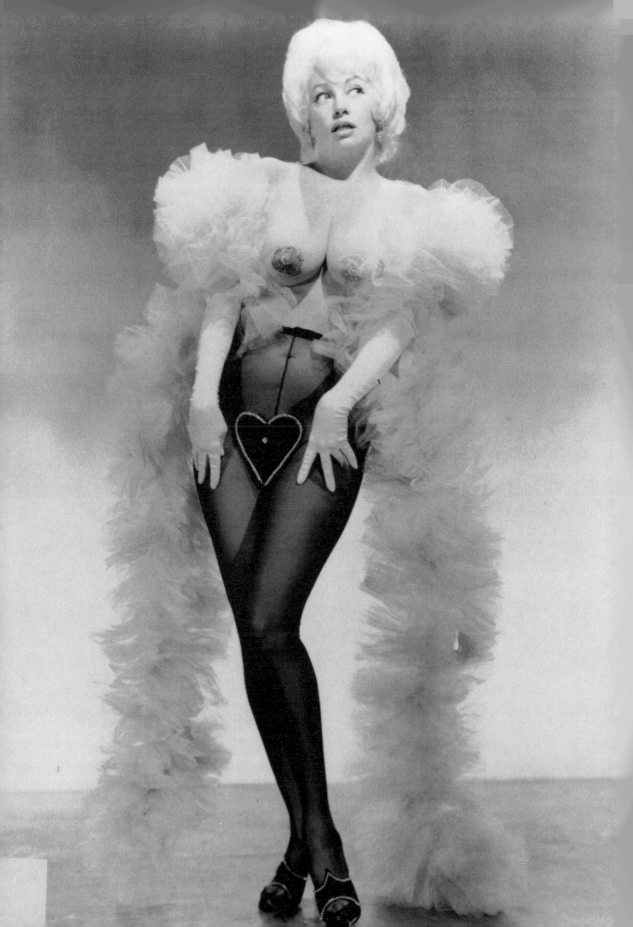

Acknowledgments

I want to extend my deepest gratitude to the extraordinary ladies who gave generously of their time (and in most cases offering photos from their personal collections) to make their chapters in *Bombshells* come alive: Yvette Vickers, Joy Harmon, Dixie Evans, Sheree North, and especially the wondrous and enchanting Cynthia Myers. Dixie Evans provided delightful photos of Jennie Lee and Virginia Bell in addition to the pictures for her own chapter. Additional photos for the Virginia Bell chapter appear courtesy of Vienna, Virginia, collector James F. Carlin. All-time great glamour photographer Bunny Yeager supplied all of the photos for the chapter on Maria Stinger, as well as the photo of Maria that appears on the cover. Thanks to glamour immortal June Wilkinson for writing the foreward. And I am indebted to Mr. Hugh M. Hefner for kindly granting permission for the use of three classic *Playboy* photos of Cynthia Myers. Additionally, I am grateful to British collector Neil Kendall for his contributions regarding Sabrina and Dixie Evans.

St. Martin's editor Jim Fitzgerald was indispensable to the successful completion of this book. I must also acknowledge the invaluable efforts of my agent, Stan Corwin.

For anyone interested in classic glamour and pinups, I write and edit a quarterly magazine, *Glamour Girls: Then and Now*, in partnership with Bunny Yeager. Each issue includes photo-packed, in-depth interviews and features on some of the most exciting women from the 1950s to today. In January 1998 we also published a special full-length digest book, *Glamour Girls of the Century*, with biographical entries on the top one thousand beauties and bombshells of the twentieth century, with more than two hundred photos. For more information, write to: Bombshells, P.O. Box 34501, Washington, DC 20043.

June Wilkinson

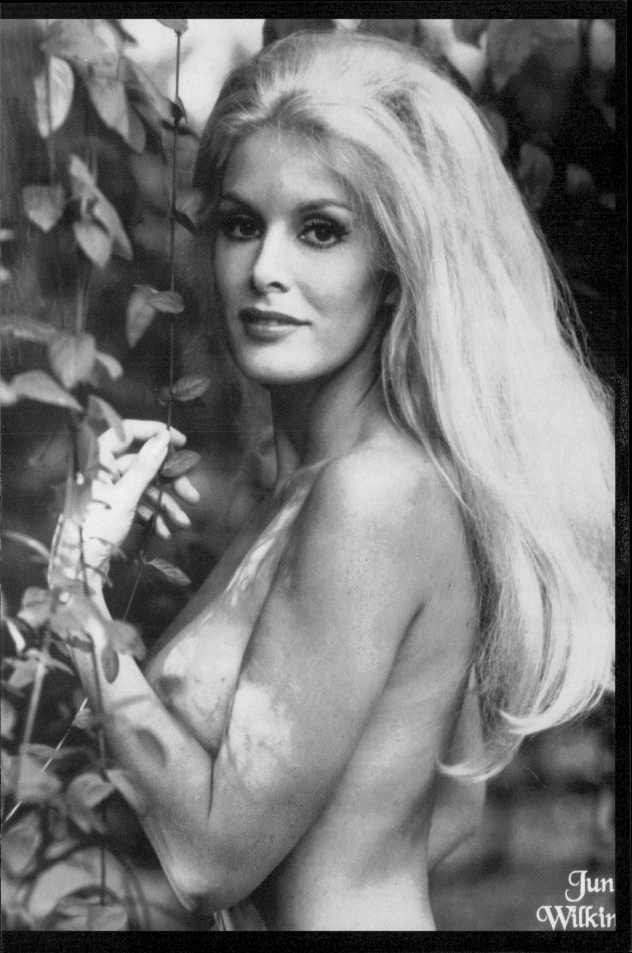

Jun
Wilkin

Foreword by June Wilkinson

During my four decades in show business, from my early days appearing in *Playboy* and other magazines through my roles in movies, TV, and stage productions, it's been my experience that journalists seem to find it very difficult to write intelligently about women who are considered **"sex symbols."** For some reason, the fact that a woman is considered attractive and sexy leads most writers to dismiss all of her other qualities. The usual result is a story that is inaccurate, trashy, and insulting.

Steve Sullivan is a very different kind of writer. In his book *Va Va Voom!* (in which I was proud to have been included), he demonstrated that it is possible to write lively, entertaining accounts of some of the most sensual ladies of the modern era while also being respectful and truthful. You'll find the same qualities here in *Bombshells*. There are ten fabulous ladies in these pages, including friends of mine such as Cynthia Myers, Sabrina, and Joi Lansing. Steve's chapters — and of course the wonderful photos — help readers understand why these women have been considered sexy and fun, but they also show that they had much more to offer than just sex appeal. In my book, that's a winning combination!

bomb*Shells*

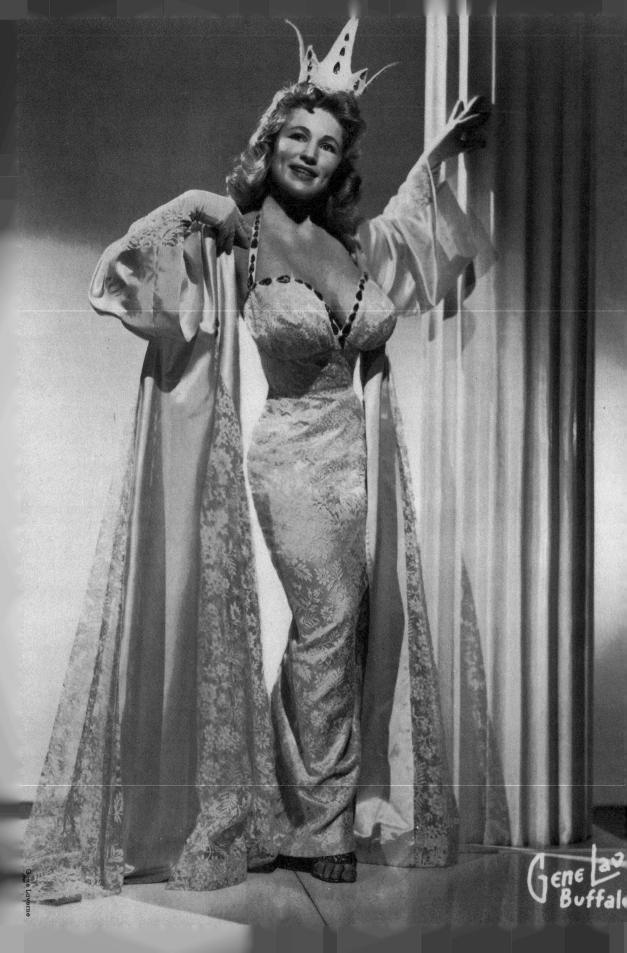

GeneLav
Buffalo

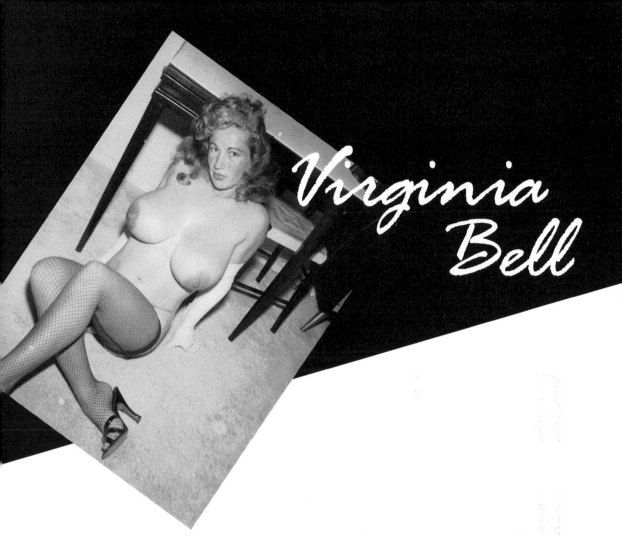

Virginia
Bell

As burlesque enjoyed the final years of
its golden age during the 1950s, the
top-level strippers who made the
era memorable could be divided
into two categories: those who
reserved their artistry for the swankiest
nightclubs, and those who plied
their trade on **"the circuit."** Virginia
Bell — rivaled by few other strippers
in her popular following — was
equaled by none in her dedication to the network
of burly theaters that would soon become a relic
of history.

Born in Montrose, California, Virginia was of Serbo-Croatian heritage; her father was said to have been a rancher. According to one Bell researcher, Virginia graduated from a Los Angeles high school in 1949, and was dating a well-known football star at the time. She graduated from junior college around 1951, and launched her modeling career after some candid beach snapshots of her formidable figure inspired the keen-eyed lensman to prod her in the direction of a professional photographer.

This quickly led her to a female theatrical agent who proclaimed, **"When I first saw Virginia's picture, I didn't believe it — I thought the pictures were faked. But when she came in and showed me what she had, I knew I'd stumbled onto something special. Mansfield's are big, [Meg] Myles's are bigger, but Virginia's are the all-time most!"**

Atop a five-foot-two, 120-pound frame, Virginia's breasts were indeed an imposing sight, and were to become her trademark. The exact dimensions of her most prized assets varied with the source. When she began modeling, her bust measurement was quoted as forty-two inches; later this number was regularly inflated to forty-eight. But unquestionably Virginia Bell's bust — which earned her such nicknames as **"Little Miss Pleasure Chest"**— was among the most celebrated of her time. One magazine proclaimed that her breasts were **"more than enough to make Lili St. Cyr, Candy Barr and Tempest Storm look like something out of Louisa May Alcott's 'Little Women.' "**

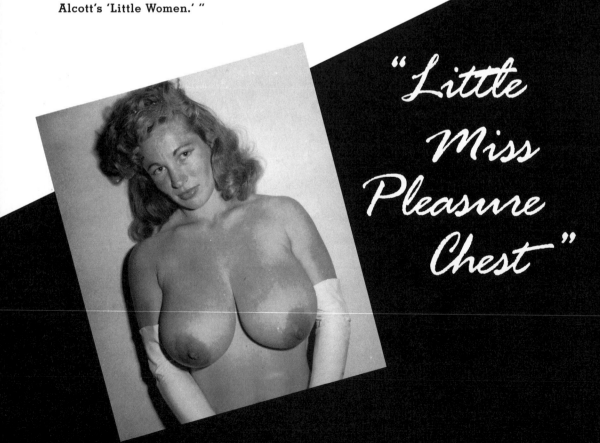

"Little Miss Pleasure Chest"

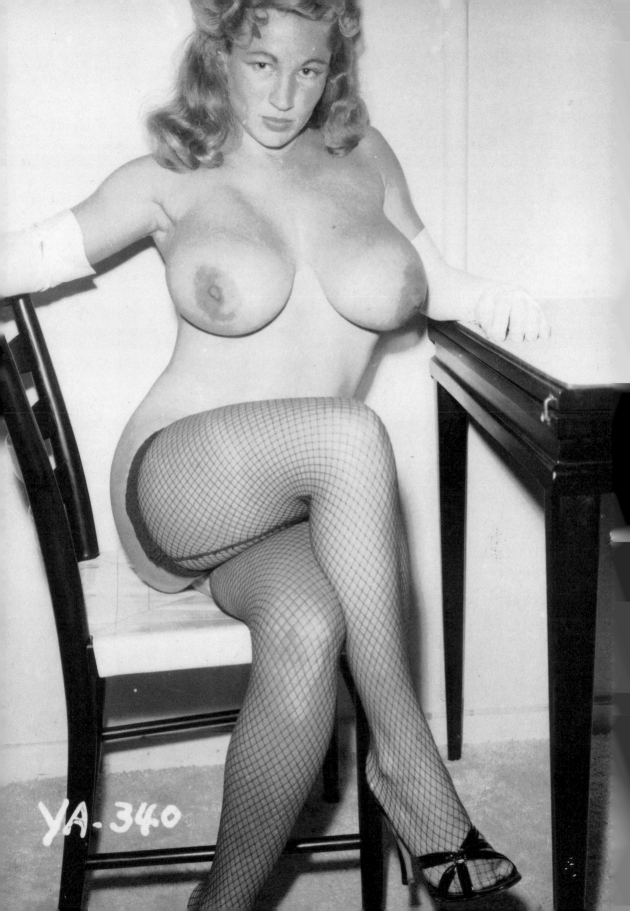

YA-340

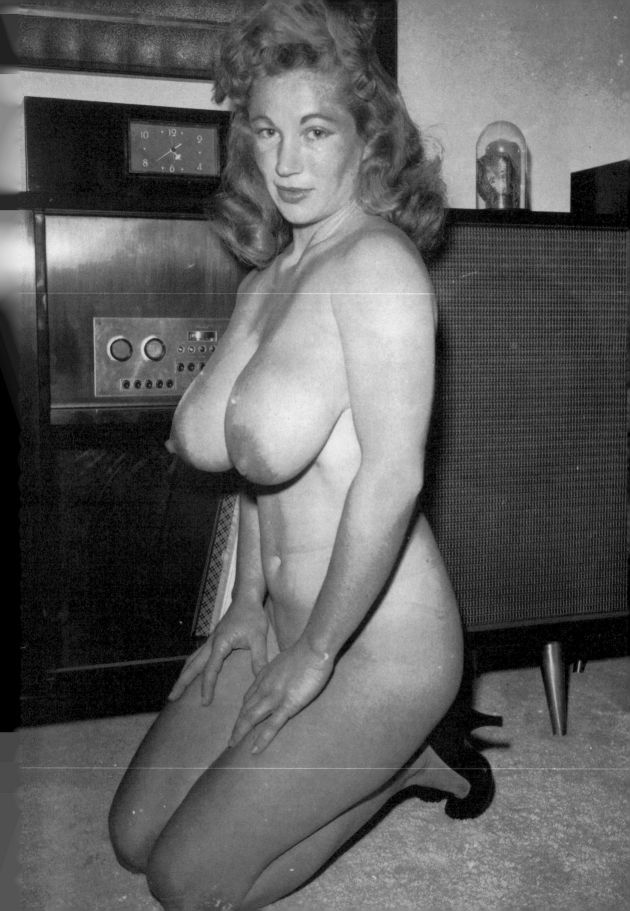

It was on the burlesque stage that Virginia first came into the public eye in the mid-1950s. She reportedly made her burlesque debut on the stage of Cleveland's famed Roxy Theater. A headliner from the start, she was billed as **"Virginia (Ding Dong) Bell, 48-24-36,"** and earned $1,500 per week.

By 1957, the fledgling exotic's epic figure was becoming a frequent sight in girlie magazines, and remained so for the next several years. Her first magazine cover was the September 1956 *Night & Day*. Immediately, the magazine was flooded with letters demanding more Bell. *N & D*, along with other magazines, regularly ran ads for sexy photo sets of Virginia, with such text as: **"Inch for Inch, the Biggest, Bounciest Pin-Up Girl of Them All . . . Must be SEEN to be BELIEVED. Never before a woman like this!"**

While she appeared in many different magazines, Virginia became closely associated with *Fling*, which in later years would repeatedly cite her as the definitive **"Flinggirl"** who set the standard to which all others would have to aspire. Arv Miller, the magazine's founding publisher and editor, recalls that *Fling*'s future was still in doubt when Virginia made her debut in issue 10 (1958). **"Virginia really put me on my feet,"** he declares. When her appearances in issues 10 and 16 sent newsstand sales soaring, Miller decided to devote the publication to the biggest and best bosoms in the land.

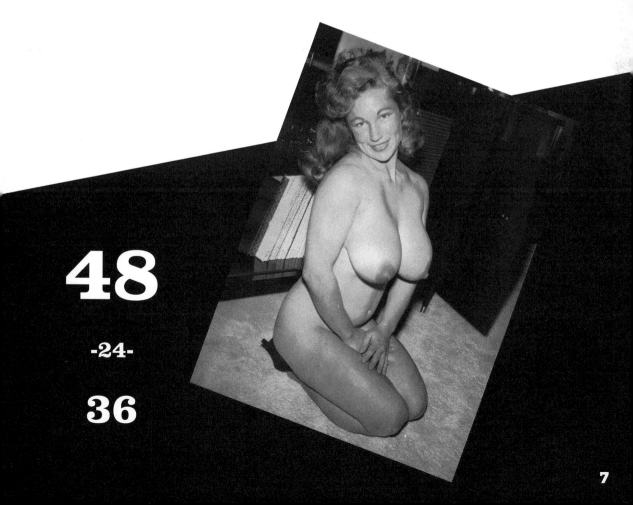

48

-24-

36

Remarkably, Miller never actually met the woman responsible for the turnaround of his magazine. **"She wrote me once in 1959 to thank me for running her pictures, but that's all."** Despite the close *Fling*-Bell connection, **"we never really had a lot of pictures of her. It was just two layouts by Ron Vogel — that's it, aside from some amateur-quality photo packs I got from New York. And I used those two layouts over and over and over!"**

To this day, oddly, Virginia is most widely remembered as a nude magazine model, while her prowess as a burlesque star is forgotten by many. Nevertheless, during her prime, she ranked in the top echelon of strip luminaries. More than once, she was proclaimed **"the hottest thing to hit a runway since the heyday of Lili St. Cyr."** Every stripper needs a gimmick, and Virginia's was her so-called fast bust roll, which sent her mighty mammaries flying. She was also noted for her athletic agility in bending her torso all the way back, an impressive feat considering the extra weight she was carrying up top.

The burlesque circuit, as it survived into the 1950s, was a chain of about fifty theaters operated out of Boston and most heavily concentrated in the East and Midwest. Strippers who worked the circuit committed themselves to a grinding schedule of three to four nights in one town, a day of rest, and then on to the next destination. Typically, they would tour fifty weeks a year, with minimal concession to holidays. Most other top performers, after achieving fame, left all this behind to work in nightclubs and Las Vegas. But Virginia stayed the course: from the outset of her career until its end around 1970, as the circuit steadily dwindled with the lingering death of burlesque, she continued making the rounds of theaters until only a handful remained.

Ohio was the dominant state on the circuit, with burly theaters in Cleveland, Cincinnati, Toledo, and Akron, among others. It was there that Virginia met Eli Jackson, a veteran of the carnival scene who was branching out into burlesque. They married around 1960, and for the next few years were based in Cincinnati. By 1963, they had relocated to Tampa, Florida.

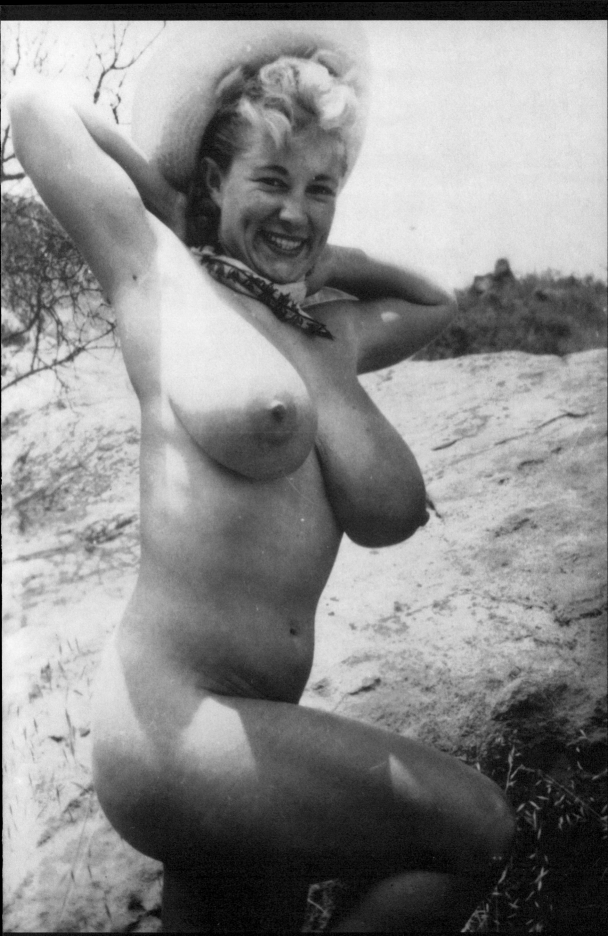

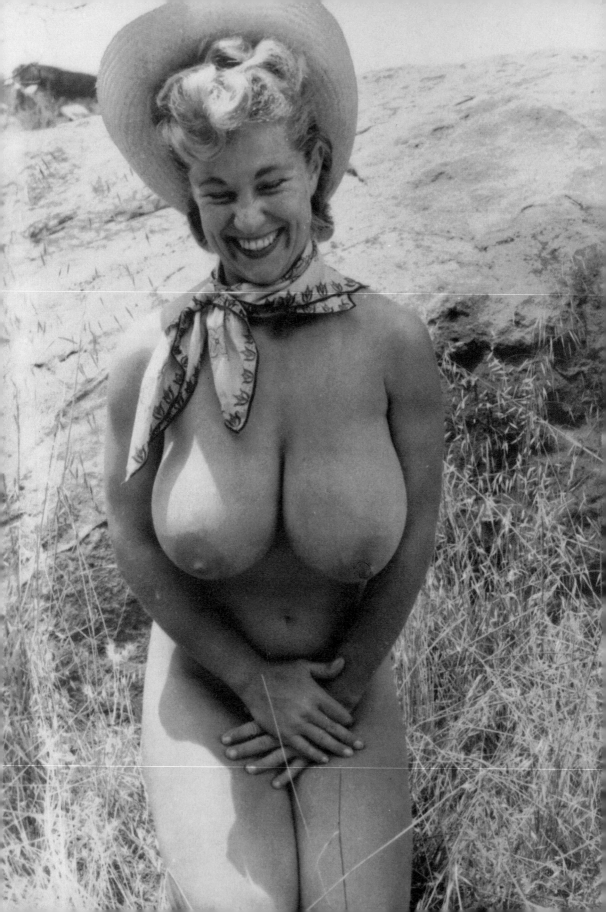

In early 1958, with Virginia one of the hottest attractions on the circuit, she purportedly turned down an offer to perform with the famed Folies Bergere in Paris. Several months later, she was reported to have signed a thousand-dollar-a-week movie and TV contract with Cleota Productions; however, nothing more was ever heard of this opportunity.

In addition to serving as her manager, Jackson was a constant presence at Virginia's stripping performances. As the so-called candy butcher, he appeared onstage at intermission selling photos, magazines, and other promotional materials, such as playing cards with her picture on them. And he was instrumental in arranging the film that helped ensure her enduring renown.

Bell, Bare and Beautiful

Virginia staked her claim for cinematic fame with the now-legendary nudie film, *Bell, Bare and Beautiful*. In his entertaining book, *A Youth in Babylon: Confessions of a Trash Film King*, producer David F. Friedman — whose credits included *She Freak*, *Blood Feast*, and the cult classic *Two Thousand Maniacs* — recalled how the film came to be. Jackson had devised the idea of a nudist-colony picture starring his wife, with Friedman and Herschell Gordon Lewis producing and directing, and Jackson doing the distribution. The film was to be shot in Miami in February 1963. The script was by Jackson and Virginia, **"neither of whom had ever written anything before, except for checks and grocery lists."**

Jackson was insistent on shooting the film quickly in Miami, because his wife was three months pregnant. Friedman was not overwhelmed by his leading lady: **"Virginia, whose main attributes in the profession were her mammoth mammaries . . . looked okay onstage, but Herschell and I both agreed she wasn't beautiful."** They began shooting at 10 P.M., and by 3 A.M. had filmed fifteen pages of the forty-page script.

The second day, they shot the nudist-camp scenes. **"Strangely, Virginia, a professional stripper, was hesitant to bare all for a movie camera. Furthermore, she was downright adamant about appearing nude in any scene in which another person was present. Go figure."** The entire film was completed in three days.

B, B & B opens with wealthy bachelor Rick Bradshaw obsessed by a recurring dream of a beautiful girl he has never met. Determined to learn if she exists, he has an artist paint his vision and offers a reward for finding her. The theatrical agent for stripper Virginia writes to alert him that she is the girl. Much of the early action takes place at a burlesque theater in Pittsburgh. He finally tracks her down in Miami, where he sees Virginia perform her strip act, and tries unsuccessfully to persuade her that she is the girl of his dreams before being chased out by her possessive manager. The next day he seeks her out again at a nudist camp. Finally Bradshaw pays off the manager to let Virginia go, and after a kidnap attempt by the manager's thug fails, she and Bradshaw return to the camp and **"lived nudily ever after."**

fling

✴ PASSPORT TO PL

NO. 16 FIFTY CENTS

Bell, Bare and Beautiful had its advance-screening premiere in May 1963 in Miami Beach. It was early the following year that it began to attract a cult following in New York and San Francisco art houses, and over time the film's fame spread nationwide to the point where it became synonymous with big bosoms.

Arv Miller had something to do with the movie's potent following. When he devoted most of the August 1964 issue of *Fling* to *B, B & B*, it produced one of his biggest sellers of the era and helped generate new demand for the picture. But it was quite a task for the publisher. **"I had to get the whole film and go through it frame by frame to pick out [what] I wanted so it made sense,"** he remembers. He took negatives from the 35 mm print, blew them up four times, and cropped the pictures. Then he made up dialogue to go with the sequence of photos. **"I never saw the damned picture! I didn't have a sound projector. I see that issue now, and I'm amazed at what I did. It actually makes sense."**

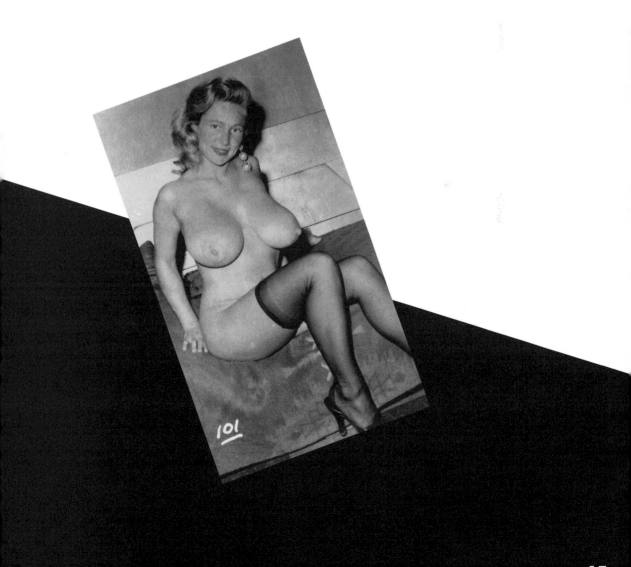

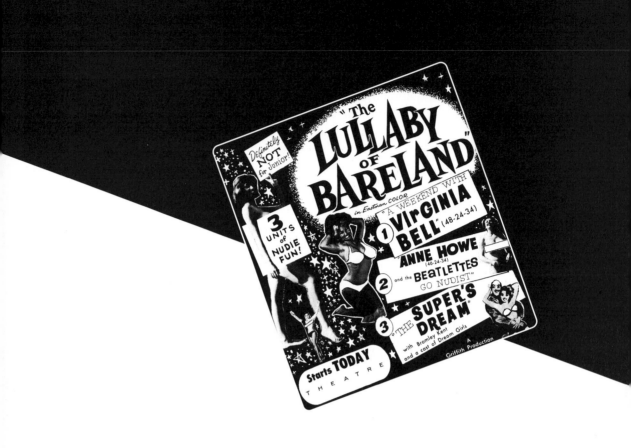

Virginia also appeared in a number of other 1960s nudie films. Perhaps the best known was *The Lullaby of Bareland* (1966), produced by strip-club owner Leroy Griffith. The first of the film's three segments, **"A Weekend with Virginia Bell,"** focused on her stage act, followed by a nudist-colony episode featuring voluptuous stripper Anne Howe. A flimsy drama built around the featured action has a bored married couple fleeing to Miami to liven up their sagging love life. The picture was filmed at a Florida nudist camp, as was another project in which she appeared, *Civilization and Its Discontent*. Additionally, La Bell shot many nudie shorts, which were sold by mail during the six-ties and have been reissued on video, mainly showing her posing nude and caressing her body in threadbare indoor settings.

Despite the fame she achieved on the runway, Virginia repeatedly expressed distaste for her profession, which led her to briefly quit stripping several times. Finally, in the early 1970s, Virginia retired to Tampa with her husband, and they operated the string of movie theaters he owned in the state. According to a club owner for whom they often worked, the couple subsequently broke up and she returned to California.

VOL. I, No. 5

Spree

50 CEN...

How to have a Snow "Ball"

THE NEW

sir

Knight

VOL. 1 NO. 8

50¢

ADULTS ONLY!

A provocative postscript to the Bell story came several years ago after Miller ran another magazine retrospective on her. "I got a call from a woman who said she was her daughter. She hadn't seen her mother in years, and wondered where she was. I was taken by surprise, and told her the pictures were from 1959 and I hadn't heard from Virginia since.

"Virginia was either single or just divorced then. She was like a kid herself, she wasn't very old. She got involved with a guy, he got her pregnant, she had a child, then gave the child up for adoption. She later married somebody else [Eli Jackson], and never contacted the child." Miller was unable to confirm the truth of the account. "But what a great story."

It must have been a source of pleasure to Virginia that by the 1980s she had become a larger-than-life legend to a new generation of aficionados. In the age of silicone some busty beauties may have since surpassed her natural endowments, but few have exceeded her enduring personal appeal.

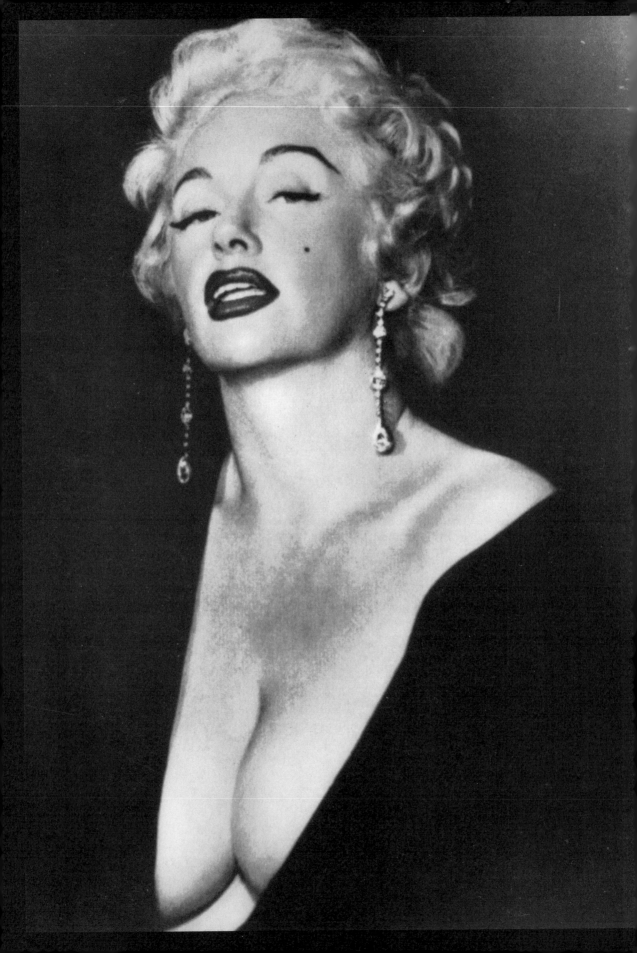

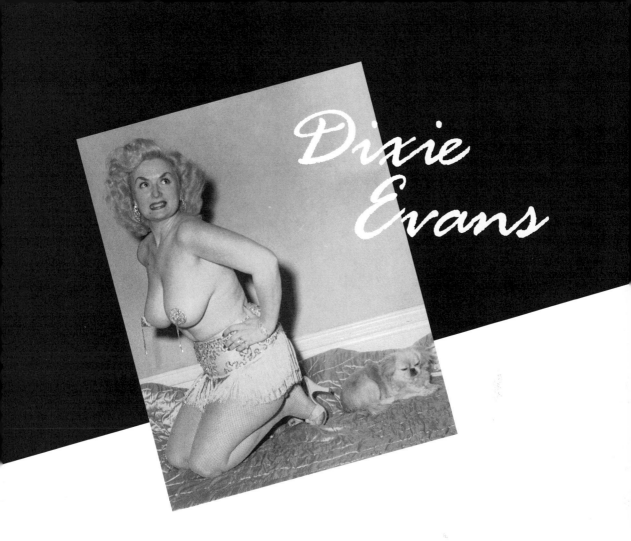

Dixie Evans

Like jazz, burlesque
is a uniquely American
art form in both its origins
and evolution, and it vividly
reflects a part of the American
character. Unlike jazz, however, its role in
popular culture has for years been
neglected. Dixie Evans has made it her
life objective to turn this around.

In her youth, she was one of the last great stars to emerge at the end of burlesque's second golden age. **"The Marilyn Monroe of Burlesque"** transported the magic that was Marilyn to the realm of striptease with uncanny precision. Today, she carries the tradition forward as president of Exotic World: the Strippers' Hall of Fame and Museum.

Mary Lee Evans was born on August 26, 1926, within weeks of her later inspiration Norma Jean Mortenson, and like Norma Jean her early years were shaped by misfortune. After taking the family from Long Beach, California, to Australia, where he drilled some of that nation's first oil wells, her father died when she was eleven.

Returning to grow up right outside Hollywood, Mary Lee yearned for the glamour of show business. She worked for a time planting celery in the field, and during World War II served as an airplane mechanic — at the same aircraft factory where Marilyn was hired for her first job. She soon caught the eye of talent scouts and photographers. **"Pinups were a really big deal back then and all the pretty girls posed,"** she remembers. Mary Lee gained a little experience as a model, and had chorus parts in army touring shows as far back as 1941. The teenager styled her hair into a peekaboo and dyed her hair blonde, and was selected for Frederick's of Hollywood's 1949 catalog for her likeness to Veronica Lake.

The budding beauty's image began to appear in men's magazine advertisements billed as **"shoot the starlets." "My agent would get four of us girls together and drive us to some location like a deserted mansion, a ranch or a beach. As many as thirty photographers showed up. They just wanted to see a pretty girl posing nude. . . . You never saw them or their photographs again."** In another fine historical parallel, one of the photographers who shot the youngster was Tom Kelley, within a year of his famous session with Marilyn.

Deciding that her real name was too plain for Hollywood, she changed it to the more eye-catching "Dixie." The aspiring starlet made several cheesecake reels during the late forties, such as *The Casting Couch* and *The Hula Dance*, which were shown for a nickel in the old amusement arcades. **"I made lots of those wild strip films. All the girls did them, we just wanted to be entertainers."**

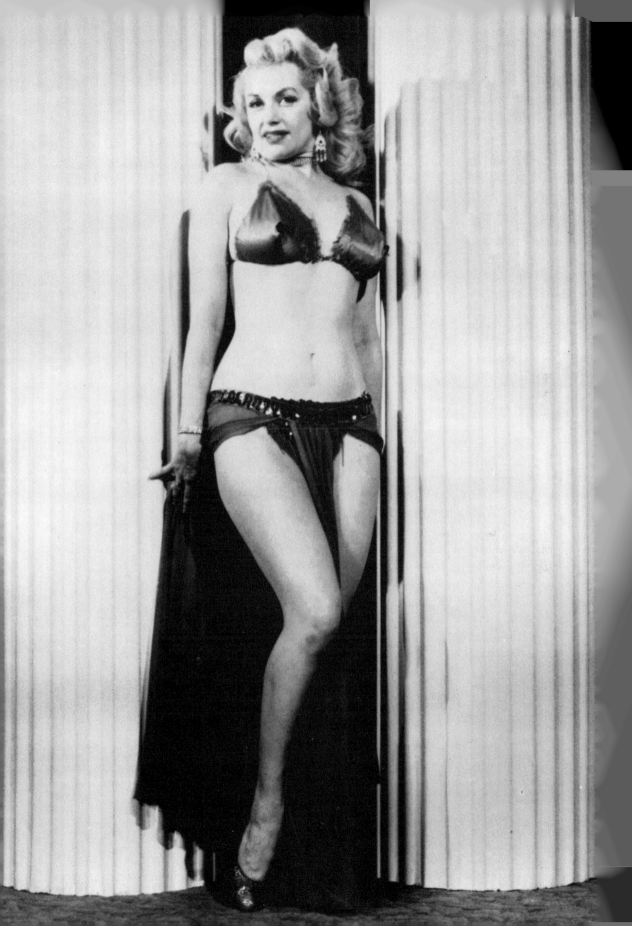

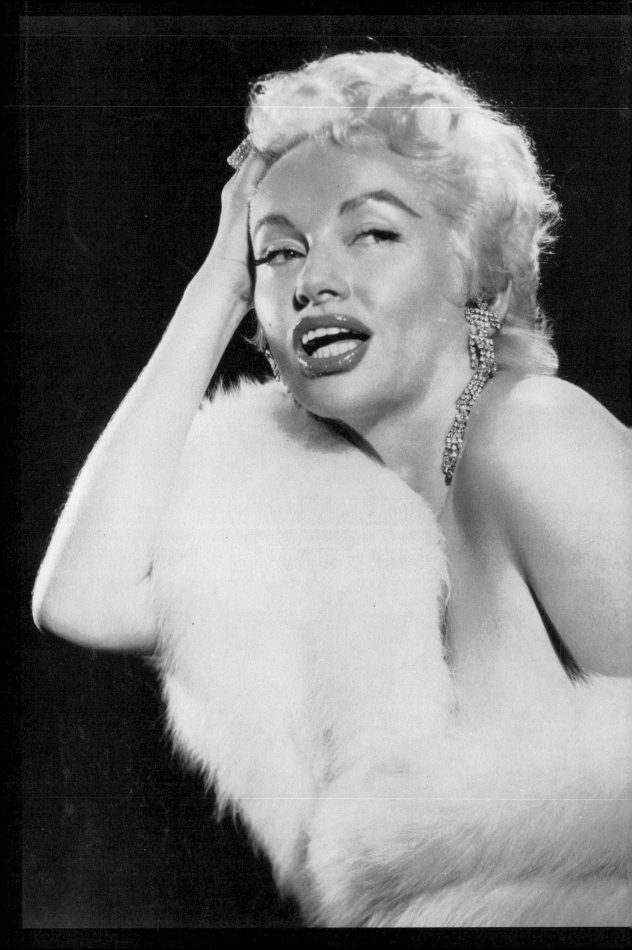

Dixie gathered more valuable experience in the late 1940s as a chorine traveling with the Moonie Dancers (later the Orchid Moons) along the West Coast for almost two years. Finally, when the troupe performed in Mexico City, she quit. **"I met a bareback rider in the circus and we fell in love. So I joined the circus, riding elephants."** This provided Dixie with her only mainstream movie role. In *The Greatest Show on Earth*, the 1952 Cecil B. DeMille epic, Dixie played a harem girl in several scenes to pad out the number of circus performers.

After quitting the circus, Dixie worked as a theater page, until the show went broke in San Francisco. With no money to return to Los Angeles, she went down the block to a nightclub, the Spanish Village, and was hired as a stripper. **"When I found out what a stripper made (two hundred dollars a week), I quit trying to be a page and stayed with burlesque. The place was a bit of a dive and the whole thing was terrifying. But I was finally in show business."**

In early 1952, she found her way to the El Rey theater in Oakland — home base for emerging striptease legend Tempest Storm. Pete De Cenzie, owner of the El Rey, became Dixie's manager. For the first time, Dixie sampled the real world of burlesque. **"Boy, was there a difference from the nightclubs. This was big business. The tympany drumrolls, the musicians, the orchestra pit, comics, singers. Suddenly there was no kidding around — I was a headliner. So I acquired a professional attitude. I invested my money in props, costumes, and jewelry. You had to learn quickly."**

Being a headliner meant a lot of travel across the major burlesque circuits. It was Harold Minsky who introduced Dixie to the Midwestern and Eastern circuits where most of the top strippers worked. **"All the girls tried to do something a little unique — you had to have a gimmick or you couldn't be a headliner."**

Initially, Dixie's gimmick was incorporating her dancing into a story: an aspiring starlet trying to crash the movies. She would enter the stage clad in a smart suit, a pillbox hat, chiffon scarf, and dark glasses, looking every inch the sophisticated movie star. She would explain to the audience how difficult it was to get started by knocking on casting directors' doors. As the orchestra played "You Ought to Be in Pictures," she walked through a studio door and performed a strip as a screen test. After seducing a producer through a suggestive mime as the band played "You Are My Lucky Star," Dixie would cover her naked body with a fox fur.

The most unforgettable episode of Dixie's early years in the business was the time she became the first and only stripper to take it all off at New York's Waldorf-Astoria in 1952. Dixie had been booked as a novelty act, not a stripper. She launched straight into her starlet act, oblivious to the shocked gestures of the stage manager. By the time she removed her gold lamé dress, it was too late for management to do anything. **"I thought I'd made it,"** she recalls with a laugh. **"But of course it was all a big mistake. They were great about it, though. 'If we'd known you were a stripper, we'd have put you on last,' they told me."**

It was a good act, but Harold Minsky felt something more was needed. He told Dixie that she looked just like Marilyn Monroe, who had just made her big motion picture breakthrough in *Niagara*. And so the gimmick that would make Dixie Evans a star was born.

The Marilyn Monroe of Burlesque

It was at the Minsky-Adams Theater in Newark, New Jersey, in 1952 that Minsky billed Dixie for the first time as **"the Marilyn Monroe of Burlesque,"** accompanied by a vigorous publicity campaign. That night, she duplicated her act with Monroe in mind. Having practiced Marilyn's walk and talk before a mirror all afternoon, she dazzled the audience. **"My fees went from $250 to $400 a week within months. I didn't feel that I had a lot of talent, so I felt secure with a Marilyn billing. It really worked for me."**

During the next several years, Dixie would develop routines built around scenes from Monroe's movies *Gentlemen Prefer Blondes*, *Bus Stop*, and *The Prince and the Showgirl*, as well as her nude calendar photo session. She had mannequins made of Marilyn's male costars and used them in her routines.

The insecure beauty was a star, one whom promoters depended on to open top clubs around the country. **"It was a big responsibility. You were a star who had to project glamour. People paid five dollars a seat to see me, and that was a lot of money. I was booked two years in advance."**

Dixie traveled the circuit via Greyhound buses during the mid-1950s. The **"Kane circuit"** provided the focal point of her journeys, with burlesque houses in Dayton, Cleveland, Youngstown, Buffalo, Chicago, Norfolk, and Boston. Typically, Dixie spent two weeks in each theater before moving on to the next booking. **"You never had a chance to build up long-term friendships. It was always going on to the next show."**

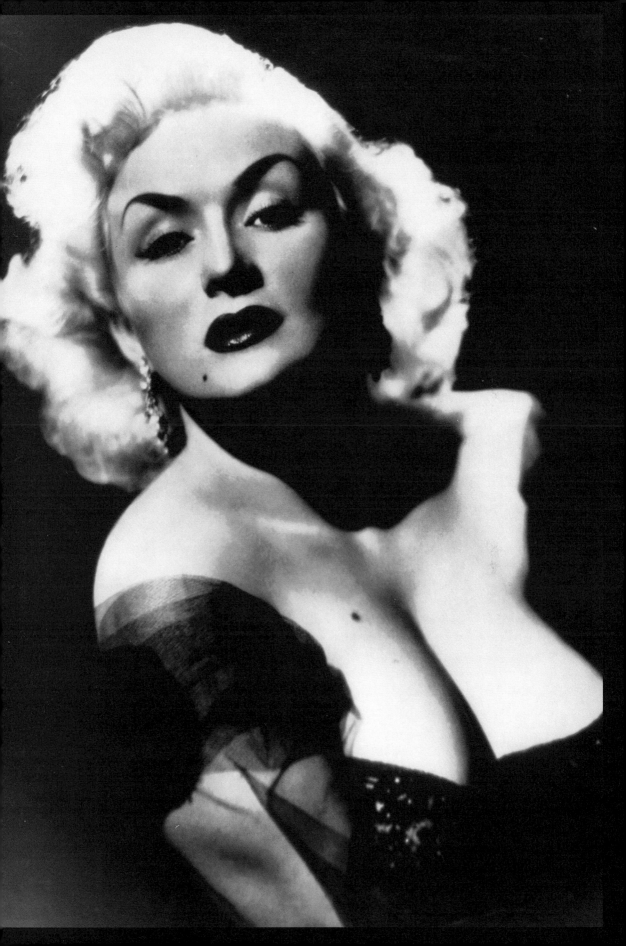

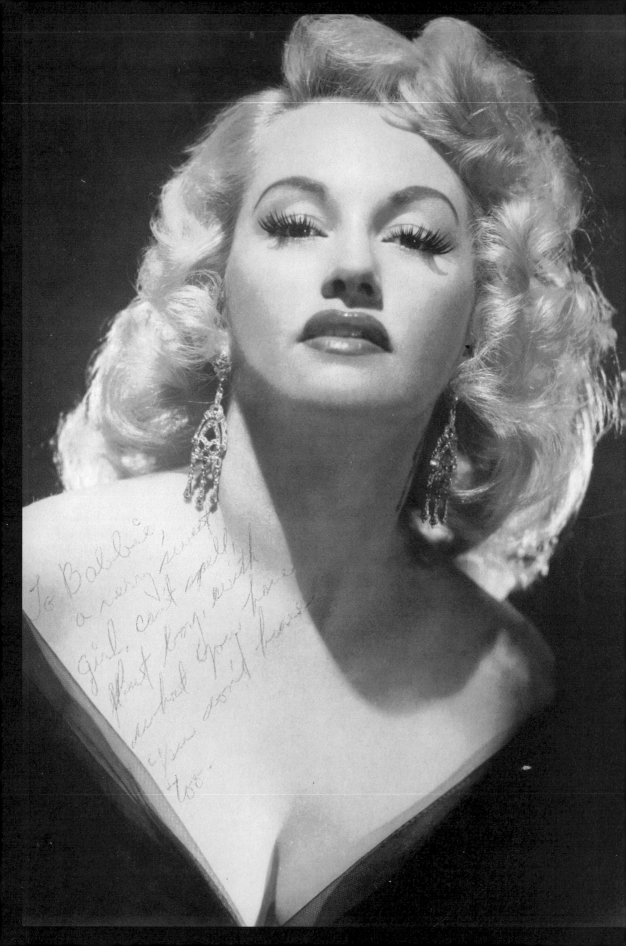

She followed the grueling schedule of three shows a night, the first at 9:00 P.M. and the last at 4:45 A.M. In the first two shows she would do her regular Hollywood number. For the early-morning crowd, Dixie would do a quicker strip, usually to "Shake, Rattle and Roll," with the lyrics rewritten to fit the Monroe persona.

Dixie was keenly aware of the changing times that would ultimately doom burlesque. **"We were struggling to keep burlesque alive. There were fewer clubs to play, and girls like Jennie Lee ["the Bazoom Girl"] were trying to promote us through the Exotic Dancers League. But our little burlesque world was going to die."**

With the rise of television and the decline of business, theaters cut costs by reducing bands from five members down to a piano and drums. Corners were cut at every opportunity, further driving away patrons. The Kane burlesque circuit and the Columbia circuit in the north were breaking up. With fewer theaters, strippers began to concentrate on nightclubs. The elaborate shows to which the top strippers had been accustomed became only a memory, except for a few superstars such as Lili St. Cyr. The emphasis was now on the strip, not the show, and girls were under pressure to do more explicit acts to keep the audiences coming.

By 1955, Dixie was at the peak of her fame. She began a three-year stay in Miami to recuperate from the hectic traveling. Her Monroe act had incorporated a routine based on Marilyn's recent divorce from Joe DiMaggio. Dressed in an abbreviated Yankee uniform and swinging a gold-plated bat, she would wail, **"Joe, you walked out and left me *flat*,"** accompanied by a crash of drums and cymbals as she did an exaggerated bump. At the end of the bit, she would plant a kiss on the two baseballs she held in her hands, and toss them into the audience.

While performing at the Place Pigalle in Miami Beach, Dixie was informed before the show one night that Joe DiMaggio himself was in the audience. Overcome with panic, she didn't want to perform the routine until DiMaggio came backstage to tell her of course he wanted to see the act — **"I've traveled so many miles just to see it."**

Dixie went onstage and did the full Marilyn-Joe number, this time directing it straight at DiMaggio in his ringside seat. He loved it, and even came up onstage to applaud her. About two hours later, after she finished changing, she found DiMaggio waiting patiently for her alone on the sidewalk, and they went on a late-night date. **"You're a nice girl, you remind me of Marilyn,"** he said. **"Joe was a real gentleman,"** Dixie recalls. **"He was very refined. I took him home after we'd been out for breakfast, and introduced him to my mother. She was thrilled."**

In 1956, Marilyn's lawyer, Irving Stein, wrote Dixie a letter threatening to sue because her act was allegedly damaging the star. **"I was just a young girl trying to earn an honest living in show business,"** notes Dixie. Eventually the threat was dropped, but not before Dixie had received still more valuable publicity. It did not diminish her admiration for the woman who had become central to her own career. By the outset of the 1960s, Dixie felt her popularity was waning and her billing was down; she linked this with the new sex symbols who were threatening the Monroe legend. **"I wasn't making fun of her, I was just trying to make a living in my own crazy way. I adored her. I hung on to Marilyn out of loyalty when these new girls came along like Bardot and Jayne Mansfield. It was as though Marilyn and I had been thrown into the slag heap. I was really hurt."**

Her bond with Marilyn was such that sometimes, when Dixie would see a picture that she thought was of Marilyn, she discovered it was actually of herself; their identities had virtually merged. **"I had this strange feeling of being tied together, yet torn apart."**

While preparing to go onstage one night in 1960, she turned on her dressing-room TV and was startled to see Marilyn on a stretcher being admitted to the hospital after a miscarriage. **"I just felt sick to my stomach."** At the club owner's demand, Dixie went onstage, but sent a heartfelt letter to Marilyn wishing her a speedy recovery. Three weeks later she received a reply:

"My dear, dear Dixie,

Among all my many friends and acquaintances over the world, your telegram has been of the greatest comfort to me at this time."

Dixie felt elated and honored. **"I did want to meet her, throw my arms around her and hug her. But I didn't want her to think I was getting too familiar, so I didn't write back."**

For years, her contracts had stated that she must do the Monroe act that was her claim to fame. But after fulfilling her contractual obligations, she decided to drop the routine. **"I refused to impersonate a sick girl."** As a result, Dixie couldn't get a booking for six months.

In 1961, Dixie married Harry Braelow, once the world's fifth-ranked middleweight boxer, who had seen her perform at the Place Pigalle. They divorced about seven years later.

Marilyn's death in 1962 devastated Dixie personally and professionally. As she commented two years later, **"When she died, I felt my own career died, too."** She was in depression for months, and began to drink heavily. **"I was mourning the loss of my career in remorse for poor Marilyn. I didn't know what to do or where to go."**

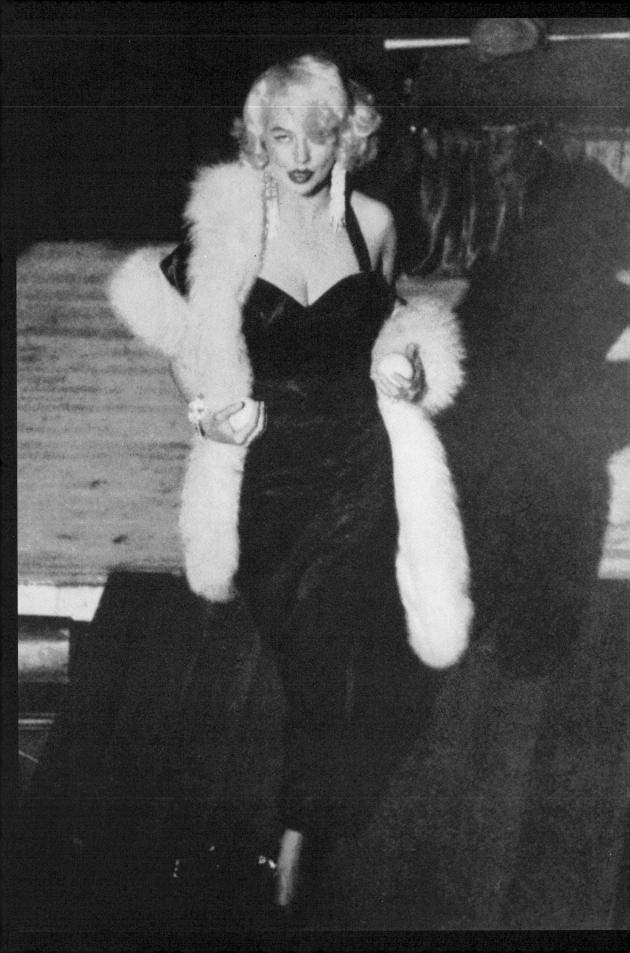

After returning to the stage, Dixie, often disguised in black wigs, tried a series of different acts, including routines built around the films *Irma la Douce* and *Cleopatra*. She also modeled lingerie for exclusive clients and did afternoon strips in seamy nightclubs and bars. But it wasn't working. One nightclub owner cruelly told her: **"Without your Marilyn act, you're as dead as she is."** Dixie was barely scraping by. **"It was the end of the line."**

It was in late 1963, now living in New York, that the most troubled period in her life ended. She went into therapy to overcome her emotional problems, lost weight, and emerged a new person. **"I wasn't this blonde, brassy showgirl anymore. . . . It was like a snake shedding its skin."**

Then, around early 1964, former stripteaser Shirley Day came to Dixie and said she needed a headliner to open her plush new club on the Upper East Side. Dixie took one look at the Orient Nightspot and was immediately struck with visions of *Gentlemen Prefer Blondes*. With three days to spare, she put together a new act featuring interpretations of Marilyn's most famous musical numbers, including "Diamonds Are a Girl's Best Friend" and "Running Wild." However, there was a crucial difference from her old act: this was not a comic impersonation, but a loving, heartfelt tribute.

The show's immediate success grew after Dixie spent three months with a New York drama coach and thousands of dollars with dressmakers to duplicate Marilyn's clothes. "A Portrait of Marilyn" became one of the greatest triumphs of her career.

Many an observer would come up to her after a show and tearfully tell her that she had brought Marilyn back to life onstage. Walter Winchell wrote in his syndicated column: **"The Broadway play *After the Fall* [by Arthur Miller] leaves a poor impression of Marilyn Monroe. For a wonderful, wholesome lasting impression, though, catch Dixie Evans."** After playing to standing ovations for six months, Dixie finally felt released from the Monroe legacy. She retired from full-time performing in 1967.

From 1969 to the mid-1970s, Dixie was part owner and sales manager of the Bimini Hotel off the Miami coast. It wasn't until the early 1980s that she became involved in the world of burlesque once again after returning to California upon her mother's death. Jennie Lee had founded Exotic World: the Strippers' Hall of Fame and Museum, and as her health began to fail in mid-decade she called upon burlesque friends like Dixie to help run the museum.

Since Jennie's death in March 1990, Dixie has served as president of the Exotic Dancers League of North America and of Exotic World. For any fan of burlesque, the museum is a delight — although its remote location in Helendale, California, makes visiting a challenge. There are hundreds of framed and autographed photographs of burlesque immortals from the 1930s to today. Strippers' memorabilia (gowns, G-strings, etc.) abound, and in May 1995 a small movie theater was added, showing vintage films of strippers in performance to help keep the memories alive.

But beyond question the museum's greatest asset is Dixie Evans herself. She greets scheduled visitors at the door and leads them through the museum while providing a running commentary on the history of burlesque. And her Marilyn impression is still devastating. It is Dixie's boundless enthusiasm, energy, and good humor that make each visit a treat.

Dixie takes her responsibility seriously. Virtually every day is devoted to keeping the flame alive. She makes frequent appearances on talk shows like Joan Rivers and Jenny Jones; responds to requests from producers to ensure that movies such as *Blaze* or TV shows featuring old-time burlesque are historically accurate; arranges strippers' reunions and special events; and constantly plans new improvements for the museum. In 1996, she was featured on the cover of *Holding On*, a book by David Irsay and Harvey Wang about **"dreamers, visionaries, eccentrics, and other American heroes."** Dixie's vision shines like a diamond in the California desert.

"I get letters from all over the world. It's wonderful to know that people do still care about you. I still feel important, because we are a vital part of Americana which should be preserved."

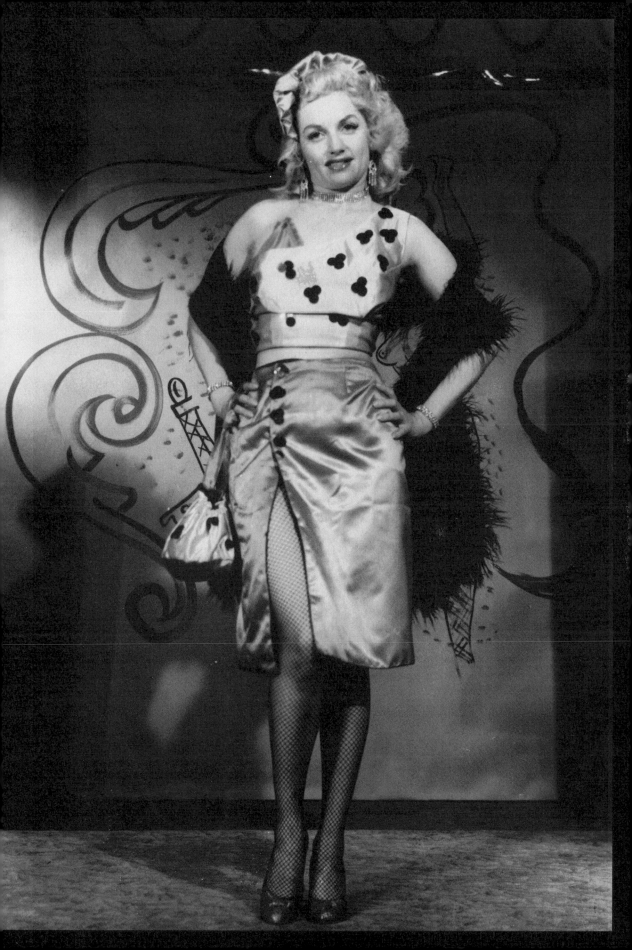

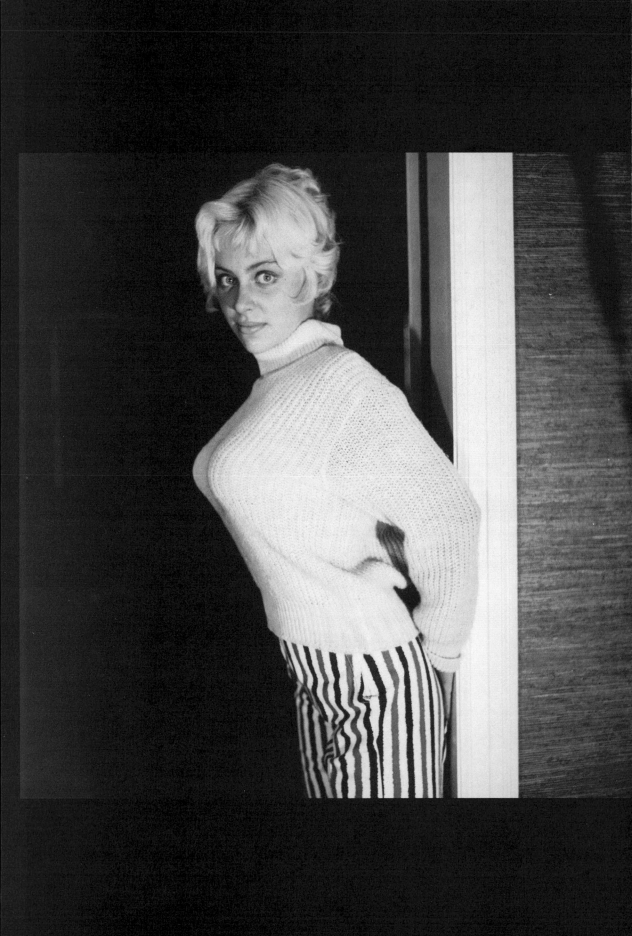

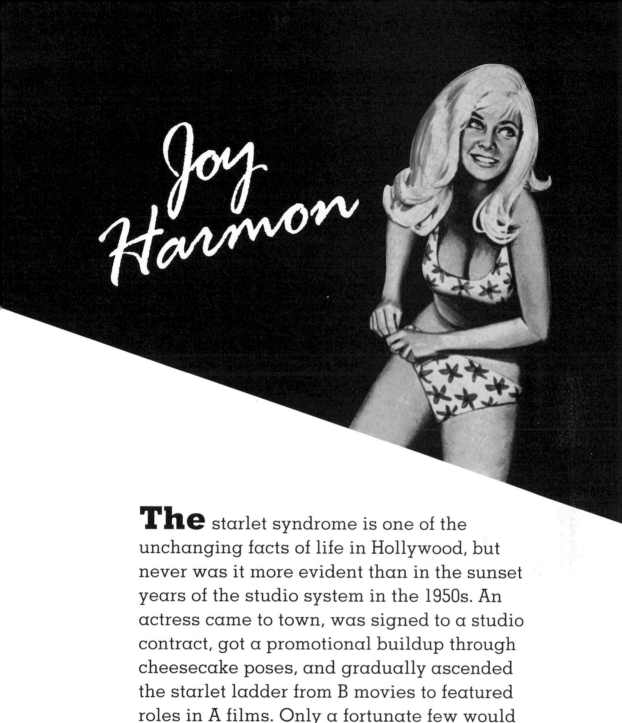

Joy Harmon

The starlet syndrome is one of the unchanging facts of life in Hollywood, but never was it more evident than in the sunset years of the studio system in the 1950s. An actress came to town, was signed to a studio contract, got a promotional buildup through cheesecake poses, and gradually ascended the starlet ladder from B movies to featured roles in A films. Only a fortunate few would crack the barrier to full-fledged stardom, and even those who succeeded sometimes wondered if it was worth the price. As Jayne Mansfield's career began its downward spiral in 1963, she said poignantly, **"Once you were a starlet. Then you're a star. Can you be a starlet again?"**

Joy Harmon symbolized for many the eternal fifties Hollywood starlet. A classic blonde bombshell in the Mansfield mold, she built a devoted following through hundreds of TV appearances, scores of magazine layouts, and several stage roles, plus a handful of featured movie performances. Never quite a "star" despite being responsible for one of the most unforgettable scenes in modern movie history in *Cool Hand Luke*, Joy nevertheless was — and remains — an unforgettable personality.

Joy was born on May 1 in St. Louis and grew up in suburban New York and Connecticut. Her introduction to show business came early, because her father handled publicity for New York's famous Roxy Theatre for more than a dozen years. By the time she started going to school, showbiz was in her blood. **"I couldn't wait to get out of high school,"** she admits. **"I knew exactly what I wanted to do."**

Joy's voluptuous figure blossomed around age thirteen or fourteen. She says she was never uncomfortable about her curves, but there were drawbacks. **"I wasn't popular in high school. It was really my own fault. I would wear tight sweaters to school, and the guys would all look at me — of course they would, because of how I dressed.**

"My idol was Marilyn Monroe, and I went to all her movies. At the theater, when I went out to get candy for my mom and dad, I would wiggle right out the way Marilyn did, and show myself off. When I was fifteen, I went to Miami at the Fountainbleau Hotel and did a show impersonating Marilyn. We had come to Miami for a family vacation, and when I saw the sign advertising the show, I just walked in and auditioned." In the show, Joy performed **"Diamonds Are a Girl's Best Friend"** in a slinky red dress. **"I had her down perfectly. Later, a lot of times when I got a role I'd have to be careful or else I'd be doing Marilyn — it just became second nature to me.**

Joy Harmon on Broadway in "Make a Million"

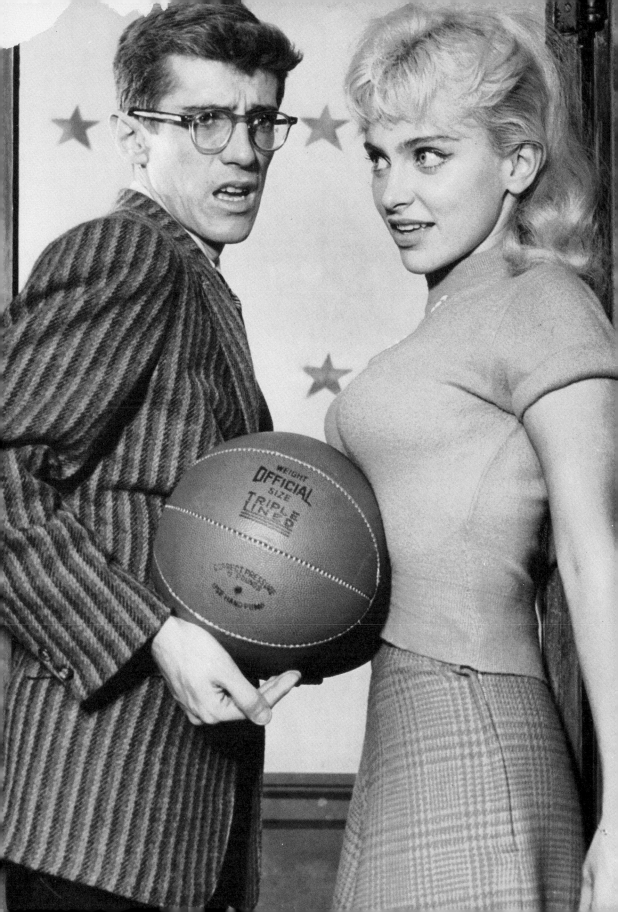

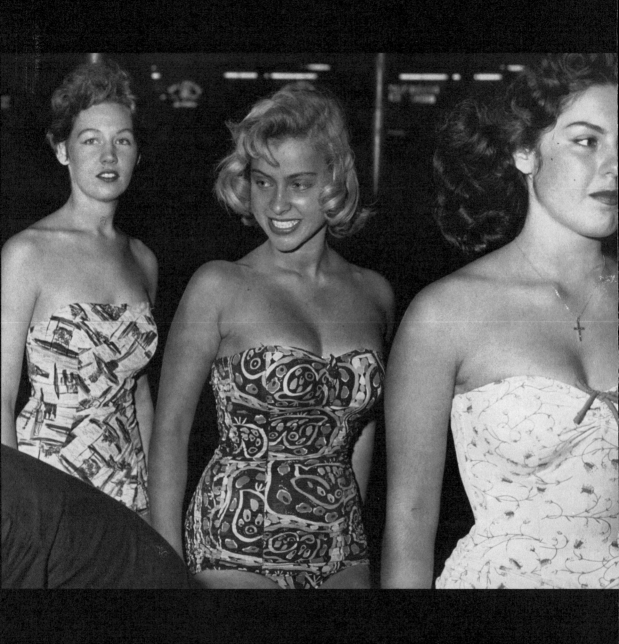

Joy (center) in Miss Connecticut pageant

"I wouldn't know what to do when the guys stared at me, but I liked the idea. I wouldn't talk to them because I was too shy, but they probably thought I was stuck-up. And I didn't have any girl-friends, because I'm sure they thought, 'Who does she think she is? How cheap!' I can't blame them, when I was wiggling around school in tight skirts. My mom helped me use my figure in a positive way, so that it was all comedy and not offensive."

A frequent beauty contest winner, her biggest honor was placing as the runner-up in the Miss Connecticut pageant and earning the right to attend the Miss America event at Atlantic City. After one pageant victory, Joy made her first national TV appearance on *The Steve Allen Show*. For her second TV appearance, in early 1957 on the Garry Moore program, she simply walked across the stage in a tight skirt and said: **"I have a message from Jayne Mansfield."** Moore, with a quick glance at her fulsome chest, replied: **"I get the message." "I made those kinds of appearances on a lot of TV shows,"** says Joy, giggling. **"I was always billed as Miss Something-or-Other and came out in a skimpy outfit, just being the dumb blonde. I loved that!"**

Broadway Bombshell

Joy's big break came at age seventeen when she landed the ingenue lead in the Broadway comedy *Make a Million* starring Sam Levene as an advertising executive. The show opened around the end of 1957. **"I played a ding-a-ling secretary. The biggest laugh in the whole show came when I was standing there in a tight sweater just as the idea man for the TV show came in with two basketballs, saying, 'I've got a great idea for a new show,' and we got stuck in the door. It was a laugh that we could just milk — very corny, but funny."**

The gag worked because the teenager had already filled out to the startling dimensions of 41½-22-36 atop a five-foot-five frame. Joy understood that a curvaceous form was a powerful asset for a budding actress in the 1950s. **"The whole thing back then with girls like Jayne Mansfield was the competition about who was the biggest up here [pointing to her chest]. And it was always the measurements —'Here's Joy Harmon with a forty-one-inch bust!' It was very much the thing to have a big bust measurement."**

Make a Million kept Joy on Broadway for a year, and she made the most of the opportunity. Once, she walked through Times Square at lunch hour in a skintight red dress while photographers captured the open-mouthed stares of admiration from male onlookers. In another commercially sponsored stunt, a leotard-clad Joy walked down Wall Street at midday accompanied by a guernsey bull, snarling traffic for nine blocks.

Joy began to turn up in numerous men's magazines starting in the fall of 1957. **"It was all just for fun. Because I'm naturally sort of naive, it was easy for me to fall into the sexy dumb-blonde parts. All those magazines wanted me to pose topless, and I was always fighting it. They'd be shooting a sexy layout, and the photographer would say, 'Let's just drop the top down,' and I'd say no. . . .** *Playboy* **asked me to do a centerfold. I just didn't want to do nudity. I wanted to act."**

After being signed to a contract with Screen Gems–Columbia Pictures, her first featured film role was in Columbia's *Let's Rock* (1958), starring Julius LaRosa as a ballad singer who is persuaded to switch to rock; Joy appears as a "pickup girl."

The rising starlet headlined an Off-Broadway production of *Susan Slept Here*, a comedy based on a Debbie Reynolds film. **"It was a good role for me, because I was on-stage every minute of the show. They made me a little sexier than Debbie Reynolds had been in the movie."** After its initial New York run, she took it around the United States and Canada for seven months. Joy also did a production of the famous sex farce *Pajama Tops* in the role of tempting French maid Claudine. **"It was a fun, burlesque-ie kind of show,"** Joy recalls. **"I did the part wearing little shorts with an apron, mesh stockings, and a French accent. I'd come bubbling in and sort of shook all over."** June Wilkinson made the part her own in 1961 and later carried it to Broadway and beyond.

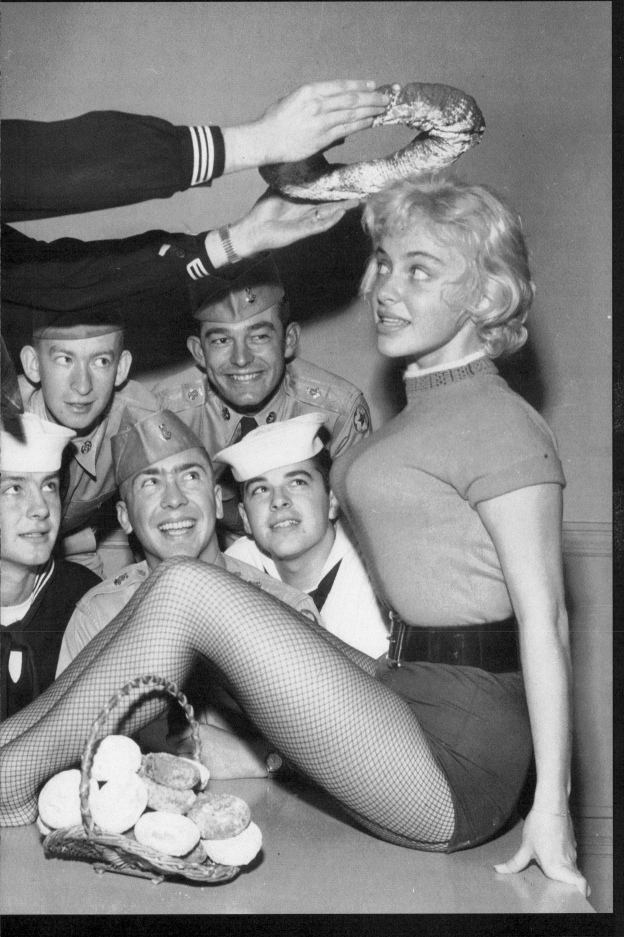

L.R-R281

Joy returned to Broadway for the hit comedy *Come Blow Your Horn* — the first play written by Neil Simon. Starring Hal March and Warren Berlinger as young men working for their domineering Jewish father and embroiled in a comic family feud, the play provided a good role for Joy **"in my usual dumb-blonde style."** When Berlinger moves in with older brother March and begins to emulate his more worldly style, Joy jilts ex-sweetie March and falls for the younger man. After a six-month Broadway run in 1961, Joy left to join a road company performing the show in major cities.

Her next big break came through showbiz legend Groucho Marx. **"Groucho saw me in *Make a Million* and invited me to come to California to be a guest on *You Bet Your Life*. After I went back to New York, he called me and asked me to do some more shows. He liked me to play the dim-witted blonde."** Groucho later decided to drop longtime announcer and hapless straight man George Fenneman and revamp the show, and utilized Joy (billed as "Patty Harmon") as his eye-catching "straight woman" in his new series, *Tell It to Groucho*, which ran from January to May 1962. When Marx hosted *The Tonight Show* for a week, Joy served as his comic foil.

Her friendship with Groucho went beyond their on-screen partnership. **"When I came back to California for the show, my mom was ill, and my dad had to take care of her. So my younger sister Gay and I moved into an apartment and we spent a lot of time with Groucho. He was kind of like my dad. He changed when we were shooting or when his friends would come over. Then he'd suddenly act flirty like I was his hot girlfriend. And I was really like his daughter. He never laid a hand on me or anything — it was all part of his act."**

41 ½

-22-

36

Screen Gem's No. 1 Blonde

After the demanding grind of three long stage tours, Joy says, **"I was tired of traveling. So I was glad when Screen Gems brought me back to California under contract, and I was working all the time for them."** Joy's third and final film for Columbia was the hit 1963 comedy *Under the Yum Yum Tree* starring Jack Lemmon, with Joy as Carol Lynley's girlfriend. From 1963 to 1969, she appeared on virtually every TV series associated with Screen Gems, plus some others.

One of her best-remembered TV roles was as Mickey Dolenz's girlfriend on four or five episodes of *The Monkees* in 1966–67. She also turned up twice in 1963–64 on *The Beverly Hillbillies* playing Max Baer Jr.'s girlfriend; twice on *My Three Sons* as Don Grady's girlfriend; several episodes each of *The Man from U.N.C.L.E.* and *Gidget*; and various other series including *Batman* (in a February 1967 episode featuring Frank Gorshin as the Joker), *That Girl*, and *Bewitched*. In her most prolonged TV role, Joy was a regular on the ABC daytime serial *Never Too Young* in 1965–66. The series focused on teenagers and their parents, and Joy played the girl-friend of Tony Dow (formerly of *Leave It to Beaver*).

Joy appeared in four films released in 1965. Top-billed in *One Way Wahine*, a comedy shot in Hawaii, Joy and pal Adele Claire go for a vacation on the islands only to get caught up in a scheme in which they serve as lovely distractions while two male partners grab a cache of money stolen by gangsters from a Chicago bank. Joy performed the torrid dance **"The Wahine Rock,"** and posters featured her bikini-clad form with the tag line: **"Blonde! Blue-Eyed! And Built for Bikinis!"**

Her most famous role to that date came with *Village of the Giants*, a delightfully goofy Bert I. Gordon production. A fantasy loosely based on an H. G. Wells story, *Village* is about eight teenagers who are stranded in a small suburban town, steal some "magic goo" created by boy genius Ronny Howard, and become thirty-foot giants who decide to terrorize the town. In this camp classic, Joy played the girlfriend of Beau Bridges. When they eat the "goo" and begin sprouting, the camera slowly pans up Joy's body as her shirt buttons explode. When the formerly

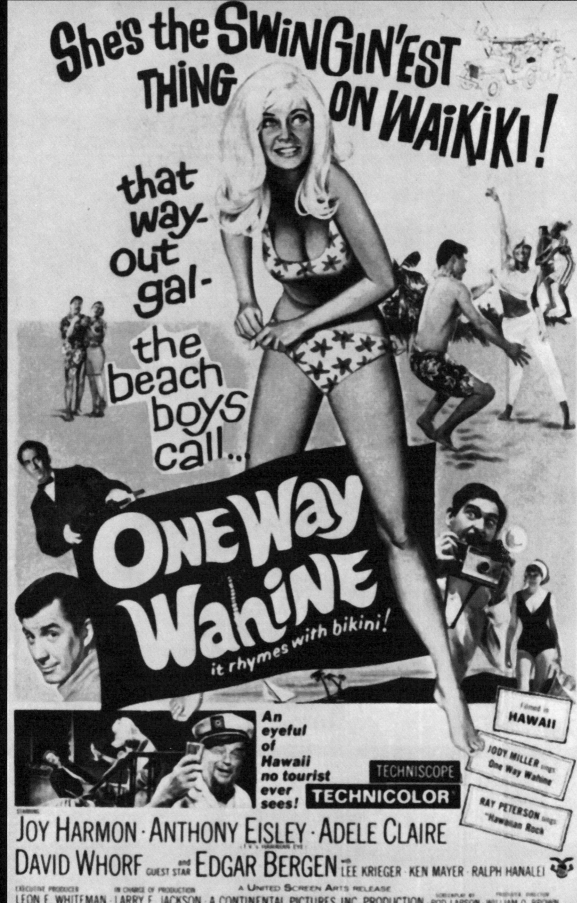

brash blonde blushingly holds her arms akimbo, one of the guys remarks, **"What's the matter, hot shot? Don't cha like your new size?"** She responds, **"I was big enough before!"**

In a film highlight, the giants encounter the town's teenagers in the village square, and begin dancing energetically to the music, with closeups of Joy's torso in a revealing orange bikini. Just for fun, she bends over to pick up one of the local teens, Johnny Crawford, and laughingly continues to dance as Johnny clings for dear life to her bikini bra strap. This scene was depicted in posters for the film. In the end, the giants are cut down to size by little Ronny's ingenuity, and slink back out of town.

Her frenetic dancing in *Wahine* and *Village* showed off the prowess Joy had developed through one of her off-screen activities. **"When I wasn't acting, I danced in clubs in Hollywood with my sister Gay, who was a go-go dancer. I filled in for her once at the Aladdin Hotel in Las Vegas, and sometimes clubs in L.A. would hire me to dance. I loved it."**

Cool Hand Luke

Little did Joy realize in 1967 that she was about to embark upon the most renowned role of her career. Set in 1948, *Cool Hand Luke* is the story of rebellious former war hero Paul Newman, who is convicted for knocking off parking meters and sent to a brutal southern chain-gang camp, where he is gradually accepted by George Kennedy (the Oscar winner as Best Supporting Actor) and the other prisoners, who come to respect his fierce spirit and independence.

"My agent got me an audition at Warner Brothers. Paul Newman and [director] Stuart Rosenberg were there. I was told to wear a bikini, just to see if the girls who were auditioning had a good figure. I wore a big sweatshirt over the bikini and then pulled the sweatshirt off." Rosenberg interviewed fifty to one hundred actresses, but Joy's qualifications were unmatched.

"They sent me to Stockton [in northern California], and I was there for two and a half days. I just sat in a hotel room, because Stuart Rosenberg didn't want any of the guys to see me. Joanne Woodward wasn't there, and no wives were on the set. He wanted a totally fresh reaction, and for the guys to have the feeling of being without women for a long time. There was no makeup, he wanted me to look natural."

The scene unfolds soon after Newman has joined the chain gang, and the men are slaving away on a lonely road. They see Joy walk out of her dilapidated farmhouse in a skimpy, low-cut blue dress with several rips in the fabric. Their eyes boggle as she fiddles with a garden hose before beginning to wash her car.

As she begins to wash the vehicle, it becomes apparent that this extraordinarily constructed girl is quite aware of her audience — she glances in the car's rearview mirror and takes a sultry look at the prisoners' reflection in the hubcap. She leans over, displaying ample cleavage, and we see just how fragile her attire is. Newman just grins in silent admiration.

"Hey, Lord," begs Kennedy, "whatever I done, don't strike me blind for another couple minutes. Oh, my Lucille!" "Your 'Lucille' — where'd you get that?" asks Newman. In an immortal line, Kennedy replies, "Anything so innocent, and built like that, just gotta be named Lucille!"

Next she stands and methodically squeezes the big sponge as the soapsuds cascade down the front of her already wet dress. Kennedy chortles and visibly trembles in astonished excitement. She squeezes some more, and slowly wipes the soap off her dress. As she carefully brushes her bosom, she shoots a provocative glance toward her helplessly panting audience. "She doesn't know what she's doin'!" exclaims one prisoner. "Oh, boy, she knows exactly what she's doin'," responds Newman with amused cynicism. "She's drivin' us crazy and lovin' every minute of it!"

Finally, Joy bends down to take a drink from the hose, walks up to the car and presses her bosom against the window as she washes. As she sways back and forth in that soaking, low-cut blouse and rubs ever harder against the window, her cleavage assumes startling proportions, and the men are literally gasping for breath, until the scene cuts to the camp shower.

It's amazing to realize that Joy's entire scene in *Cool Hand Luke* lasts for less than five minutes. Perhaps no other single motion picture scene of the 1960s stimulated more fantasies than Joy's Big Tease.

"I knew that the guys would be turned on, and I knew I had a tight dress on and that my figure would be showing," says Joy. "But I had no idea they were showing my bosom rubbing against the windows. Even when it played in the theaters, it just looked to me like a sexy girl washing her car. Now, looking back, I can see the double meaning of the girl deliberately driving the prisoners crazy. I was just acting, not trying deliberately to be sexy; that was secondary. Maybe that's what made the scene work so well. I've always been kind of naive and innocent, and that's the way I played it."

Cool Hand Luke appeared to be the biggest breakthrough of Joy's career — the role that would catapult her to major stardom. However, all-out stardom did not follow. **"I never really had the desire to become a big star. I know people said that after *Cool Hand Luke* I should have really gone after it. I was constantly working, with calls from Screen Gems to do one TV show or another. I probably wasn't very smart; maybe if I'd planned things more carefully, I could've gone further in my career."**

In 1969–70, Joy appeared in *Love, American Style* as Michael Callan's girlfriend, and twice on *The Odd Couple* as a ditzy waitress. She also kept busy with TV commercials. **"I did a Milky Way commercial in about 1967 that ran for two years, playing a kooky young receptionist eating Milky Way bars while I was talking. I also did an airline commercial as a passenger wearing a very short, revealing red dress, and a Ford Mustang commercial as kind of a blonde ding-a-ling."** In 1969, she did sexy print ads clad in a bikini as **"Miss Body Beautiful"** for a line of auto-body products.

Her first movie after *Cool Hand Luke* was *Angel in My Pocket* (1969), a comedy starring Andy Griffith as a parson who helps settle a small-town political rivalry. In a colorful reprise of a familiar role, Joy portrayed a beauty contest winner, Miss Holland. **"I had to go onstage and dance in this crazy costume — I had little windmills, run by batteries, stuck on my bikini top. I was giving a performance at Andy Griffith's church. I was chewing gum and saying, 'There's something wrong with my batteries!', and he was trying to fix it so that I could go on. Finally the batteries started working and the windmills' arms started going around, and I said, 'See! It works!'"** The picture turned out to be her last.

The reason for the end of Joy's showbiz career was her marriage to TV and movie producer Jeff Gourson. **"I met my husband horseback riding. Jeff was working for Alfred Hitchcock at the time as an assistant editor. We got married three months later."** Jeff Gourson later became an editor at Universal, working on films such as *Somewhere in Time* and *Tron*; he also produced the hit TV series *Quantum Leap*.

In 1969, American International Pictures **"wanted to put me under contract. But my husband didn't want me to do it, and I turned it down. He never liked that sexy image I had."** After Joy left showbiz behind, the couple's son Jason was born in 1974, followed by daughters Julie and Jamie. The breathy, little-girl vocal quality that served Joy so well in her acting days is unchanged today. **"All of my roles had that ingenue quality. Even today, I still sound young and I think young."**

During recent years, Joy has put her distinctive vocal qualities to work in TV and movie voice-overs. **"I did all the voice-overs for *Quantum Leap*. Sometimes I put in an actress's voice, but mostly it was in crowd scenes, looping in the extras' voices. . . . And I do kids' voices, naturally!"** Joy's looping has also included work on *Columbo* and several horror films.

While considering a part-time return to acting, Joy has embarked on her own business, Aunt Joy's Cakes. **"It started a couple of years ago. I always used to bake cookies for Groucho and for people on all my acting jobs. I started supplying cakes to local coffeehouses, and then Disney and the other studios started asking me to bake cakes for parties and other special occasions. It's very fulfilling. I like to know that what I do makes people happy."**

Joy's recent reemergence at collector shows was an eye-opening event for a lady who's always seen herself in exceedingly modest terms. **"I just can't believe that people remembered me! They were so glad to see me and to know that I was all right. I never made it to be a star, but I did have a following, which I was totally unaware of. That really made me feel warm.**

"I've always been a very fortunate person, and I'm grateful for everything that's happened to me. It's given me a lot of happiness. I worked for a long time, I married late, and I have a wonderful family and now a new career. I really feel blessed."

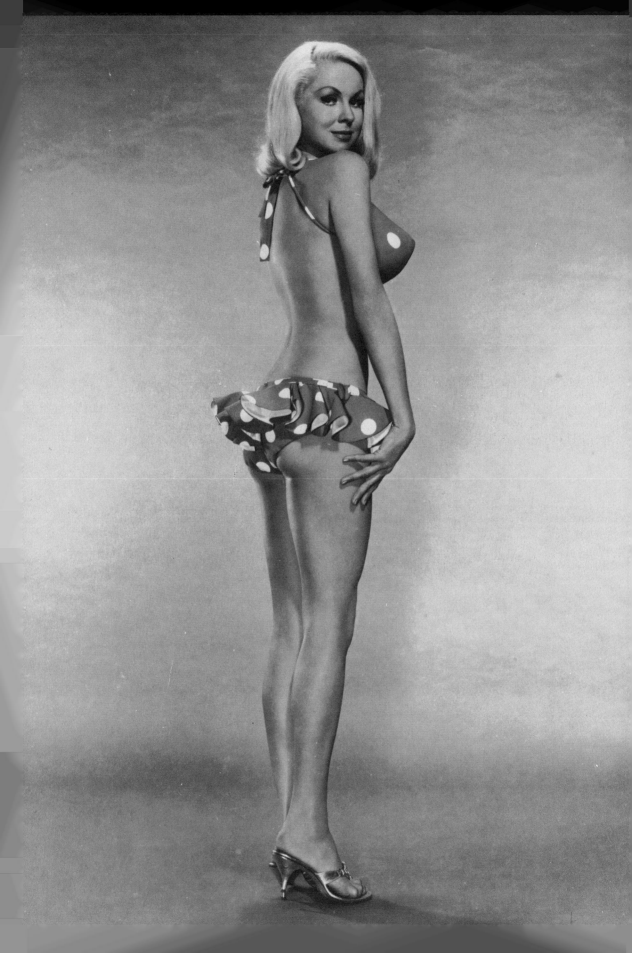

Joi Lansing

Among the leading Hollywood sex
bombs of the 1950s, Joi Lansing was unique.
A non-smoking, non-drinking, practicing
Mormon is hardly a typical character profile
for a glamour queen. But still more striking,
a 1996–97 All-Time Glamour Girls Survey
conducted among international pinup fans
placed Joi in the Top Fifty, surpassing many
of her contemporaries who were bigger
"stars" by traditional standards. The sheer
power of her beauty, astonishing figure, and
golden-girl aura has enabled her to exert an
enduring hold on the memories and imagi-
nations of her fans.

The future blonde bombshell was born Joyce Wasmansdorff (not **"Joy Loveland,"** as stated in her studio biographies) in Salt Lake City to a devout Mormon family. Attributed dates for her year of birth have ranged from 1928 to 1936; a birthdate of April 6, 1929, seems most credible. When she was six, her family moved to Los Angeles. As a well-developed sixteen-year-old, Joi started working as a photographer's model.

From an early age, Joi (whose first name was generally spelled "Joy" until the mid-1950s) had her eye on Hollywood. In 1957, she recalled, **"Strangers used to stop me and Mother and tell her I should be in pictures. It got so I believed it."** After she was seen in a high school play, MGM's Arthur Freed signed her as a contract player, and altered her last name to "Lansing." Her first major nationwide exposure came with a cover story in the March 28, 1949, *Life* magazine, which described her as Hollywood's newest **"dumb blonde."** One director dubbed her a latter-day Jean Harlow.

Joi's studio biography remarked that some of her early movie appearances **"landed on the cutting room floor because they were considered too sizzling"** for a young girl. Her debut occurred, uncredited, in 1947's aptly named *When a Girl's Beautiful*, as a **"Temptation Girl."** She appeared (barely) in at least six other films during 1948–49; in the 1949 Esther Williams flick *Neptune's Daughter*, Joi finally played a character with a name. The following year, her MGM contract was not renewed.

While modeling swimsuits on the side, Joi won the 1950 Miss Hollywood beauty contest. That same year, American soldiers had the opportunity to ogle Joi as part of a Hollywood contingent touring armed forces bases from Japan to North Africa and Europe.

From 1951 to 1953, she was married to actor Lance Fuller, whose movie credits would later include *This Island Earth* and *God's Little Acre*. The union ended unhappily. Meanwhile, Joi continued to accumulate small parts in a wide range of movies, including *Singin' in the Rain* (as an audience member) and as a showgirl in the Jane Russell vehicle *The French Line*. She also began turning up frequently on television, including the 1954 pilot episode of *December Bride* and guest shots on *The Jack Benny Program* and *Ford Theater*. Additionally, she served as a regular "TV Girl Friday" on Los Angeles's *NTG* show, hosted by showman Nils T. Granlund.

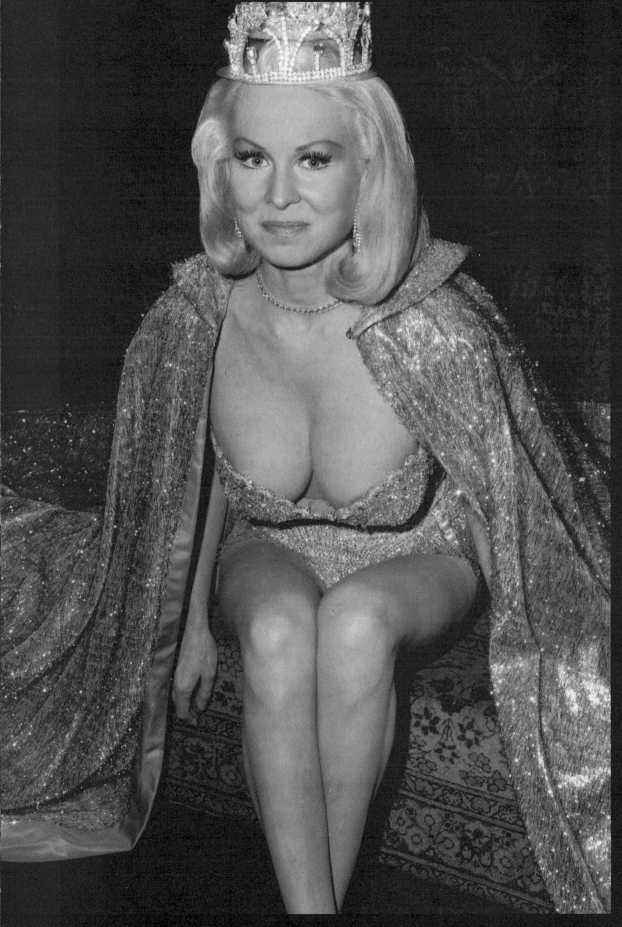

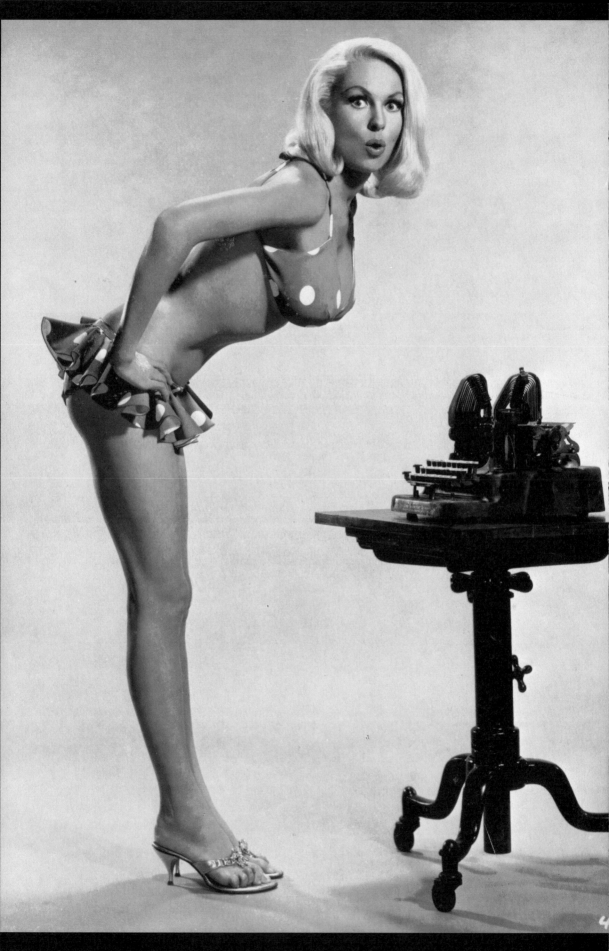

1955-1959: The Starlet Emerges

Joi's career to this date had to be considered a disappointment for a would-be Harlow. The small screen would provide her vehicle to stardom. In early 1955, *The Bob Cummings Show* (later known as *Love That Bob*) debuted on NBC, starring the ever boyishly charming Bob Cummings as a girl-crazy pinup photographer. Joi was a delightfully welcome regular in 125 of the sitcom's episodes as Shirley Swanson, a bosomy model who chased after Bob. That September, the show switched to CBS for two years, until returning to NBC for two final seasons concluding in September 1959.

Joi, Kim Novak, and other sexy starlets graced Howard Hughes's 1955 sand-and-bosoms epic *Son of Sinbad*, whose female lead was stripping legend Lili St. Cyr. At last, in 1956, Joi landed her first featured movie role, in the acclaimed children's story *The Brave One*. The tale of a Mexican peasant boy and his love for a bull destined to die in a bullfight earned the Oscar for Best Original Story. Another costarring role came the same year in an action film, *Hot Cars*.

One could hardly turn the station without seeing Joi. Her TV appearances in 1956 alone included *Make Room for Daddy*, *Fireside Theatre*, *The Adventures of Ozzie and Harriet*, and the anthology series *Conflict*. A memorable episode of *I Love Lucy* in which the Ricardos and Mertzes are stranded on a desert island, which turns out to be a movie location, and encounter threatening natives features lovely Joi in a swimsuit.

Many adolescent males got their first gander at the blonde stunner in an episode of *The Adventures of Superman* in which she **"wed"** the Man of Steel, actually a scam used to catch a criminal. While continuing to appear on the Cummings show, her TV guest appearances kept coming. During 1957–59, these included two more *Ozzie and Harriet*s, a Lucy and Desi comedy special, *The Frank Sinatra Show*, and *Studio 57*, among others. She also found time to appear in several "Joe McDoakes" comedy shorts released by Warner Brothers from 1954 to 1956.

One of her most unforgettable TV appearances occurred in 1958 with Jack Benny and Danny Thomas. After seeing Joi in a daringly low-cut gown doing a sketch with the two comedians, leaning over between them provocatively at one point, some bluenoses sent complaints to the network. Joi's admirers, of course, cheered for more. Some years later on *The Joey Bishop Show*, she performed a song in a gown whose top appeared to be almost entirely transparent. As Joi finished, Bishop ran up and draped a jacket over her shoulders.

A small part in Orson Welles's 1958 film classic *Touch of Evil* looked good on her resume, but the only scene in which she is recognizable comes when Welles enters a strip joint, and one of the dancers pictured on the poster outside is Joi. Welles also gave her the lead role in a thirty-minute 1958 TV drama, "Fountain of Youth," regarded by some as her finest performance.

A supporting role in Frank Sinatra's sentimental 1959 comedy *A Hole in the Head* occurred when Sinatra was romantically involved with the Marilynesque beauty. Several years later, Joi would appear in another Sinatra film, *Marriage on the Rocks*. And in the early 1970s, according to Kitty Kelley's biography of Ol' Blue Eyes, he quietly paid Joi's medical bills during her final illness.

1960–1972: A Trouper to the End

The 1960s opened promisingly with Joi's memorable supporting role in the hit comedy *Who Was That Lady?*, a spicy farce starring Tony Curtis as a college professor caught kissing a pretty student, with Janet Leigh as Tony's jealous wife. Joi (as Florence Coogle) and Barbara Nichols, as her comparably curvy blonde sister, almost steal the show in a hilarious restaurant scene with Curtis and pal Dean Martin. Another good role that year came in the sci-fi film *The Atomic Submarine*.

Klondike, an adventure series set during Alaska's 1898 gold rush, was Joi's second network series as a regular, playing gambler James Coburn's girlfriend Goldie. However, after several episodes in the fall of 1960, the series was overhauled with Joi dropped from the cast; it was canceled the following February. In a happier event in August 1960, Joi married producer Stan Todd, who also became her business manager.

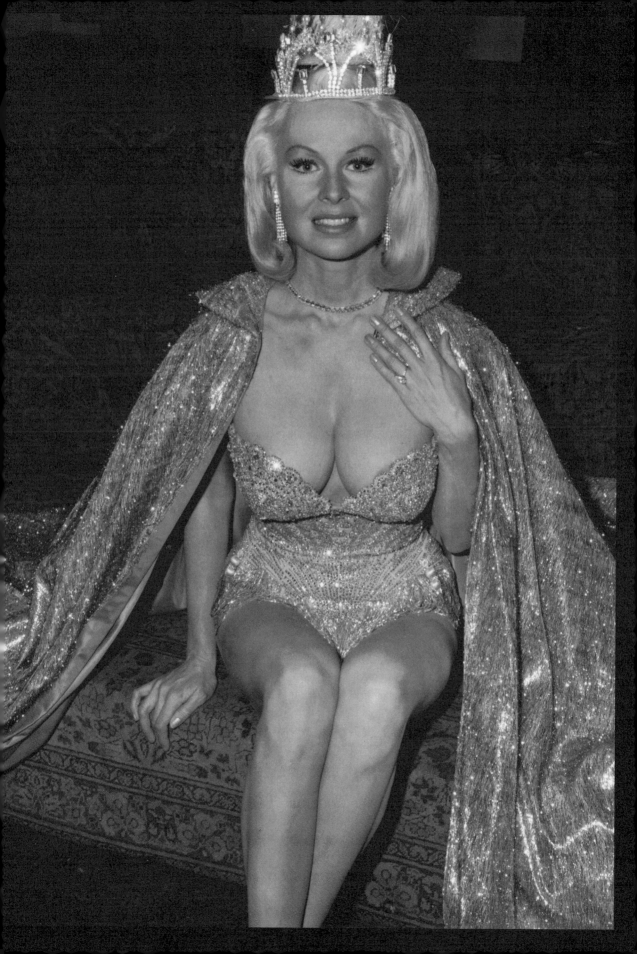

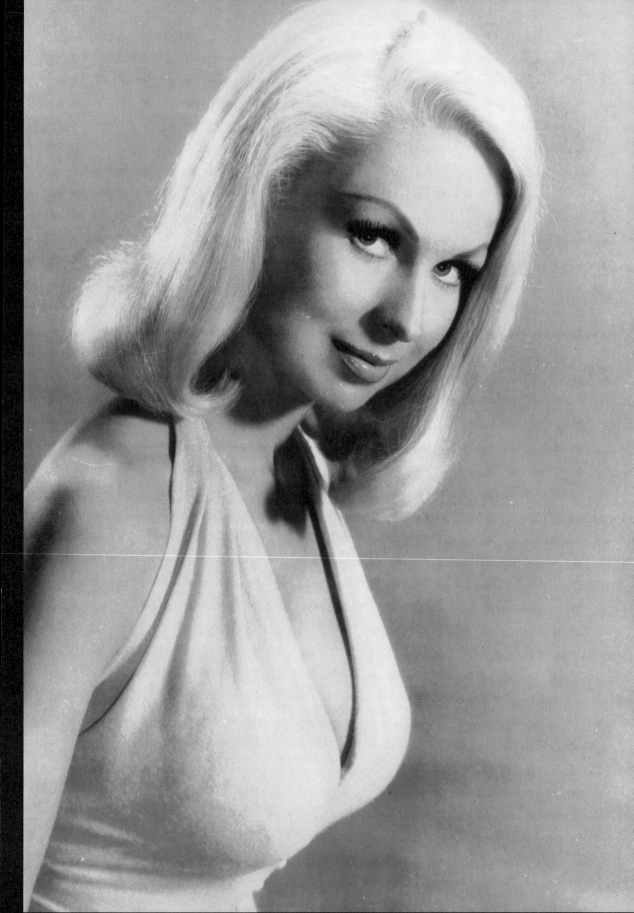

Seeking a different direction, Joi focused more on live theater performances and singing. Her nightclub debut occurred at New York's popular Living Room Club. In addition to releasing a single on the small REO label, "Love Me" backed with "What's It Gonna Be?," she also reportedly recorded an album, *Joi to the World*.

Joi was also a contributor to a short-lived fad that proved ahead of its time, video jukeboxes, and recorded at least three music videos. "Web of Love" provided the basis for a colorful production depicting Joi caught in a large "web," and then changing into a swimsuit to seduce a lucky fellow at an indoor pool.

In her nightclub appearances, **"Joi saunters up to the mike in the most daring gown in all of show business,"** wrote Milt Gentry. **"The bottom half of her dress clings to her slender gams like wet tissue paper, and the top half — well, there almost is no top half. It roughly approximates two wide shoulder straps joined somewhere in the neighborhood of her navel, and it is filled to overflowing with a figure that makes Jayne Mansfield look like Fred Astaire."** Also during the early 1960s, she signed on to replace Xavier Cugat's gorgeous ex-wife, Abbe Lane, as vocalist with his band at a few U.S. engagements and in a TV special recorded in Portugal.

Ushering in a new career phase in early 1964, Joi was cast by *The Beverly Hillbillies* in the role of bluegrass musician Lester Flatt's wife, Gladys, an ambitious but hopelessly untalented singer and actress. Joi made once-a-year appearances in this role through 1968.

Joi's always splendidly curvy form had taken on even more spectacular dimensions by this time. One publication remarked that **"her physical training has added three-and-a-half inches to her bustline and thousands of dollars to her bank account."** It has been speculated that Joi obtained breast implants, bringing the top measurement of her famed 39-23-35 dimensions to an imposing 41 by 1962.

In a potential career breakthrough, it was reported in 1965 that Joi was up for the female lead opposite Dean Martin in the Matt Helm spy romp *The Silencers*. But the role wound up going to Stella Stevens, who turned in a bravura comic performance. The missed opportunity was reminiscent of a decade and a half earlier, when Joi lost a juicy supporting role in *The Asphalt Jungle* to another blonde named Marilyn Monroe.

By the late 1960s, the privately modest beauty who had turned down thousands of dollars to pose for *Playboy* said she was ready to consider going nude in the right film role. **"I hope they have a big enough lens,"** she said teasingly. Sadly for her pinup admirers, it never happened.

The longtime starlet could sense that her motion picture career was winding down with the 1967 hooter *Hillbillys in a Haunted House*. But nightclubs and dinner theater provided a venue for her continuing beauty and talent. Joi starred in a 1968 production of *Gentlemen Prefer Blondes* for eight weeks in Memphis; put her old-fashioned sex appeal to work by starring in a summer of 1969 nostalgic revue, *Follies Burlesque '69* in Latham, New York; and followed in 1970 with *Come Blow Your Horn* at the Thunderbird Hotel in Las Vegas. In a 1970 interview, Joi noted that doing a nightclub act would **"give me time to sit things out and see which way the wind will blow — what the new trends will be. Frankly, I'm confused."**

In 1970, Joi learned that she had a cancerous tumor, and underwent surgery early that summer. Following a brief recuperation, she resumed her career later that year by shooting a grade-Z horror film, *Big Foot*, directed by Robert Slatzer — who later garnered publicity for his claim that he had briefly been married to a prestardom Marilyn Monroe.

Another blonde-bombshell actress, June Wilkinson, knew and liked Joi. Around 1971, June had to turn down an offer for a dinner-theater production of her famous vehicle *Pajama Tops*, and suggested that Joi stand in her place. **"She gave it a try, but she was in the final stages of cancer then, and wasn't able to do it. The theater finally held the show until I was available."**

In 1972, Joi was signed to star in a new production of *Follies Burlesque* at the Meadowbrook Theatre in New Jersey, scheduled to open that July 26. However, she was again taken ill, with severe anemia. She died on August 7 in Santa Monica.

Joi had emphasized to George Lee: **"I am not how I look, inside. Outside, I'm blonde and fluffy — but inside I do have a heart and soul and deep feelings. Yet no one gives me credit personally, because of the exterior."**

A few years earlier, Joi took a philosophical look at her career. She noted that she had proudly publicized her exceptional dimensions, but while they were responsible for landing her numerous roles, there were drawbacks. **"My being blonde and curvy, you might say, was a kind of mixed blessing,"** she reflected. **"I was always known as a glamour girl and categorized only as that. It was very limiting. I was held back by my image."**

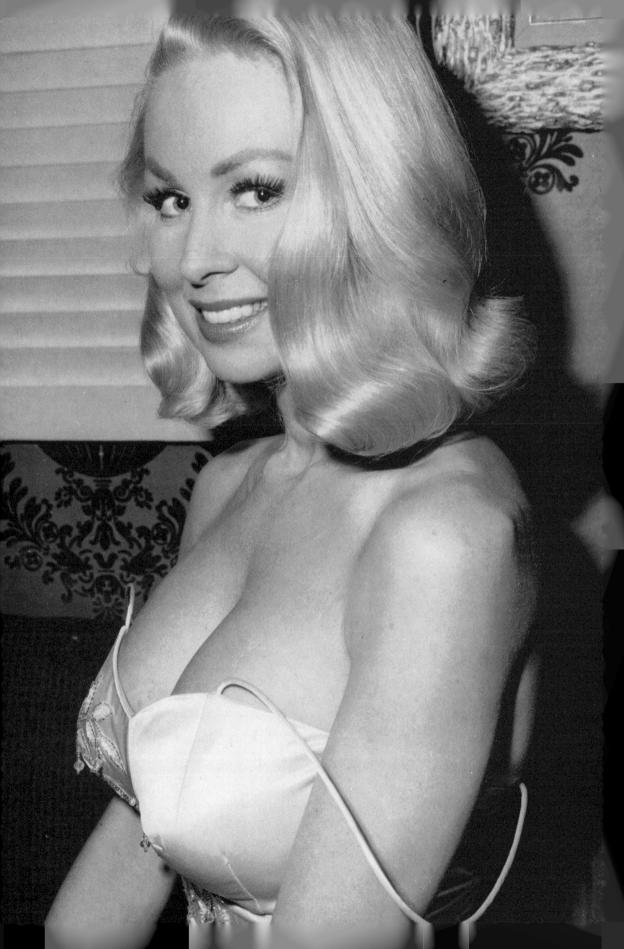

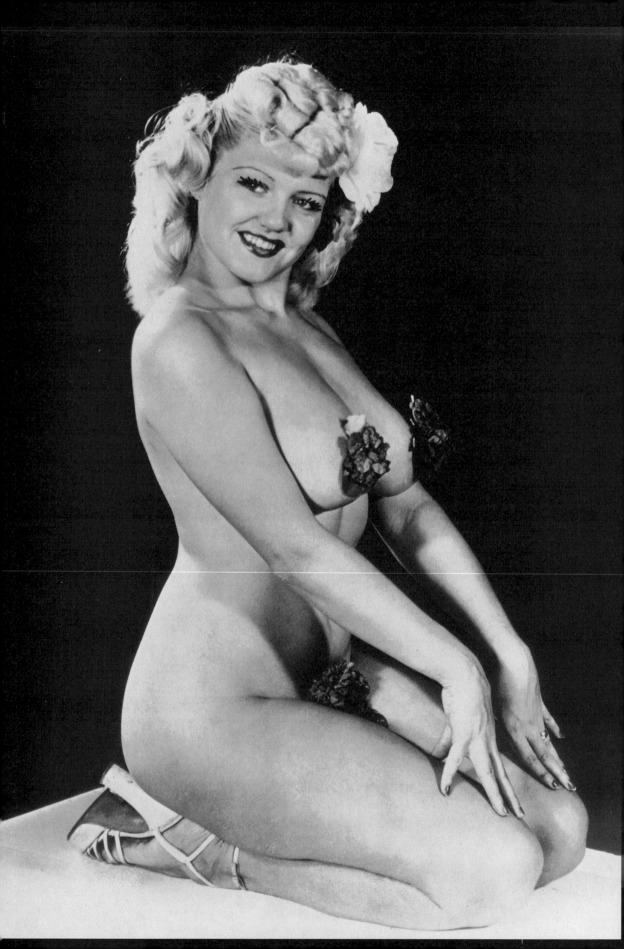

Jennie Lee

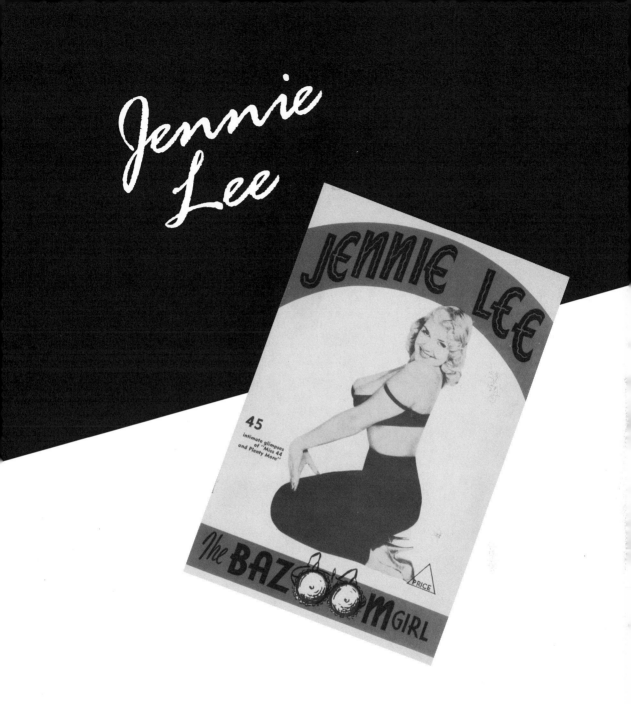

She was known as the Bazoom Girl, but to her friends and fans, Jennie Lee's vivid character and generous spirit were even more unforgettable than her outrageous physical attributes and wild stage performances.

Born in October 1928, in Kansas City, Virginia Lee Hicks
began her burlesque career as a teenager just out of high school.
Upon seeing her first burlesque show with a group of friends, the
already well-constructed youngster decided that she had just as
much to offer as the gals onstage. Fired from her first job as a
showgirl at a K.C. burlesque theater, she decided to try stripping,
and put together an act that proved a smash in a tryout at a
Joplin, Missouri, theater. Before long she was performing as a
headliner before enthusiastic off-duty GIs.

By 1950, the buxom (42-28-38) blonde was working in theaters
throughout the burlesque circuit, billing her mighty torso as
"the biggest bust in burlesque." During the bosom-crazy fifties,
this was enough to bring Jennie before a national audience, and
she made the most of the opportunity. Later, she regularly pro-
claimed herself **"Miss 44 and Plenty More!"**

In addition to her natural assets, Jennie was renowned for
her prowess in twirling tassels in opposing directions, and for
sometimes performing cartwheels onstage. In her uninhibited
enthusiasm she was also known on occasion to test the outer
limits of the law regarding the presence of pasties and G-strings.

Stripping and frequent modeling for men's magazines were
hardly the limits of her professional activities. Jennie also
starred in legitimate stage comedies in Los Angeles such as
Diamond Lil, *Will Success Spoil Rock Hunter?*, and *She Dood It
in Dixie*. In addition, she made recurring appearances on TV's
classic private-eye show *Peter Gunn* as — what else? — a strip-
per. She also headlined nudie movies, including *Abandon* (1958),
The French Follies (1959), and *Ding Dong . . . A Night at the Follies*
(a full-length 1959 burlesque movie). One of her early strip film
shorts brought her into court in February 1952 on the charge of
performing an indecent dance in the photographer's studio, but
after Jennie insisted on a jury trial she was quickly acquitted.

*"Miss
44 and
Plenty
More"*

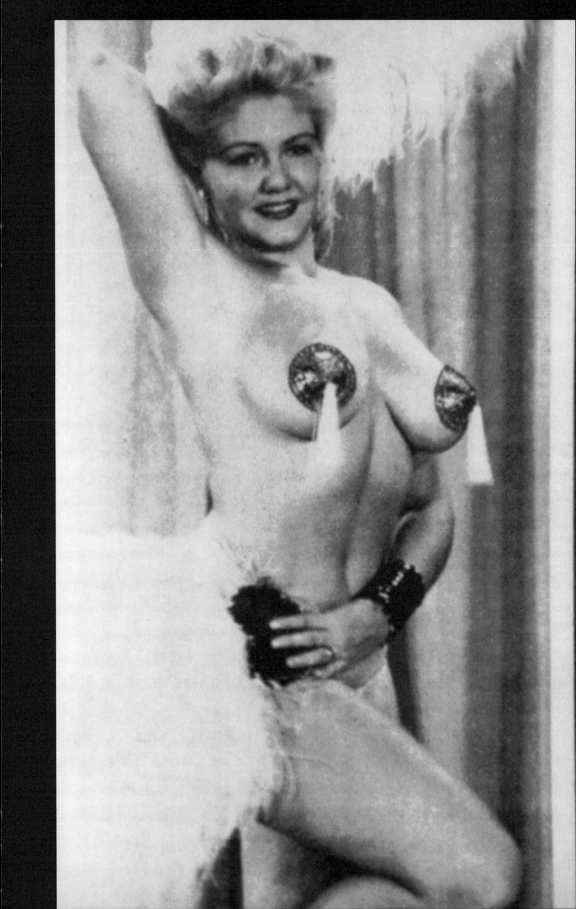

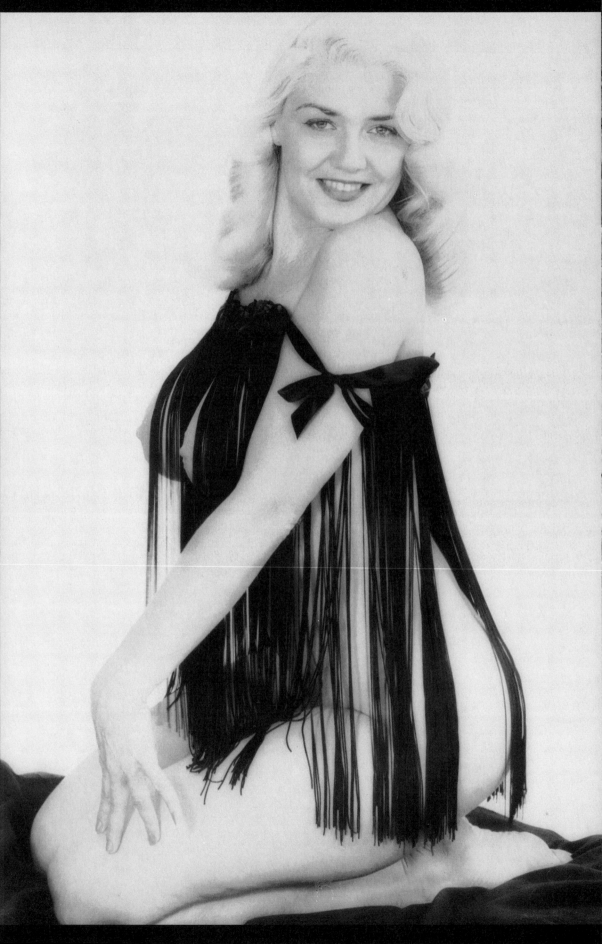

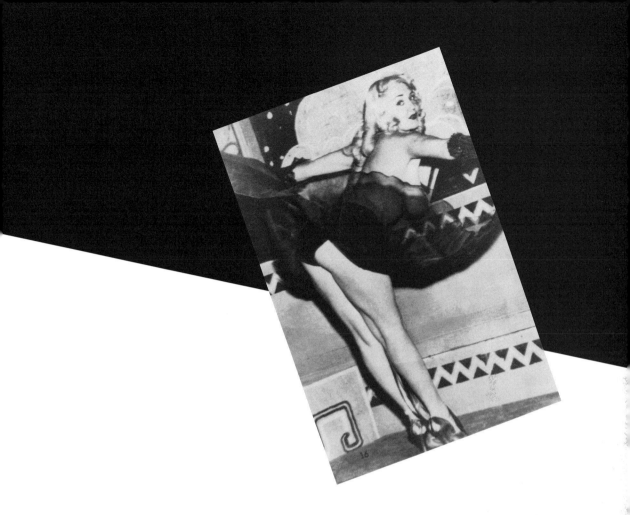

As her fame spread, Jennie took her act abroad, including a six-month tour of Asia in 1956, leaving Japanese and Filipino audiences stunned by her overwhelming physical presence. By this time, her organized fan club numbered over five thousand, calling themselves **"the Bazoomers."** But for the most part, she worked the clubs and theaters of the West Coast.

Jennie ascended to a new level in pop culture in 1958 when she became the inspiration for one of the year's biggest hit records. A group of Los Angeles high school pals including budding musicians Jan Berry and Arnie Ginsburg ventured downtown one night to see the Bazoom Girl in action, and the show left them dazzled. One of the group's members later recalled: **"As she bounced, or I should say as *they* bounced, the old men [in the audience] would accentuate the bounces by chanting, 'bomp bomp bomp bomp,' etc. . . . While driving home in the car, we started the 'bomp bomp' chant, added some lyrics reflecting Arnie's love for his new-found girl, and 'Jennie Lee' was born."** The rock 'n' roll novelty by Jan & Arnie (which later evolved into the hit-making duo of Jan & Dean) reached the Top Ten on the *Billboard* chart in early summer.

In late 1959, Jennie and fellow strip great Candy Barr offered their expertise to teach the female costars of the film *Robin and the Seven Thieves* the art of the exotic dance. While Candy coached Joan Collins, Jennie counseled Joanna Barnes for the actresses' roles in the picture. **"Toward the end of this torrid tutorial, when Jennie shook her tassels and howled with sensual glee, Joanna could do likewise — and like a pro,"** related one magazine account.

For all her success onstage, nothing in Jennie's career was more important than her 1954 founding of the Exotic Dancers League of North America (which she served as its first president). Her friend Dixie Evans recalls that in those days, strippers had only two choices to represent their collective interests: the Burlesque Artists of America, which was widely ignored, and the American Guild of Variety Artists (AGVA), which represented actors and others in the entertainment industry. Jennie was not only an active member of AGVA, but later became president of the organization — just like another entertainer named Ronald Reagan.

When Jennie and her fellow peelers discovered that the minimum wage for dancers in Los Angeles (eighty-five dollars a week) was below the rates in other cities, they complained to AGVA but received no satisfaction. So they formed the Exotic Dancers League to fight for better wages, less crowded dressing rooms, and an end to practices like requiring dancers to hustle drinks from customers between their turns onstage. Jennie took the responsibilities of the new union very seriously. The group was **"founded on the proposition that the exotic dance has a rightful place in modern entertainment,"** she declared, and was formed **"to combat the many discriminations that hazard the profession."**

Like all good strippers, Jennie never missed an opportunity for some juicy publicity. But in her case, much of the publicity was designed to promote her profession as well as herself. She would lead pickets of nightclubs that underpaid strippers; on one occasion, she organized a public burning of old G-strings **"as a symbol of our fight for freedom and expression."** Another widely publicized PR stunt in 1964 featured Jennie and friends picketing a Hollywood revue of topless swimwear, asserting (tongue firmly in cheek) that the suits were **"unfair to strippers"** by lessening the appeal of nudism onstage. At one point, she removed her bikini top for dramatic emphasis.

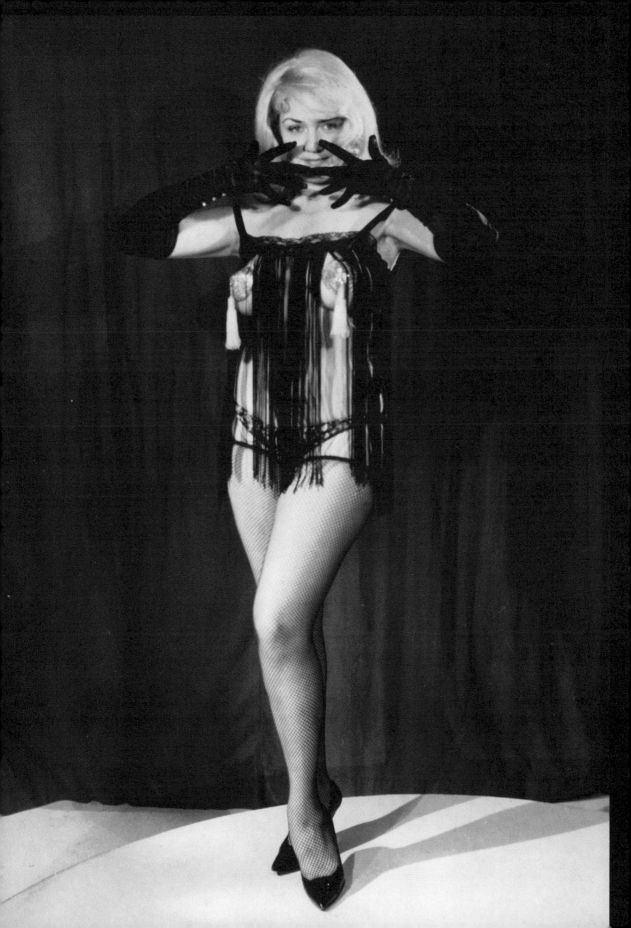

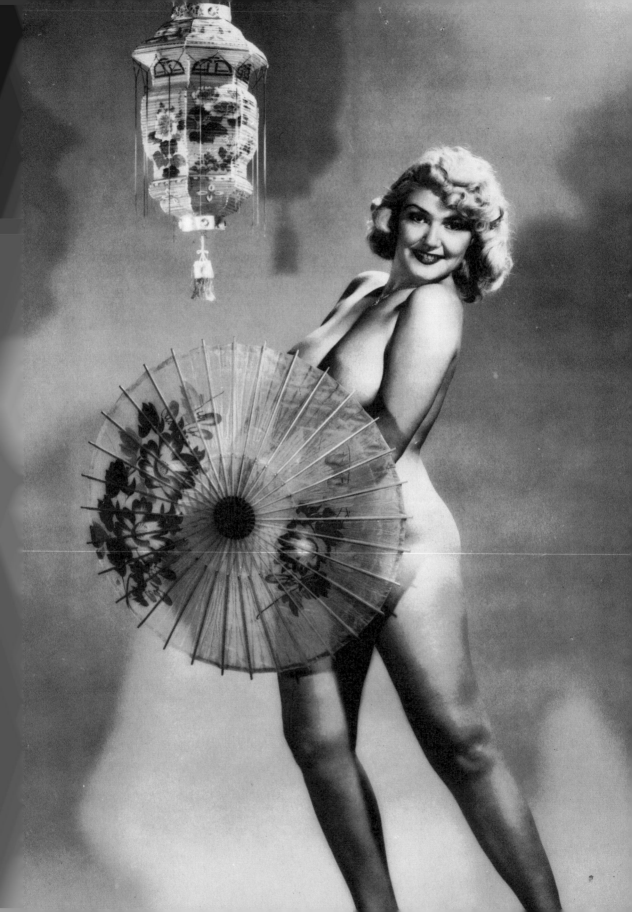

Dixie Evans laughs as she recalls that Jennie sometimes acted as her own press agent. "She was so smart, so industrious . . . Jennie would do *anything* for publicity. We'd all think up crazy stunts, and she was especially good at that." Among her promotional efforts were self-designed lingerie that she marketed commercially, and an exercise tape accompanied by a **"Jennie Lee Better Built Slant Board."** In 1959, the league started an annual Ten Best Undressed list as a counterpart to AGVA's annual awards. Jennie also garnered press coverage for her Barecats stripper softball team. Another vehicle for publicizing the profession was a regular column Jennie wrote during 1962–64 for the Montreal-based newspaper *Continental Flash*, **"Who's Who in Burley-Q?"**

During the 1960s, Jennie expanded her acting endeavors into mainstream cinema. She had bit parts in the 1961 film *Cold Wind in August*, the 1962 sci-fi film *Moon Pilot* (with Jennie as a voluptuous siren), and the 1964 Mamie Van Doren sex comedy *Three Nuts in Search of a Bolt* (in which Jennie played Miss Griswald). Her numerous nudie pictures during this decade included *Hollywood Bustout* (1961, described by Jennie as **"sort of like a travelogue — with sex"**), and *Mondo Hollywood* (with scenes of Jennie stripping onstage, billed as **"the Bazoom Girl"** in the credits). Perhaps the most noteworthy of her unclad epics was 1969's *I, Marquis de Sade*, which chronicled the father of sadism, with Jennie and bosomy Russ Meyer bombshell Babette Bardot in featured roles.

In early 1968, Jennie met an aspiring singer, Charles Arroyo,

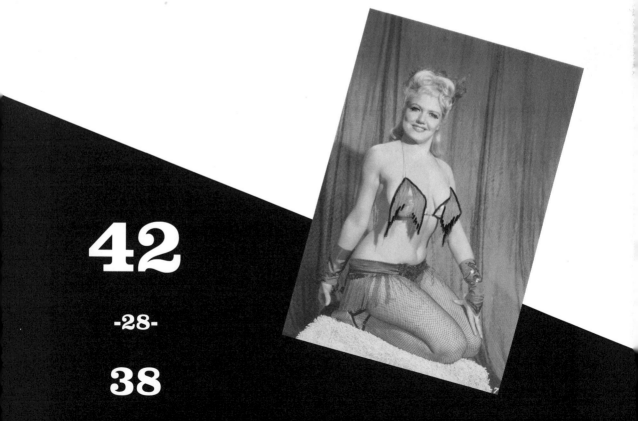

42
-28-
38

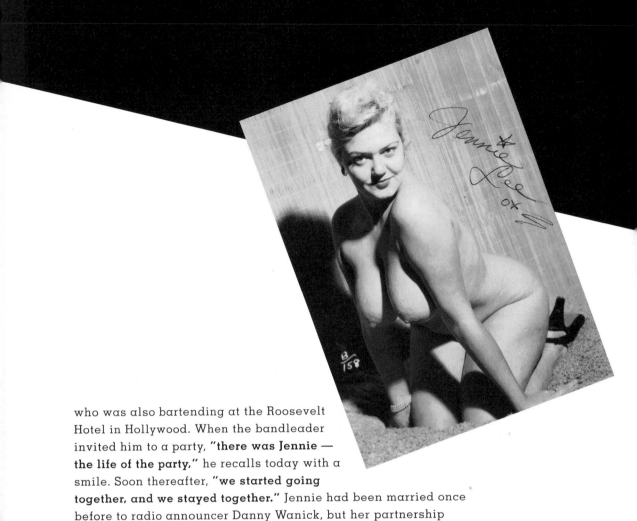

who was also bartending at the Roosevelt Hotel in Hollywood. When the bandleader invited him to a party, **"there was Jennie — the life of the party,"** he recalls today with a smile. Soon thereafter, **"we started going together, and we stayed together."** Jennie had been married once before to radio announcer Danny Wanick, but her partnership with Arroyo would prove enduring.

The following year, the couple bought the Sassie Lassie nightclub in San Pedro. She stripped there regularly while he helped run the business. About six years later, after the closing of nearby military bases hurt business, they closed the club and bought another bar, the Blue Viking in San Diego, again with Jennie as the headliner. During the early 1970s, she also starred in an art-house film called *We're a Family*.

By this time, the always zaftig Jennie had added considerable weight to tip the scales at more than two hundred pounds. Arroyo recounts that she went to several different hospitals to get her weight under control through various pills. **"Finally, she gave up. She told me, 'I got so tired of all the different diets, that's all I did. Now I'm just going to enjoy the years I have left,' and stopped trying to fight it."** But the excess poundage didn't inhibit her a bit as she continued stripping; indeed, she even posed for extensive new nude magazine layouts during the late 1970s and early 1980s, and gained a new group of fans who preferred their women full-bodied.

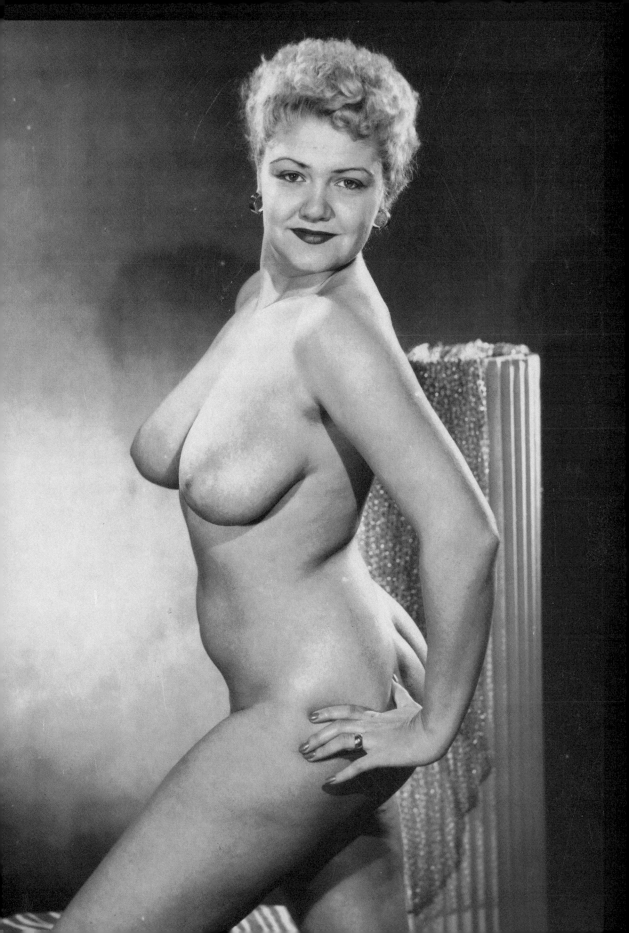

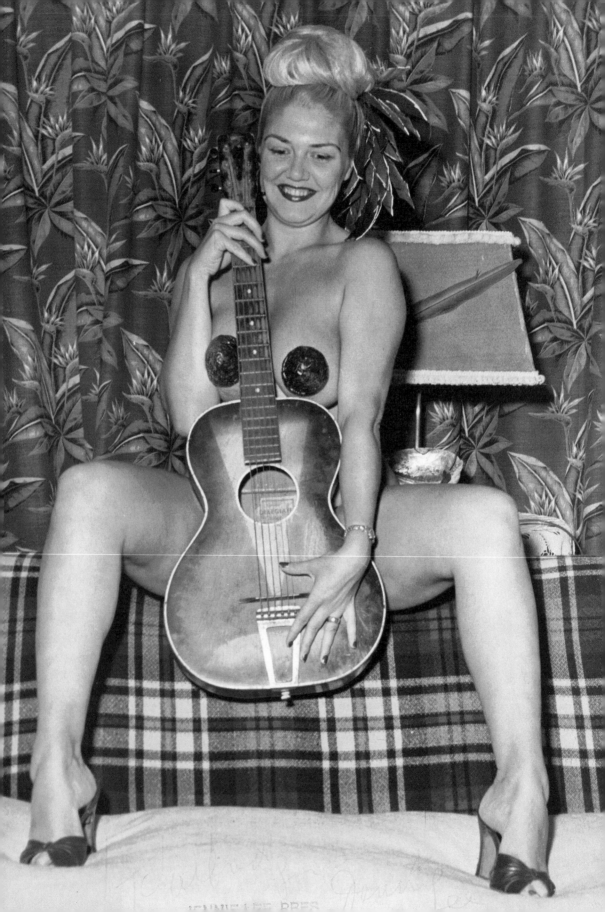

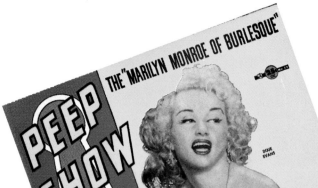

Dixie Evans

THE "MARILYN MONROE OF BURLESQUE"

PEEP SHOW

- BUILT FOR BIKINIS
- BUBBLE BATH WITH A BOA!
- THE BABY OF STRIP TEASE ALLEY
- SUN-KISSED SEX APPEAL
- THE FACE MEN CAN'T FORGET
- A TORSO WITH NEW TWISTS

Joy Harmon

REX
FOR THE MAN ABOUT TOWN

NOVEMBER · FIFTY CENTS

Joy Harmon
Stops
New York
Traffic

ROBERT PAUL SMITH
WARD MOREHOUSE
S. J. PERELMAN

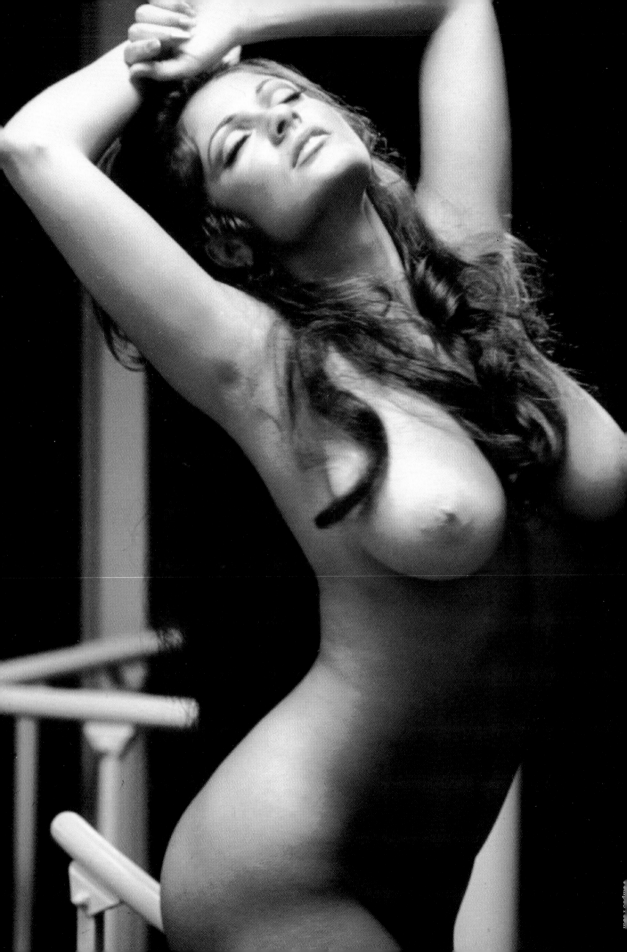

Pompeo Posar

Sabrina

PHOTOPLAY
THE WORLD'S TOP FILM MAGAZINE
MARCH 1956

1'3

SABRINA: how far can you go on a gimmick?

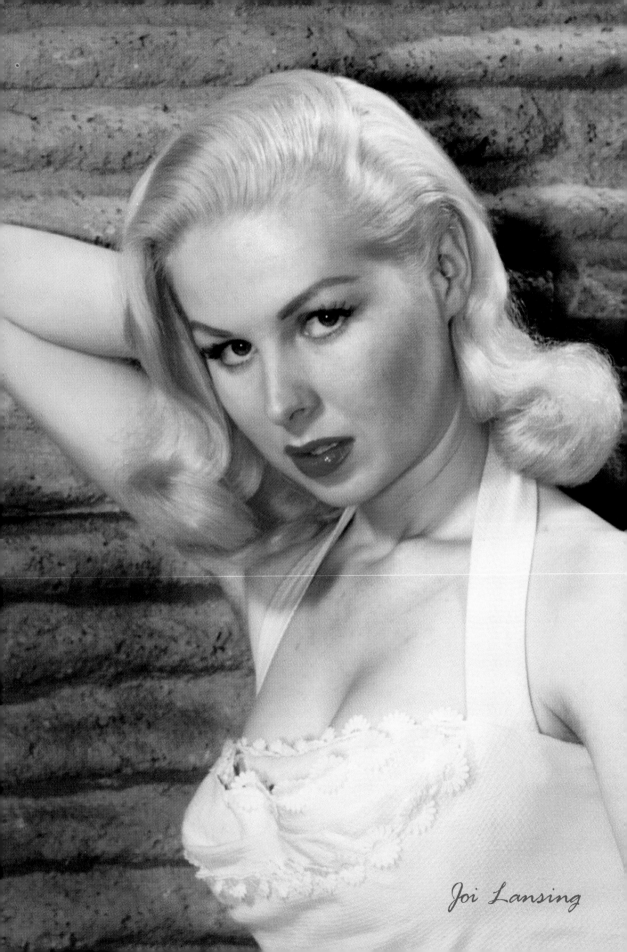

Joi Lansing

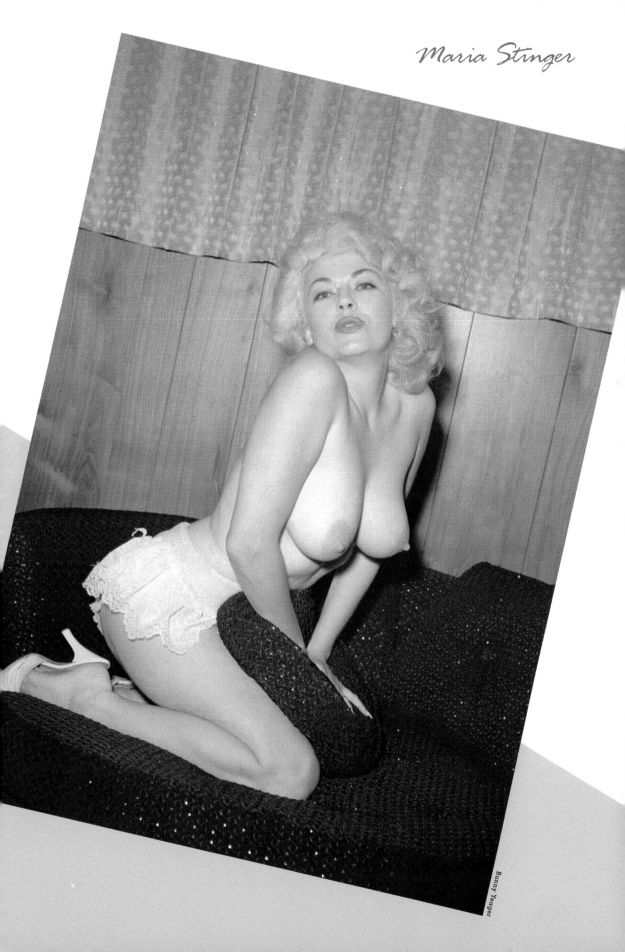

Maria Stinger

Bunny Yeager

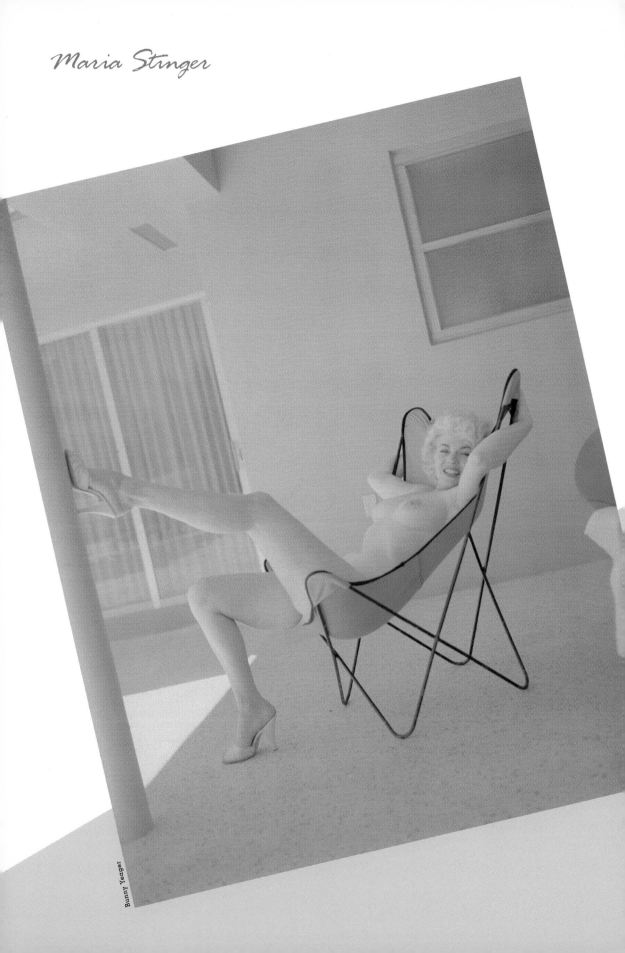

Bunny Yeager

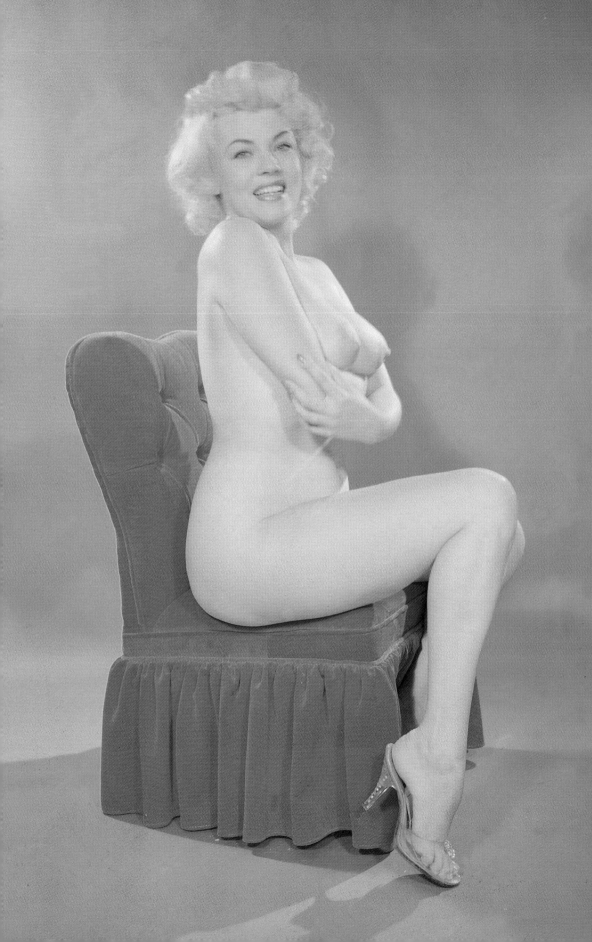

Bunny Yeager

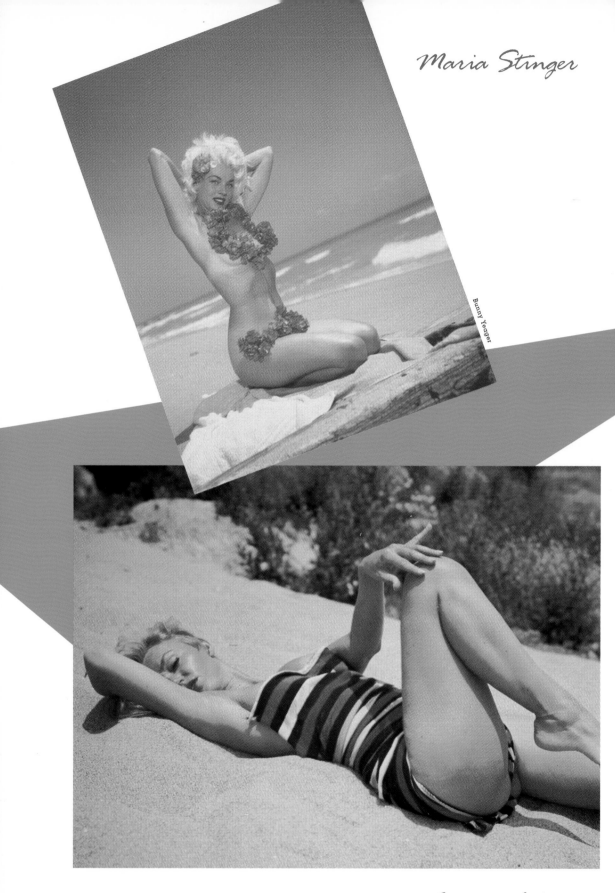

Maria Stinger

Bunny Yeager

Yvette Vickers

Leaving a Legacy

The Sassie Lassie in San Pedro was to serve a crucial function in Jennie's life: it became the original site of her longtime dream, the Exotic Dancers' Hall of Fame and Museum, later known as Exotic World.

It started on a small scale in the early 1970s, as Arroyo began putting up on the wall some of the many photos and bits of memorabilia that Jennie had accumulated over the years. Once they decided to expand the concept to an actual museum, the real work began. **"I have a strong, strong faith,"** says Arroyo. **"The idea came out of a depression, and it developed into a kind of miracle."**

A few years after its humble beginnings, the museum moved to the San Bernardino County desert town of Helendale. Due to its remote location in the midst of the Mojave Desert, the land was available for a good price. Jennie and Charlie busily accumulated more photos and burlesque artifacts; to generate more publicity, she began a tradition of hosting annual strippers' reunions.

Given her exceptionally colorful background, it is all the more remarkable that in 1981, after she and Charlie moved to Hesperia (a small town near Helendale), Jennie became president of the town's Republican Women's Club and a member of the Hesperia Business and Professional Women's Club. She even ran for mayor once. **"It's funny — they accepted me because I never hid my background,"** she told an interviewer in 1987. **"I came right out and said, 'I was a stripper and I am a stripper.' I even showed them some of my nude photos just to make sure they know who I am."**

"I love being an entertainer"

Even though she stopped stripping regularly by 1978, Jennie's love of her profession was so strong that she continued to perform at benefits and other special events until she was too ill to go on anymore. Comedy had always been a part of her crowd-pleasing act, and it became even more central to her later performances, which she described as **"a satire on sex and politics."** Stripping **"is a wonderful life for a girl,"** she would tell anyone who asked.

By 1988, Jennie's health was failing, and her old friend Dixie Evans arrived to help run the museum. **"She never complained once,"** marvels Dixie. **"I've never seen anyone as strong as her." "Even the illness never really stopped her,"** says Arroyo. **"She kept on working. . . . I think she was a woman of rare quality."**

Following Jennie's death on March 24, 1990, Dixie and Charlie Arroyo carried on with Exotic World. Thanks to Dixie's unflagging energy, the museum has continued to expand, and the story of burlesque's golden age is being told to new generations, just as Jennie had hoped.

"I love being an entertainer," Jennie said in 1987. **"It's been a lot of fun. I had a good career and made lots of money. And anyway, how else could I travel the world like a millionaire without actually being one?"**

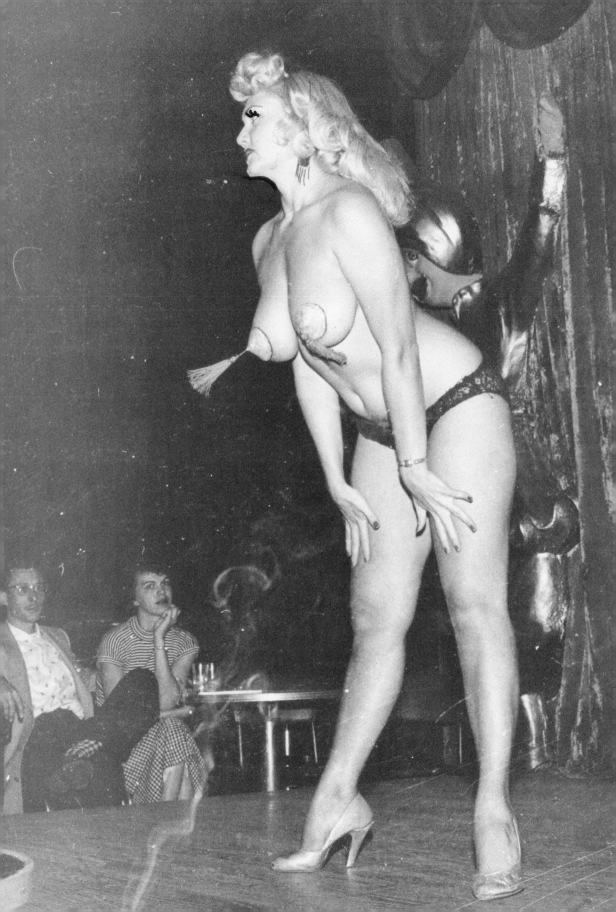

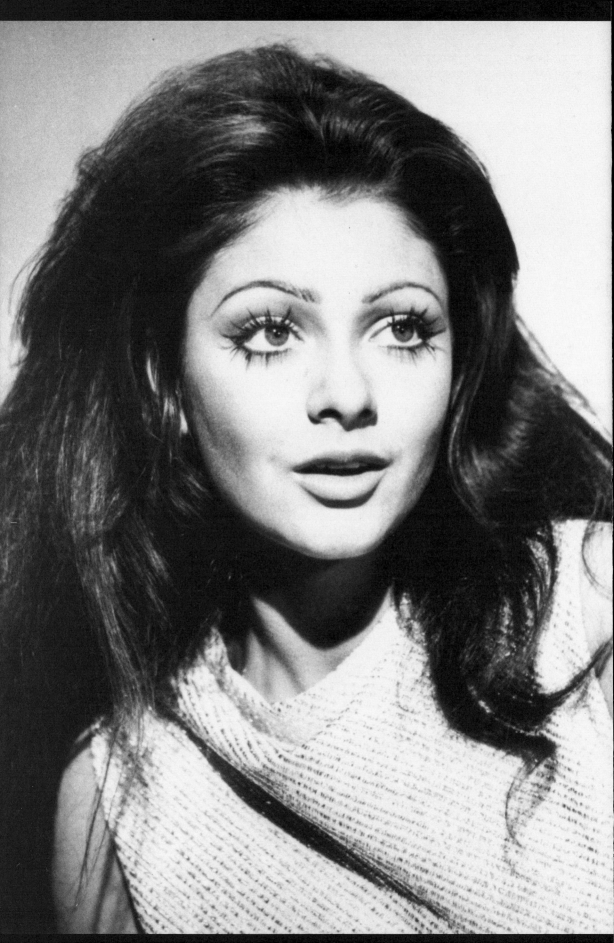

Cynthia Myers

Through nearly four and a half decades, *Playboy* magazine has published thousands of magnificent photographic images of the world's most stunning women. But in the opinion of many (including this author), no single photograph — indeed, no glamour shot ever taken for any publication — has ever matched the astonishing impact of its December 1968 centerfold. For her legion of admirers, Cynthia Myers will always reign as the Ultimate Playmate.

Every detail of Cynthia's centerfold is utter perfection: a breathtaking creature with startlingly bright, luminous eyes; a face flushed with youth and promise, but also with a sense of nervous excitement; luxuriant dark hair falling down beyond her shoulders; torpedo-like breasts that jutt out proudly and firmly despite their great size; a provocative yet somehow innocent nude pose kneeling with legs apart (but nothing showing — this was 1968, after all) on a white shag rug, a hand on each knee, and a cute little teddy bear alongside one thigh. It was not a sexual pose, but rather suggested (given the issue's timing) a remarkably lovely girl poised with excited expectation just before Christmas presents are about to be unwrapped. Of course, she was herself the most wonderful Christmas gift any man could possibly imagine.

She went on to costar in one of the most legendary cult films of the era, Russ Meyer's *Beyond the Valley of the Dolls*. But even had Cynthia vanished from sight after her gatefold appearance, her image would still have been burned into the memories of a generation of American men.

Cynthia was born on September 12, 1950, in Toledo, Ohio. **"My father was killed in a car accident when I was four. I was raised by loving grandparents, my mother, Mary, and an extension of aunts and uncles. It was a very close-knit, upper-middle-class, typical midwestern family with traditional midwestern values."**

She began to notice that her startlingly voluptuous figure was attracting male attention **"very early,"** she chuckles. **"I knew that I was a little different from the other girls when I first turned thirteen. I knew that the boys liked it, and the girls didn't like the attention I got. I couldn't help it. I had a lot of boyfriends — admirers who were a little infatuated or just liked me. But what I really missed was having a girlfriend growing up, someone to share things and go shopping with.**

Russ Meyer, Cynthia Myers, Dolly Read, and Hugh Hefner (1970)

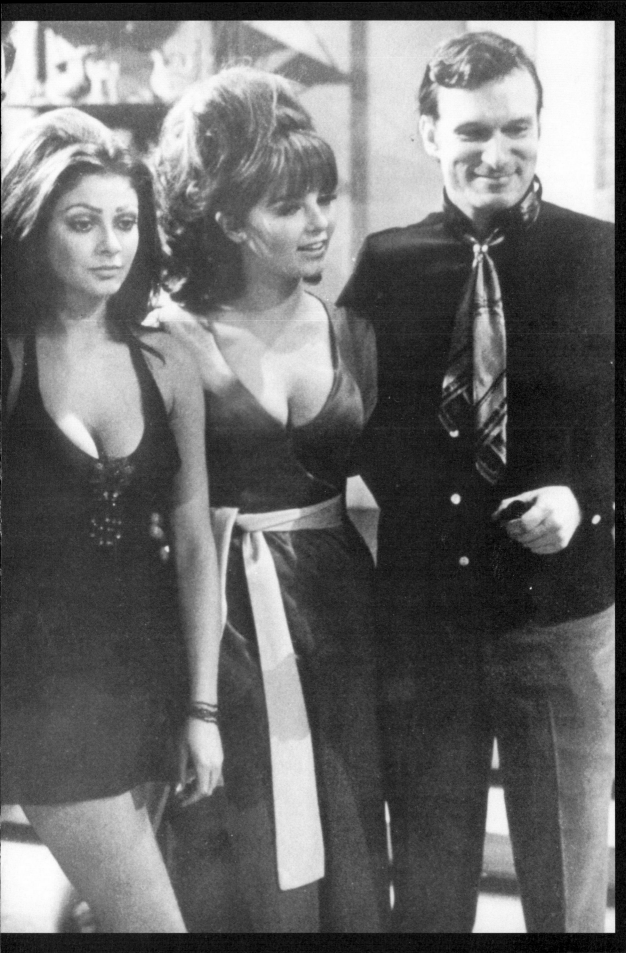

"I was lonely, so I started riding horses, and showing them in competition. A lot of my extra time was spent at the stables and getting ready for shows. I started in little barn shows, and wanted to move up to bigger shows on the equestrian circuit — hunters and jumpers. If you want to succeed you've got to have a good horse, and that costs an awful lot of money. So I finally had to give up competitive riding.

"Then I started to get offers to model when I was fourteen. People noticed that I had a voluptuous figure. I didn't have the height [five-foot-four] for fashion, but they wanted me to model bikinis. My mother said no, which is what I would say if I had a daughter that age."

It was at age fifteen that Cynthia made a decision that would change the course of her life. "So many people had told me, 'With your figure and face, if you don't pose for *Playboy*, you're crazy. You're a natural for them. Just let them know where you are — you're Playmate material.' I figured, everyone thinks I should, so maybe I ought to do it."

Still, it took some prodding to take that crucial step. In 1967, Cynthia did some modeling for a family friend, Jerry Halak, who built custom-designed cars in Toledo for wealthy clients. **"Since Detroit is only fifty-two miles away, I modeled for him at a few Detroit auto shows. When I told him about the people who'd suggested I contact** *Playboy*, **he sat me down in his living room and helped me write the letter. And just in case I chickened out, he even drove me to the post office to mail it!"**

"I sent them a bathing suit photo with a note to Mr. Hefner. I addressed the letter to Marilyn Grabowski [Playboy's **assistant picture editor], just to be sure it wound up on someone's desk and didn't get lost in the shuffle."** Grabowski responded with a letter advising Cynthia to keep in touch until she turned eighteen.

"Then I had a semester break my senior year at Woodward High School, and I came down with my girlfriend to Miami. A man [Mike Levine] saw me coming out of a swimming pool, and took my picture for the *Miami Beach Reporter*.**"** A few days later the photo was emblazoned across page one of the June 20, 1968, edition of the *Reporter*. During her brief stay in Miami, Cynthia was offered a modeling contract by a major swimsuit manufacturer, and scheduled a photo session with legendary glamour photographer Bunny Yeager, but these would quickly be superseded by her dream opportunity.

Playboy History is Made

"When I called home to my mother, she said *Playboy* **had called, asked when I had to go back to school, and wanted me to come to Chicago for a test shoot. They booked me on a plane the next day."**

When she arrived, **"there was a bit of a rush, because the December and January issues were coming up, the two top-selling issues, and people expect a little bit more. They already had a girl picked out for December, but Hefner decided that I would be the December Playmate.**

"So they had to start taking a lot of pictures right away to get me into the December issue. I shot mornings and nights." The photographer was Pompeo Posar, perhaps the most renowned of all of *Playboy's* staff photographers. **"He knows how to make you feel relaxed, but he's also talented at capturing that innocence and naïveté in the photos — he doesn't miss that opportunity. He knows that six months from now, you'll have a more experienced, sophisticated look, and knows exactly how to get the first photos that a lot of men like. All of those mixed emotions are there in the centerfold — the sense of innocence, you've never done this before, you're scared, like a little fawn who's been captured and is not with his parents or his surroundings anymore. You can see that look in my eyes in the centerfold.**

"I really didn't know what to expect — I had nothing to compare it to. Pompeo was so expert and tactful in handling a girl who walks in and is scared to death. He knows you're trusting him, and he doesn't abuse that. I knew that it would all be very professional. These people have been taking the finest photographs of women in the world, they're there to make you beautiful."

When Cynthia first saw the centerfold shot, what was her reaction? "I didn't realize that my breasts were that big!" she says with a laugh. "I'd never seen them from that angle. Wow! No wonder people were looking at me that way! It must have been hard for all those boys when we were walking down the school hallway, for them to keep their mind on math and geography! No wonder the girls hated me. My goodness, they must have thought, if that's normal, how in the world am I going to grow that much in six months or a year? I definitely didn't set the norm for female figures [39DD-24-36]!"

The shooting schedule became less intense once the centerfold shot was completed. "Once the gatefold is in the can, so to speak, everything becomes a little more relaxed." After the supporting pictures were wrapped up, Cynthia returned home. "I was too young to be published, so Mr. Hefner would have to hold my photographs until I was of legal age."

Also because she was still seventeen, there was the matter of legal consent from a parent or guardian. "My mother had already enrolled me in a Catholic school for that fall, and at first she didn't want to give the consent. So it was my grandmother who actually signed the release." Soon thereafter, however, her mother — always Cynthia's most important supporter — came around to back up her actions.

She was soon back at the Playboy Mansion for some holiday-themed photos, including the "living Christmas tree" shot used for the December cover. And she was invited to move into an apartment at the Mansion. "After I got my diploma from high school, I went home and packed. My mother cried and asked me to stay. I think she wanted me to marry the boy next door, and she was upset that I didn't go on to college. I said, 'Mom, if I don't do this, I'll always wonder how my life would have been.' And she said, 'You're probably right. Be careful and call me every day.' Then everything started to happen so fast."

Cynthia moved into a ground-floor apartment at the Playboy Mansion in July. "I began working at the Chicago Playboy Club just to have something to do when they weren't taking photographs of me. I was too young to serve cocktails, so they put me at the door to greet card holders."

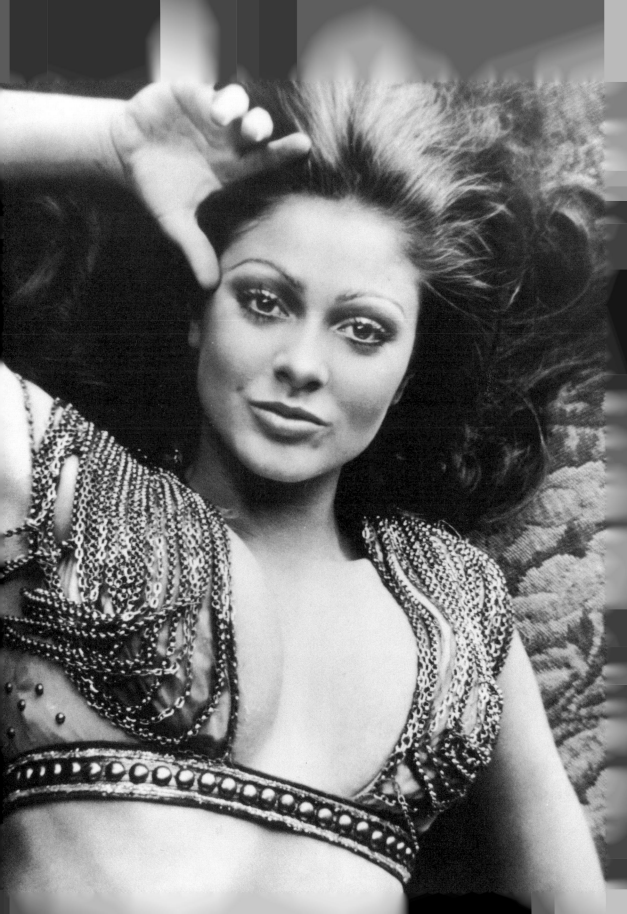

She recalls that when she first met Hugh Hefner, "he complimented me, saying, 'What an extraordinary figure.' Then he asked how they had found me. I told him, 'You didn't find me, I wrote you a letter.' It was something he took very seriously — he even had a staff meeting about it, because he'd never received the letter or the photo I'd sent. He sent out a memo that from then on, he would religiously check all amateur photos sent in by boyfriends, husbands, or the ladies themselves. He said, 'I wouldn't want to miss out on another find like you.' That made me feel really good."

The 1968 Democratic National Convention was held that August in Chicago, and the Playboy Mansion hosted a procession of political and literary celebrities. "When I was up in the morning for breakfast or later for lunch, there was Adlai Stevenson or Barry Goldwater. I was seventeen years old, a girl from Toledo practically off the farm, and there was Adlai Stevenson asking me for my political views! Art Buchwald was there; George Plimpton was staying in the apartment next to me. I was meeting all these worldly, sophisticated people. I just sat back and listened."

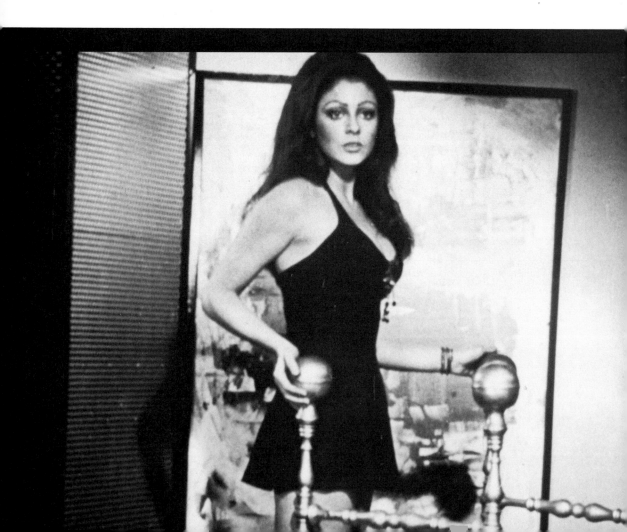

During this period, "Hef still had his reputation for staying in pajamas, rarely going outside, the ever-present Pepsi in his hand. He was a real night owl — he stayed up all night and slept during the day. He was a huge movie buff. He even had a full-time employee to maintain, research, and categorize one of the most extensive film collections in the world, I was told." Cynthia says she didn't sample those archives — "I'm sure they would have made me blush." However, she did take advantage of the rest of Hefner's film collection. Hef knew that I loved horror movies, so I was able to see all the original classic Frankenstein and Dracula movies there. He'd be working in his quarters while I watched, and every once in a while he'd stop by and say, 'I remember that scene.'"

Hefner "became a platonic pal. He always seemed genuinely pleased to have my company. . . . Remember that I was only seventeen, and he was almost fatherly with me. I felt a sense of protectiveness."

Back in Toledo, the old-fogy faction was raising a fuss. Cynthia had already seen evidence of this backlash, when she had been overwhelmingly voted Woodward High's homecoming queen but denied the top honor by school officials when they learned of her activities in Chicago. The reaction went still further, however.

"When the word got out, at first they didn't want to let me graduate, even though I had already finished my courses with high grades. There was a pretty big uproar . . . 'Our student posed for risqué photographs.'" She ultimately graduated soon after her appearance in the magazine. "My mother always traded at the same grocery store, and they snubbed her because of *Playboy*. I flew back there and told them, 'Don't you do anything to hurt my mother. If there's a problem because of something I did, talk to me about it.' I wanted to protect her — my mother's my heart. So I straightened things out.

"Toledo's a pretty big city, but it still had Midwestern morals. America was going through a big change then — women burning their bras, hippies smoking marijuana. Finally people began to lighten up and realize, 'She's not a bad girl just because she let someone take a beautiful picture of her.'

"The year after, they came over the loudspeaker in Woodward High while my sister Tana was there, and talked about all the celebrities who had graduated from there, and that if you study hard you can be like them. There was Danny Thomas, Helen O'Connell, Jamie Farr — and Cynthia Myers! And I felt like saying, 'I didn't have to study too hard to pose for *Playboy*!'" she laughs. "But it was nice. They were too afraid to accept [what I'd done] until everyone else began to lighten up. Until then, they gave us a rough time. I felt, 'Don't anybody ever look at me as if I should feel dirty or cheap.' More than likely 99 percent of the men who were looking at me that way would have given their eyeteeth to spend the evening with a Playmate, and 99 percent of the women would have given their eyeteeth to look like one. So the hypocrisy made me mad."

When the December issue came out, Cynthia's Playmate layout ("Wholly Toledo!") created a volcanic reaction. In the magazine's entire history, only one other Playmate spread, that of 1967's DeDe Lind, generated such a flood of mail. **"I heard around the magazine that they were getting bombarded with an extraordinary amount of mail. For the men in Vietnam, a Playmate was the ultimate fantasy. An ex-soldier came up to me years later and told me, 'You were the girl we left behind, the one we were desperately trying to come home to.' One man told me he had left everything behind when he shipped out but stuffed my centerfold in his shirt. That made me feel good."**

Cynthia's Playmate issue made history as the only one sent free to all G.I.s in Vietnam, so her impact on American soldiers — to this day — was without equal. **"I got so much mail, my apartment at the Mansion couldn't hold it all — they had to put it in storage units. I wrote every soldier back that I possibly could. I didn't have a desk large enough to organize everything, to make sure I got the right picture in my Lana Turner dress together with the letter. So I bought a picnic table, laid everything out there, and took five hours every evening to write letters and tried to say something personal to each fan. I wanted to do it, since they were there fighting for us."** Of course, not all the mail was on such an elevated level. **"I'd be fibbing if I said I never got a letter requesting one of my bras. God, I could have gone into the bra business!"** she chuckles.

Cynthia's Hollywood period was launched during the summer of 1968 when Hefner began his second syndicated television series, *Playboy After Dark*. She flew back and forth from Chicago to Los Angeles for the shows. Like other Playmates or models on the program, Cynthia was primarily on hand to beautify the surroundings — sitting on the couch at "Hef's party" chatting with other guests, watching the guest stars, and on occasion being introduced by Hef and answering a question. **"Being a midwestern girl, it was pretty overwhelming."**

"Shortly after doing the first *Playboy After Dark* show, I was introduced to Burt Lancaster through a girlfriend in Hollywood. What a wonderful man! Of course, I'd been a movie buff since I was a little girl. I remember on our first date, I was so in awe, but I was trying to be nonchalant as best I could. He was the sweetest, most talented man — he was everything I expected, and more.

"Arlene Dahl once said in an interview that you haven't been kissed until you've been kissed by Burt Lancaster, and she was right! It was a moonlit night, and he was walking me across the street. He put his arms around me in the middle of the street, defying anyone to stop him — and who wouldn't surrender?" she laughs in warm recollection.

"He said, 'A friend of mine is doing a film for Warner Brothers, director Sydney Pollack, and would you be interested in being in the film?' Of course, I said, 'I'd love it.' The film was *They Shoot Horses, Don't They?* It was such a unique experience, I would have paid them to let me go to work there every day!

"They gave me a principal role as one of the marathon dancers during the depression. The shooting of the film took three and a half months. All these talented people — Jane Fonda, Red Buttons, and Gig Young, who won the Academy Award as Best Supporting Actor for his role." She originally had some dialogue, including one scene in the ladies' restroom where Susannah York's character has a nervous breakdown. Unfortunately, since the picture was running long, this scene was cut.

"But everything is a stepping stone. Bruce Dern was one of the marathon dancers in the film. He said to me, 'Are you really serious about being an actress?' I said, 'Boy, I sure am.' But because of *Playboy,* I didn't want people to think, 'She went for the obvious face and figure because she can't act her way out of a paper bag.' I told him, 'Even if I had a figure like a stick and a plain face, I'd still want to do film work.'

"He said, 'I'm teaching acting at the Actors and Directors' Lab. If you're serious, you'll be there.' I was very fortunate and studied with him. While we were doing Shakespeare and the classics there, I was also able to learn cold readings of scripts, because I was going out on interviews and I needed all the experience I could get." Cynthia also studied acting with Jeff Corey, whose students in the 1950s had included James Dean. Also in 1969, Cynthia appeared on a Bob Hope TV special in which Ann-Margret was featured.

Russ Meyer Girl

In the fall of 1969, Cynthia was invited by director Russ Meyer to costar in his first big-budget studio epic. **"Russ had been trying to contact me for over a year. I've been told that I'm the prototype of a Russ Meyer girl. I think he may have wanted me to test for Vixen."** Filmed in late 1968, *Vixen* had immediately catapulted Meyer from beloved cult favorite to industry phenomenon by grossing more than six million dollars at a cost of only seventy-two thousand dollars, largely on the strength of Erica Gavin's powerfully erotic lead performance. As a result, 20th Century–Fox studio chief Richard Zanuck signed Meyer to direct and produce *Beyond the Valley of the Dolls* on a budget of $1.5 million.

"Here was a man who had practically filmed in his backyard and now a major studio hires him. . . . Fox had taken a beating with *Tora! Tora! Tora!* and *Myra Breckinridge* [destined to be another big-budget catastrophe] was being shot at the same time."

"Wholly
Toledo"

Therefore, some studio execs — even those initially aghast at hiring a skin-flick director — were looking to Meyer as Fox's financial savior. **"He was quite intense, full of energy, and I realized that it was a big responsibility for him to come to a major studio that pretty much said, 'Okay, show us your stuff. You've made a lot of money, now do it for us.' He was under tremendous pressure to pull everyone together and come in under budget, and of course everyone wants miracles. . . . Maybe we didn't all know what we were doing, but we put it together and it was a fun learning experience."**

Beyond the Valley of the Dolls (cowritten by Meyer and movie critic Roger Ebert) is a propulsively energetic film tracing the rise to fame of an all-girl rock band, the Carrie Nations. *Playboy* Playmate Dolly Read is lead singer Kelly, Cynthia portrays guitarist Casey, and lovely black model Marcia McBroom plays drummer Petranella. In typically manic and satiric Meyer fashion, the story depicts the loss of innocence as the girls venture to the big time in Hollywood and plunge headlong into a cynical new world of sex, drugs, and violence. Ebert later noted Meyer's intent that the movie **"should simultaneously be a satire, a serious melodrama, a rock musical, a comedy, a violent exploitation picture, a skin flick, and a moralistic expose"** of showbiz.

As Casey, Cynthia finds herself increasingly embittered by men while Kelly enters into an affair with strapping blond gigolo Lance Rock (played by Michael Blodgett). One night, when the group's former manager, Harris (David Gurian), comes to her for comfort after being shoved aside in their rise to fame — and after being sexually humiliated by Edy Williams as voracious porn queen Ashley St. John — Casey sleeps with him. Afterward, she angrily throws him out, but later discovers (unbeknownst to Harris) that she's pregnant with his child. He attempts suicide and is left a paraplegic.

Already drawn into a growing friendship with fashion designer Roxanne (Erica Gavin), who had eyes for her from the start, Casey tearfully confides her dilemma, and Roxanne takes her to have an abortion. Afterward, the two women share an afternoon in the countryside, and they kiss tenderly after Casey expresses gratitude for her friend's kindness.

The film's denouement is a bizarre costume party at the home of the group's flamboyant new mastermind, Z-Man (John LaZar). That night at his mansion, Casey and Roxanne bed down together and have one final, exceptionally sensuous sequence. Soon thereafter, Z-Man goes on a murderous spree, killing Lance and Roxanne. Casey runs for her life in a diaphanous black nightgown and desperately phones her bandmates for help, but is gunned down just as they arrive. The film concludes with Harris's miraculous recovery, his romantic reunion with Kelly, and a triple wedding, topped off by a mock-portentous narrator's voice intoning what it all supposedly means.

Few major films have been met with such a wildly contrasting critical response as *Dolls*. Some reviled it for gratuitous violence, while others hailed its tremendous pace and Meyer's masterful editing; indeed, a couple of critics subsequently listed it as one of the ten best films of the 1970s. Cynthia's shimmering beauty and aching vulnerability in capturing Casey's innocence and disillusionment contributed immensely to the picture's appeal.

"Erica was very nervous about doing the lesbian scene," recalls Cynthia — even though Erica's lesbian sequence in *Vixen* had become legendary. **"We were good friends, and I thought, thank goodness I'm at least going to do it with a girl I liked. Also, it was a lovely scene. She was so upset that I came to talk with her about it. I said, 'Erica, it's going to be fine. Is there anything I can do to make it more comfortable?'"** Thanks in part to Cynthia's gentle comforting, their scenes together are among the finest in the movie.

Dolls was a solid box office success, grossing fifteen million dollars, and to this day it remains Meyer's proudest achievement; Fox finally released the video in 1993. Meyer made one more film for the studio, the very un-Meyer-like flop *The Seven Minutes*, and then left to return to his life as an independent.

After *Dolls*, Cynthia landed a choice role as the only female in a Western called *Cactus*, aka *Devil's Choice*. Bob Fuller (whom Cynthia also dated for a time) starred as the town marshal, and Nick Cravat played an old miner trying to protect his gold strike claim. Cynthia was the miner's daughter who sought to help him. **"Nick Cravat was Burt Lancaster's old partner [as a circus acrobat and later in films like *The Crimson Pirate*], and when he learned Burt was a friend of mine he told me all sorts of great stories. I also got to ride a horse during the Indian attack in the film."**

Sadly, the film was never released. **"Bob Fuller was called away to begin shooting the TV show *Emergency!* with Julie London. The film had already gone way over schedule shooting in Marble Canyon, Arizona. They rewrote the ending when Bob had to leave and we did finish it, but it wound up on the studio's shelf. I'm still hopeful that a print will turn up somewhere."**

It was not long before she had one more opportunity, as she was hired for another Western. **"Vera Miles was looking for a pretty girl to be the love interest of a man she was interested in, and I got the job."** In the 1972 film *Molly and Lawless John* (produced by Miles), Vera plays the neglected wife of the town sheriff, who has prisoner Sam Elliott in his jail. Vera is smitten by Elliott and schemes to help him escape with the plan that they will run off together. But Elliott already has a gorgeous girlfriend — Cynthia, as Dolly Kincaid — and once he's out, he says thanks and goodbye. That proves to be a mistake, as Miles ends up killing him.

Cynthia had some romantic scenes with Elliott, who became a star a few years later in *Lifeguard*. **"I had so many petticoats**

on that when Sam Elliott was trying to undress me in the scene, he said, 'How in the world can I get all these petticoats off without taking five minutes?' I fainted once because of the heat [in Las Cruces, New Mexico] and all the clothing." Once again, she was able to do some of her own horse riding. And this time, the picture was completed and is still shown occasionally on TV.

Little did Cynthia know that this would be her last motion picture. Following *Beyond the Valley of the Dolls*, she had moved in with costar Michael Blodgett, and **"I put my career on the back burner when Mike said, 'Let's go to the Caribbean' or 'Let's charter a plane and go skiing in Aspen.' For a girl from Toledo, this was all pretty amazing. But I should have continued studying with Bruce Dern and concentrated on my career. I guess hindsight's twenty-twenty."** They went their separate ways in 1977.

Cynthia had more than her share of remarkable adventures in Hollywood, which she sums up by noting that she survived a "crazy" environment in the face of many temptations. **"I came to so many forks in the road where people were pushing me in one direction or the other. What saved me was my Midwestern upbringing and values. When people would say, 'If it feels good, do it,' I'd say, 'No, that's not the way I was raised.'"**

After going off on her own, Cynthia moved in for a time with the family of Gene Czerwinski, president and owner of the Cerwin-Vega stereo equipment corporation. They'd been introduced by former Playmate of the Year Donna Michelle, who had been Cynthia's roommate while Cynthia filmed *Dolls*. Having moved out of the Playboy Mansion, Cynthia **"didn't want to go back to a lonely hotel room"** when screen-testing for the picture began, so she moved in with Donna.

"The Czerwinski family had sort of adopted Donna, and she introduced me to them. Not only were they also from Toledo, Gene even went to the same high school [years earlier]." Cynthia modeled for Cerwin-Vega, serving as the company's **"Miss Earthquake"** when Cerwin-Vega developed the Sensurround system for the movies *Earthquake* and *The Towering Inferno*. She could also be seen in 1972 Cerwin-Vega ads for its sound system at the giant WATTSTAX music festival in Los Angeles. Additionally, she represented the company as a model at its Las Vegas consumer and electronics conventions almost every January for the next twenty years.

At the end of the 1970s, while living in Marina del Ray, Cynthia was engaged for two years to an orthopedic surgeon named Richard. **"It was serious enough that I began taking classes in what would have been a four-year program to become an X-ray technician, mainly so I could spend more time with him."** But the relationship ended under startling circumstances.

"One day I noticed that a local theater was showing *Beyond the Valley of the Dolls* at midnight, and I suggested that we go see it. He knew about my background, but not a lot. During my scenes

in the movie with Erica Gavin I could tell from his body language that he was uncomfortable. When we walked out of the theater he looked crushed, as if his Labrador had been run over by a truck. He looked at me and said, 'Did you have an orgasm with Erica?'

"He said, 'I know you pretty well, and I know I could never satisfy you like Erica did in the movie.' I tried to lighten the mood by saying, 'You've paid me a great compliment as an actress. I thought [the orgasm] would be good for the scene.' But instead of being proud of me as an actress or appreciating it as a hot movie scene, his masculinity was threatened. Making love with him after that was never the same, because he felt he could never match Erica. He told me, 'I'll always love you, but I've got to break off the engagement.' I cried for weeks afterward, but I got over it."

In 1981, Cynthia set off on an extended car trip to "think about what I wanted to do." She went to Las Vegas, and planned to drive by the Grand Canyon and then up to Aspen to visit a girlfriend. "I wasn't on any schedule — I wanted to enjoy my new-found freedom." Then she met "a very nice man" named Mike Spence, who worked for the government. "He was giving me directions to Lake Mead, then we started talking and he asked if I'd like to go fishing. We went fishing together, and I never did make it to Aspen." They fell in love, and were soon married. Mike now works for the Northrop Corporation as an engineer on the B-2 Stealth bomber. On February 24, 1983, their son Robert was born, and Cynthia is very much the devoted mother.

Cynthia had been completely away from *Playboy* and show business for two decades when her husband suggested that she get back in touch with the magazine. "He said, 'You're in good shape, you look great — why don't you call them?' So I called their offices, just to let them know that I'm here and I'm available. Then, five days later, they asked me if I'd like to sign autographs at Glamourcon." Since her first appearance in 1994 at the national glamour and pinup convention, which is now cosponsored by *Playboy*, the semiannual show has become an important part of her life for reconnecting her to fans and to Playmate friends like DeDe Lind and Patti Reynolds.

"It was such a pleasure to have so many fans tell me how much I meant to them. After living up in the desert away from the entertainment field for so many years, this has been a real treat." One of the highlights of Glamourcon for Cynthia was her reunion with Hugh Hefner. "As soon as he saw me, he gave me a big, long hug. He's a very dear man."

Not long after returning to the public eye, Cynthia found a new outlet when she became a leading force in the *Playboy* Mailing List on the Internet, whose several hundred members elected her as the "Playmate of the List." Whenever there is a question requiring an expert Playmate opinion, participants can always count on Cynthia for a warm, incisive E-mail response to the entire group.

And now she is ending a quarter-century hiatus from acting. While taking refresher courses in acting technique at a local university, she is reacquainting herself with her profession by accepting roles in television series such as *Dr. Quinn, Medicine Woman*, UPN's *Burning Zone*, and in the film *Money Talks*, starring Charlie Sheen.

Her reentry comes at an opportune time: in an extensive survey conducted by this author for the book *Glamour Girls of the Century* among more than twelve hundred collectors and fans in twenty-three countries (in which over three thousand women received votes), Cynthia has been voted the twelfth most beloved glamour and pinup star of the century. Only three other Playmates — Marilyn Monroe, Jayne Mansfield, and Bettie Page — garnered more votes.

With a determination as imposing as her still-mesmerizing beauty, the Ultimate Playmate is writing a second act to a life that has already left an indelible mark on pinup history.

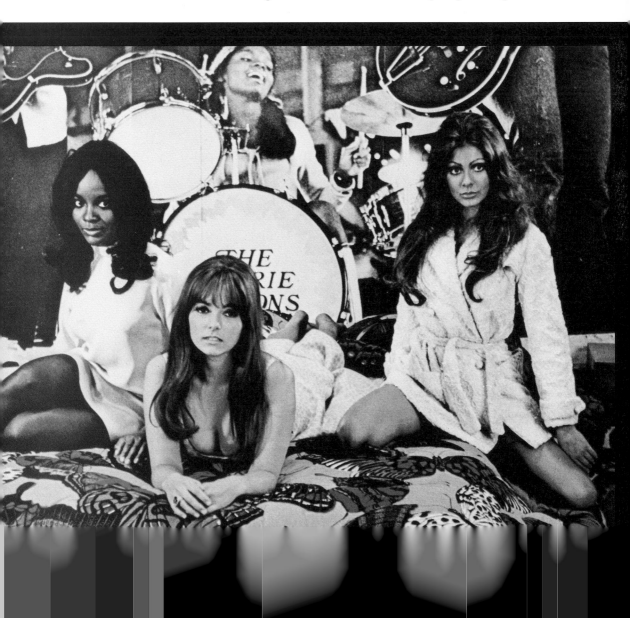

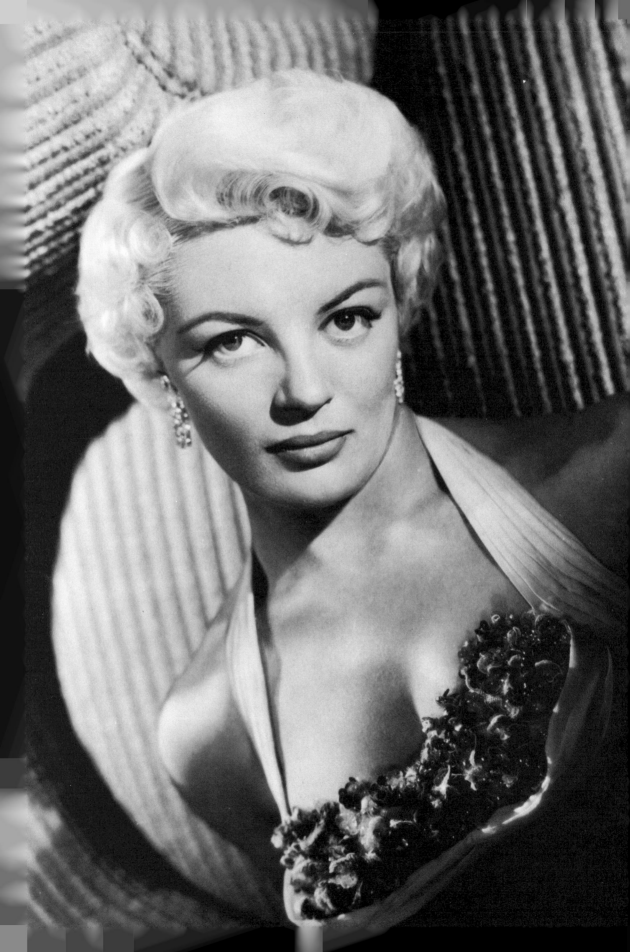

Sheree North

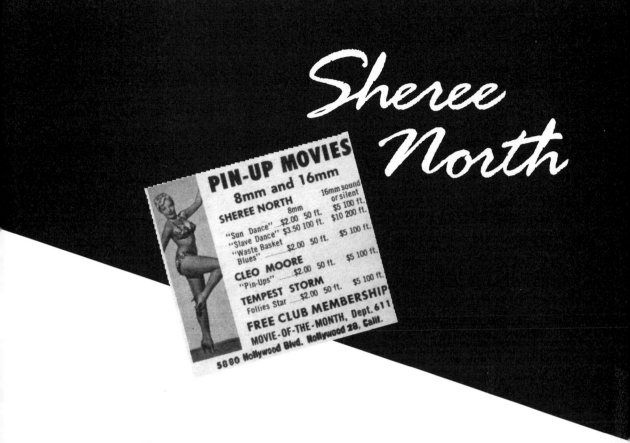

PIN-UP MOVIES
8mm and 16mm

SHEREE NORTH
16mm sound or silent
8mm
"Sun Dance" ...$2.00 50 ft. $5 100 ft.
"Slave Dance" $3.50 100 ft. $10 200 ft.
"Waste Basket $2.00 50 ft. $5 100 ft.
Blues"

CLEO MOORE
"Pin-Ups" ...$2.00 50 ft. $5 100 ft.

TEMPEST STORM
Follies Star ...$2.00 50 ft. $5 100 ft.

FREE CLUB MEMBERSHIP
MOVIE-OF-THE-MONTH, Dept. 611
5880 Hollywood Blvd. Hollywood 28, Calif.

It might fairly be said that Sheree North defines the term *survivor* in Hollywood's version of Webster's, but that would be selling the lady short. She's led a life and a half, and has emerged from it all as one of the town's most respected performers and personalities.

Dawn Shirley Bethel (her real name) was in fact born in Hollywood on January 17, 1933. Her parents divorced shortly after she was born; she was raised by her mother, who worked as a pearl appraiser for importers. Dawn began dancing at about the age of three. **"I would dance in the front window of our home,"** she recalls today with a chuckle. **"My mother and I made a deal — I would stop these 'appearances,' and I could take dancing lessons."**

Young Dawn was "thrilled" with show business from an early age, particularly after seeing the high-kicking dancers at the Orpheum in downtown Los Angeles. **"I loved the glamour of it all."** It was at age six that she began dancing lessons at the famous Falcon Studios. Her mother made a deal with the school to let the two of them do odd jobs around the studio to help pay for the lessons.

In the midst of World War II, the USO was always on the lookout for crowd-pleasing entertainers, and asked Falcon Studios to put together a camp show. Eleven-year-old Dawn was one of those selected, and for about two years she traveled with the show up and down the West Coast. **"That's where I first learned to communicate onstage, to have some personality,"** she says. **"Through that experience, I learned to find more freedom and expression on the stage that I didn't find in life."**

It was while dancing at USO shows that Dawn gained her first true notoriety — she developed a penchant for losing certain parts of her clothing during performances. On one occasion, she slipped while walking across the stage, causing a strap on her costume to come loose, and completed the number constantly switching hands to hold the outfit up. **"They were cheering me on, and it was the hit of the show. Afterwards, I was surrounded by all these adorable young men who wanted to dance with me. I was just eleven years old, but with all that stage makeup I looked like a woman. I was floating on a cloud."**

The clothes incidents continued on a regular basis. **"It did always seem that when I went onstage my petticoat or something else was falling down,"** she laughs in recollection. **"My mother sewed my clothes and was always in a hurry, and I guess she didn't do a very good job."** On another occasion, she was doing a ballet number when her costume broke. Since her mother didn't have white panties for her tutu, she borrowed the white Jockey shorts of a young man. **"Of course, they were too big, so halfway through the number they slipped off. I did a little toe dance to the side and dropped them in the wings. I was turning the ballet into a comedy, not meaning to."** In addition to the enthusiastic response these incidents received from the soldiers, they **"did teach me to have a sense of humor, to go with the flow."**

Already an alluring beauty as well as a skilled and versatile dancer, at thirteen she lied about her age and got into the chorus lines of various shows. Living near L.A.'s Greek Theater, when news of a musical audition came she would roller-skate over to the audition. Every summer, she would work in shows at the Greek, and each time would tell officials that she was sixteen; because of her earnings, she was able to collect unemployment compensation during the school year.

"I loved being in the chorus," she recalls. "They kept picking me to be a featured dancer, but I didn't like that." Periodically, the sheriff would conduct raids after receiving a tip of an under-age dancer in the show, and each time "they'd hide me in the chorus again."

At fifteen, she married Fred Bessire, a twenty-five-year-old draftsman and gambler; the union lasted eighteen months and produced a daughter named Dawn. Just a few months after Dawn's birth, "my husband wanted me to work as a dancer at a sleazy burlesque house, and on the way to driving me over we passed the Florentine Gardens," a classy Hollywood club known as one of the favored venues for legendary stripteaser Lili St. Cyr. They went in, and she was immediately hired as a dancer.

Now known as Shirley Mae Bessire, she danced at the Florentine Gardens for nearly two years, most notably in the Victor Young musical production *Pardon My French*. The other girls took turns caring for young Dawn backstage, and the baby sometimes slept there in a carefully redesigned hatbox. A photographer snapped a picture of this scene, and it was published all over the country. The Gerber baby food company saw it, and hired Sheree for a print advertising campaign as an anonymous young mother. In late 1949, she filed for a divorce, which Bessire contested; after receiving his consent, she gave him all their community property.

A divorced mother at sixteen, she worked steadily to provide for her daughter. She had to dodge police trying to enforce a California law against minors performing in nightclubs. Sheree did vaudeville at L.A.'s Paramount Theater; started a dance act with Lee Scott; danced a solo routine with an Earl Carroll musical production; performed for eight months at Larry Potter's famous supper club in the San Fernando Valley; and did choreography and costume design for other dancers.

She danced wherever she could find a job, including one engagement in a Mexican club called the Papagallo for $42.50 a week where she was also required to "be chatty" with the customers. **"We wore a lot of feathers on our heads and a lot of them behind,"** she told one interviewer in 1970. **"There weren't very many up front."**

Film Loop Queen, Vegas Dancer, and Broadway Bombshell

In addition, she posed for calendars — under the name "Muriel" — which would become collectors' items just a few years later. The best-known pictures were taken by Bruno Bernard (**"Bernard of Hollywood"**). The poses are innocent by today's standards: a pretty pigtailed brunette splashing apparently nude in the ocean. **"The bra came off, but my arm was covering everything,"** she emphasizes. Because Bernard learned that she was underage, the photos couldn't be published at the time, but were widely seen after Sheree became famous.

It was at this point in 1950 that the lovely brunette — whose name had by now evolved to Sheree — performed in four brief 8 mm "home movies," averaging four minutes each, which were marketed as stag films. She was to earn fifty dollars for each, but she later remarked that **"one was so good they gave me one hundred dollars."** "The Wastebucket Blues," "Sheree in Her Original Can-Can Dance," "How to Be an Exotic Dancer," and "Slave Dance" were considered hot stuff for their time. Sheree never appeared in anything less than leotards or bikinis, but her sensuous dancing heated up many a bachelor party, and would at least briefly get her into trouble.

"The reason they were considered so scandalous wasn't because of anything I did — I was just dancing away," she notes today. **"It was because Joe Bonica [the producer] was shooting lingering closeups of my body: moving up from my legs to my hips and my chest. I had no idea at the time."**

The United States Post Office decided in 1954 that the hot-selling films were **"lewd, lascivious and licentious,"** and tried to ban them from the mails. Postal inspectors claimed that the black leotard she wore in one number was **"too scanty."** They also banned seven other Bonica films at the same time, including striptease routines by Tempest Storm. Sheree protested, **"I never did a bump or grind in my life. There's nothing wrong with the movies. It's just modern dancing."**

In the midst of the controversy, Bonica remarked that Sheree's dances were in good taste. **"They just have a little sparkle. Sheree has a lot of zip. Let's not kid the public, she's sexy. She just winds up and — zowie! — that's it. But it isn't lewd. It's terpsichorean art."** U.S. Judge Ernest A. Tolin agreed: **"I don't believe anything I saw could corrupt the morals of the public,"** he said in his ruling against the Post Office that March. Ads for the films continued to appear regularly in men's magazines for the next decade. Magazine layouts on Sheree also began to turn up frequently starting in late 1950.

Sheree's teenaged years were filled with adventure, and one of the most memorable occurred around early 1951 when she went to Las Vegas to appear in Nils T. Granlund's show at the Flamingo Hotel. At the Flamingo, she was working for Mo Sedgeway, an associate of the hotel's infamous founder, Bugsy Siegel. "I met all these guys, and when one of them made an untoward move I would say something like, 'Keep your clammy mitts to yourself' — all this stuff that I'd heard in Jimmy Cagney movies." She laughs at the memory. "It's a wonder that they didn't shoot me, but they must have been very amused. They also thought I was very good in the shows."

She fondly recalls the easy small-town atmosphere of Las Vegas at the time. "We did two or three shows a night, and rehearsed during the day. We'd go out in the parking lot on our break, and the first car that had the keys in, I'd get in it and drive over to the stable, get on a horse, and ride across the desert for awhile. When our break was up, I'd just drive the car back. Nobody ever reported a car missing or stolen — of course, they were probably inside gambling. It was very loose and casual then."

Sheree "learned a lot" during her Vegas period. "Sometimes I had to front the show and make up my own numbers." Recalling the trademark line of the famous 1920s entertainer Texas Guinan, "I would enter from the back of the house and say, 'Hiya, suckers,' and walk up through the audience. I'd dance on the tables, and they just loved it. I was free and loose." Of course, she was well aware that the owners "were all men of terrible violence. But you're young, and you don't know anything."

After leaving the Flamingo, she returned to Hollywood and became a specialty dancer at the Macayo Club in Santa Monica. Six months later, she answered a call for chorus girls and was signed by Paramount for the film *Here Come the Girls*. It was not her first movie experience; in 1950, Michael Curtiz had hired Sheree as an extra for *Force of Arms*, and later engaged her for an unbilled bit part in 1953's *Jazz Singer*.

Around this time, Sheree went blonde, and the difference was immediate. "I goofed in show business while I was a hazel-eyed beauty with dark hair," she later commented. "I started to click the moment I became blonde." It was also about this time that she changed her last name to North. Still, she was near the point of giving up show business. The life of a showgirl was not a lucrative one for a single mother. She began taking a business course to prepare for work as a secretary. Then, just as in every good Hollywood story, came the Big Break.

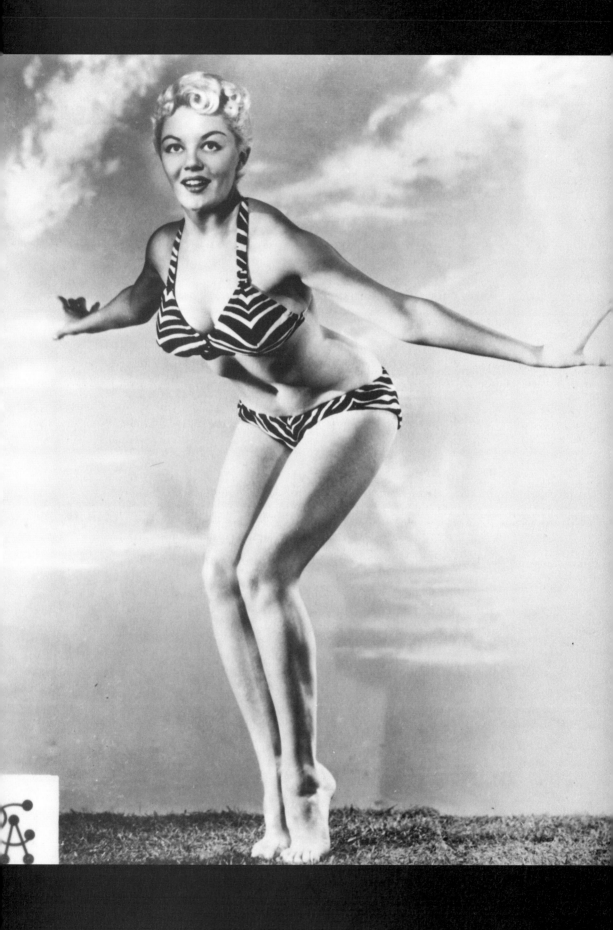

Choreographer Bob Alton had spotted Sheree dancing at the Macayo, and persuaded her to try out for a Broadway musical then being cast, *Hazel Flagg*. Songwriter Jule Styne, who was producing the show, hired her, and began five weeks of grueling rehearsals during which she wasn't paid a dime and was barely making ends meet. Also, her dance number was a small one, and she had reason to fear it would be cut.

Then the show opened on Broadway on February 11, 1953, after a tryout in Philadelphia, and Sheree was an immediate sensation. Her "Salome" dance of the seven veils lasted only one and a half minutes, and it stopped the show. Sex goddess Rita Hayworth performed her own movie version of the dance that same year, and by all accounts Sheree's rendition made Rita's pale by comparison. She was immediately proclaimed **"Broadway's Answer to Marilyn Monroe."**

Because the national publicity about Sheree had become the driving force behind the show's success, Styne wanted to expand Sheree's brief appearance and to give her some dialogue. However, to his surprise, she refused. **"All during this period, I just danced. I didn't ever talk or express myself. So I told them, 'I don't want to say any words. If you give me words to say, I'll leave the show!'"** When they realized she was serious, they relented.

One of the many impressed witnesses to Sheree's Broadway explosion was Bing Crosby, who snapped her up to appear on his first television show. The result, once again, was white heat. Sheree performed a whirling-dervish dance, and also appeared on the show as Jack Benny's young girlfriend. Sheree had just broken her second metatarsal bone (near her ankle), and had to **"sneak out of the hospital"** to do the program. Soon thereafter, in February 1954, 20th Century–Fox signed her to a seven-year movie contract.

Events were moving so quickly now that it all seemed a blur. After her abbreviated earlier movie appearances, *Living It Up* in 1954 — the movie version of *Hazel Flagg*, this time starring Dean Martin and Jerry Lewis — really established her in Hollywood. In perhaps the best of all the Martin-Lewis romps, Jerry receives a mistaken diagnosis from Dean, his doctor, that he's got just a few months to live, and they take an all-expenses-paid trip arranged by reporter Janet Leigh; Sheree dazzles in an expanded version of her role as a jitterbug dancer. Because of her ankle, she recalls it as a demanding experience: **"They would take me to the set in an ambulance, I'd go in on crutches, put them down and dance like a crazy person, get back in the wheelchair and drive back to the hospital in the ambulance."**

Fox's Replacement for Marilyn Monroe

It was at this point that Sheree found herself in the middle of the cold war between 20th Century–Fox and Marilyn Monroe. Marilyn was scheduled to do a Jule Styne musical for Fox, *Pink Tights*, but she walked out after she married Joe DiMaggio and the couple honeymooned in Japan and Korea. The film was delayed for months, and then the studio decided to proceed with Sheree taking Marilyn's place.

"I didn't realize that the studio was using me to try and get Marilyn in shape," Sheree says today. "I was much younger, highly publicized, and a platinum blonde. So they were using me to threaten poor Marilyn, which was a terrible thing to do. I was totally innocent about the whole thing. . . . I certainly didn't feel in competition with Marilyn. I didn't think about anything except having a good time and dancing."

Sheree did her Fox screen test in Monroe's wardrobe. "They told me that those were the only costumes they had around that would fit, and I believed it." Fox then made sure that every publicist in Hollywood knew about the "new Marilyn" angle. "My God, the photographers — every newspaper in the world was photographing it all. And since I was in her costumes, what was poor Marilyn to think but that they were using me to threaten her? When I went to the studio, I asked if they were trying to get me to replace her, and told them, 'I can't do anything that Marilyn does.' And they said 'No, no, that's not what we're doing.' Of course, I believed it." Soon thereafter, when Marilyn was studying acting in New York, she began signing autographs with Sheree's name.

Pink Tights was never made due to script problems. Fox then went back and forth with Marilyn over the next film it had planned for her, *There's No Business Like Show Business*, again using Sheree as the threatened replacement. However, the clash between the studio and Marilyn was coming to a head. *How to Be Very, Very Popular* was planned as Marilyn's sequel to the 1953 film *How to Marry a Millionaire*, but she had no interest in the project. This time, Sheree was in fact hired to take Monroe's role in the film.

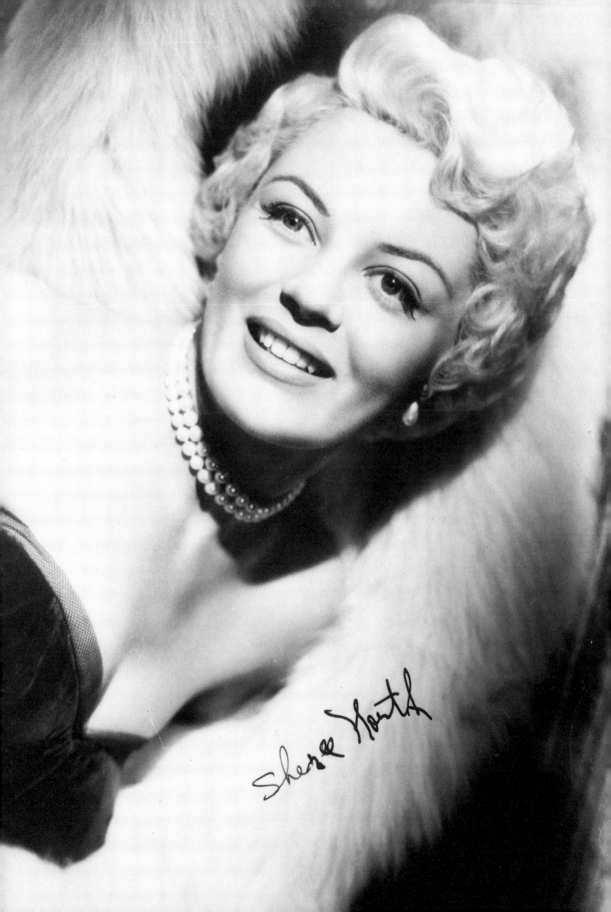

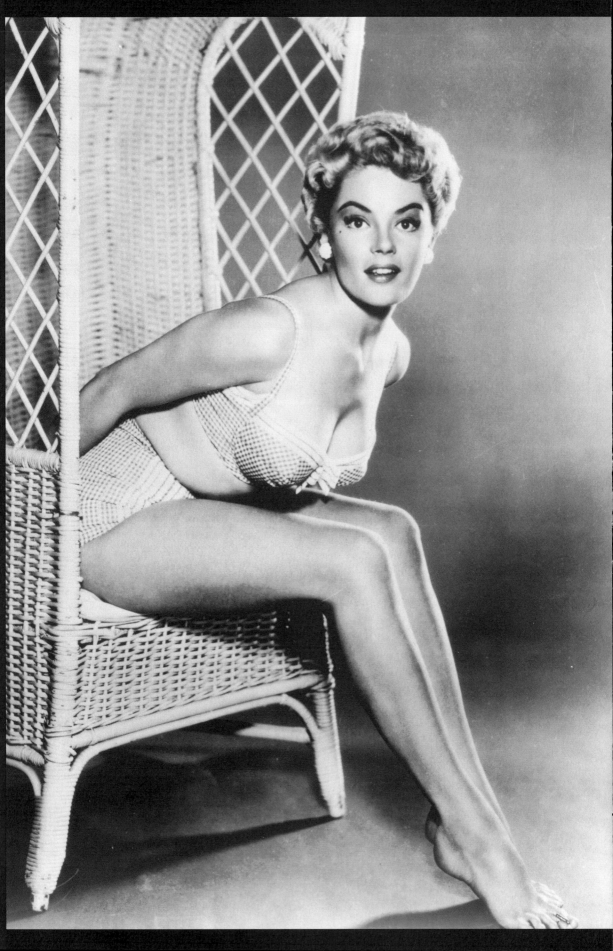

The picture went into production in February 1955, and the hype was everywhere: Sheree North, the perky young blonde who had taken the place of the defiant superstar. Helping the process along was Sheree's sharp, saucy wit, which made her eminently quotable. Asked to compare herself to Marilyn, Sheree assessed her five-foot-four, 117-pound, 35½-23½-35½ frame and told *Life* magazine, **"Let's just say she takes a bigger lead offa first base than I do — you print that and let the reader figure it out."** As for **"replacing"** Marilyn, she was all too aware that there was no way: **"Let's not kid . . . Marilyn's an institution like Coca-Cola and who's gonna replace that?"**

"The pressure was enormous because I didn't know how to act and I didn't think I would have to act," Sheree remembers. **"And suddenly there I was on the set, with all these cameras and people everywhere, waiting for me to speak. I felt totally ill-equipped. I was miserable because I didn't know what I was doing."**

In *Very, Very Popular*, Sheree and Betty Grable (in her last movie) are striptease dancers who witness a murder and flee to a college town. Sheree's wild "Shake, Rattle and Roll" number stole the picture from nominal star Betty; she also does a mean Bunny Hop. Sheree was spared from doing much speaking because her character was hypnotized through most of the film. She seemed on a rocket ride straight to the top. But then *Very, Very Popular* was released, and it proved to be anything but. Although this was hardly Sheree's fault, she decided to quit after it was over. Then Fox presented her with yet another film that had been planned for Marilyn, *The Lieutenant Wore Skirts*. She made it, and decided to quit again.

Despite her misgivings, her two 1956 pictures were quite enjoyable. *The Best Things in Life Are Free* was an outstanding musical biography of 1920s songwriters DeSylva, Brown, and Henderson, with Sheree as the female lead; a highlight is her hot dance performance to "The Birth of the Blues." *The Lieutenant Wore Skirts* was a pleasant farce directed by Frank Tashlin and starring Tom Ewell (his first film after serving opposite Marilyn in *The Seven-Year Itch*) as a TV writer married to Sheree, who is accepted for military service. Tom is stuck on base while his wife is on patrols.

The ordeal eased when she began studying acting with Jeff Corey, well known for teaching the recently deceased James Dean. However, since Corey had been blacklisted due to the McCarthyist paranoia that infected Hollywood at the time, the studio threatened to suspend Sheree if she continued to study with him. **"I said, 'Go ahead and suspend me if you like, but it won't look very good since this is Jimmy Dean's teacher,'"** she recalls. **"There was a lot of sympathy for Jimmy, so they gave in."** With new confidence in her acting abilities, making movies became **"less terrible."** That confidence also showed up in TV roles such as the 1957 *Playhouse 90* production *Topaz*.

In 1955, she embarked upon her second marriage, to music publisher and writer John "Bud" Freeman; this ended in divorce two years later. In December 1958, she wed Dr. Gerhardt Sommer, a professor of psychology at UCLA.

While Sheree's films had not been giant hits, most were solidly entertaining A-caliber productions that were considerably enhanced by her performances. But by 1958 the original blonde-bombshell role for which she had been recruited by Fox was being amply filled by Jayne Mansfield and Mamie Van Doren. She was released by the studio.

"I was focusing on my new marriage and was pregnant with my second child, Erica. I wasn't thinking of my career at all. I did the film *Mardi Gras* while pregnant, then left the studio. And I never went back."

The Theater Years

During 1959–61, Sheree retreated from show business to focus on her family. **"But when the marriage wasn't working out,"** she came to New York to do the Broadway musical *I Can Get It for You Wholesale*. The show was built around a family working in New York's garment district, with Sheree as a glamorous model who gets ahead by having affairs with powerful men. Its leading man was a young actor named Elliott Gould, and its musical standout an exceptionally gifted up-and-comer named Barbra Streisand.

Sheree recalls that the show was plagued by preproduction problems that led to numerous firings, and **"one day my turn came."** But she took the risk of exercising the right provided under her contract to open with the show, and it paid off. When the musical opened in January 1962, it was a hit and Sheree's reviews were terrific — **"and everybody was so nice to me suddenly!"**

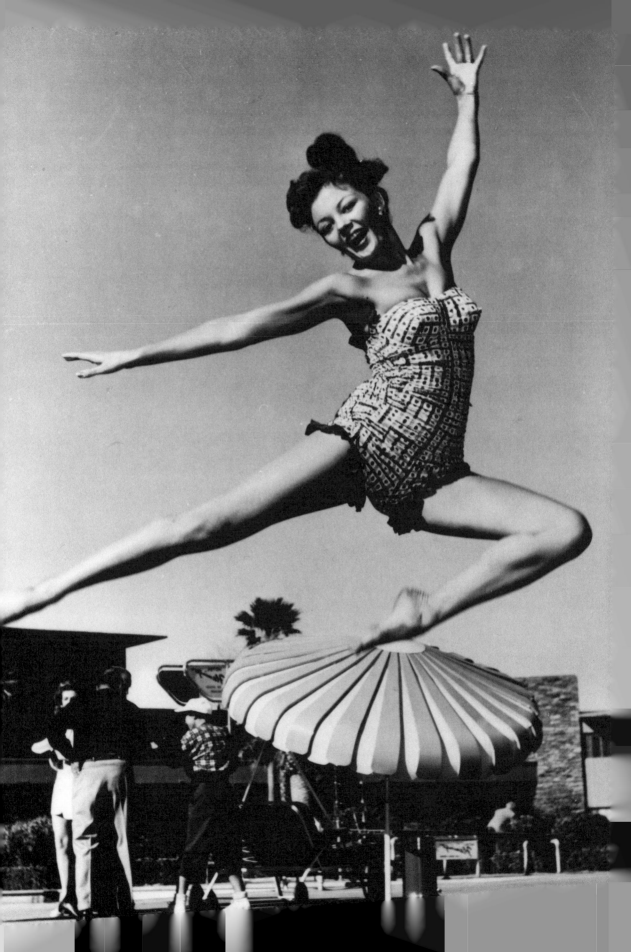

Since Streisand was not given a dressing room, she accepted Sheree's offer to share one. As the show got underway, Sheree became concerned that Gould was not exhibiting the kind of leading-man charm needed for his part, **"and I thought if he fell in love it would soften him up. I looked over the entire company, and decided that Barbra would be the best thing for him. So I sort of became the house mother for their romance."** Not long after, Streisand and Gould were married.

After seven months with the show, Sheree's personal life presented a professional crisis. Her divorce was pending back in California, and Sommer was putting up a custody fight for their three-year-old daughter, Erica. State law did not allow the child to leave California without the father's consent until the divorce was final. **"So I stayed in L.A. and never went back to the show.**

"This was cause for a lot of problems. David Merrick [the show's producer] was very unhappy with me. I told him, 'David, I can't come back or I'll lose my baby.' He said, 'Do you want to be in show business or do you want to be a mother?'" But years later, Sheree was eating with Erica at Sardi's in New York when Merrick came by, and he told her, **"She was worth it all."**

It was at the end of Sheree's run with *Wholesale* that the woman with whose career she had been so identified, Marilyn Monroe, died. The personal impact of this shattering event would be felt still more deeply eighteen years later with Sheree's involvement in the 1980 film *Marilyn: The Untold Story.*

The 1960s were Sheree's theater years, a period of intense work and professional growth in stage productions throughout the country. In 1964, she toured with her former movie costar Tom Ewell in *Thursday Is a Good Night*. Featured roles in productions of the musicals *Irma la Douce* and *Can-Can* kept her dancing skills sharp. And in 1965 came one of the most traumatic episodes of her career.

Black playwright Leroi Jones's drama *Dutchman* was perhaps the toughest, rawest exploration of race relations ever seen to that time in American theater — right around the time of the Watts riots. And Sheree was at the center of it, portraying a psychotic racist spewing a succession of epithets. **"It was an incredible experience. It riled people up. The *L.A.* Times barred any mention of the show. Police took dossiers on all of us and stood in the doorways. My car was set on fire three times. Every night, a car would circle the block and a man would come up to my door and tap very lightly — it was very scary. We were considered a big threat."** The show ran for about nine months in L.A. and was then to move on to San Francisco, **"but I'd had enough."**

The role could hardly have been more ironic, for Sheree had already put herself on the line for racial equality at some risk to her career. A musical she had performed in Reno was scheduled

to go to a Dallas nightclub that she learned did not permit blacks, so she refused to perform there. This act got her blacklisted from many clubs around the country, and prevented her from appearing in a Las Vegas production of *Sweet Charity*. She believes it may have also contributed to her long absence from feature films. In addition to her civil rights activism, Sheree was one of the founders of the L.A. chapter of the antinuclear organization SANE, and also picketed against the death penalty.

On television, one of her favorite venues was the Gene Barry police mystery/adventure series *Burke's Law*, on which she appeared at least three times in 1963–64. *The Untouchables* (1963), *The Virginian* (1965), *The Big Valley* (1966), *The Fugitive* (1967), and *Mannix* (1968) were among the many programs that she graced during this period.

The Second Time Around

Finally, Hollywood noticed all of Sheree's hard work and welcomed her back. *Destination Inner Space* (1966), her first film in eight years, was a less-than-memorable vehicle for her return. But during the following years came a succession of first-rate motion pictures to which Sheree contributed greatly.

The sassy, hip-swinging blonde bombshell of the fifties was no more. Sheree was now a still-beautiful but more seasoned character actress. Most often, she portrayed a gal from the wrong side of the tracks with a sensual presence but a heart of gold. The years out of the limelight had deepened her acting resources, and in this second phase of her career the range of roles she could play was considerably wider than the first time around.

A 1969 film in which Sheree costarred with Elvis Presley — *The Trouble with Girls (and How to Get into It)* — proved an unforgettable experience, not because of the picture but because of the man. **"He talked to me a lot about his unhappiness and deep depressions. Sometimes he would go home and his dad would put a tray outside his door and he wouldn't come out of his room for weeks. . . . He was a good guy, you couldn't help but like him. After I did one dramatic scene, he was so touched, he didn't know what to do so he took me in his arms and gave me a huge kiss."**

Sheree was impressed by Elvis's openness and politeness. **"He was one of the first leading men who sent me a big bouquet of flowers the first day on the set."** The two had something in common: **"He knew that I had started as sort of a rock 'n' roll dancer, so he had a good identification with me."**

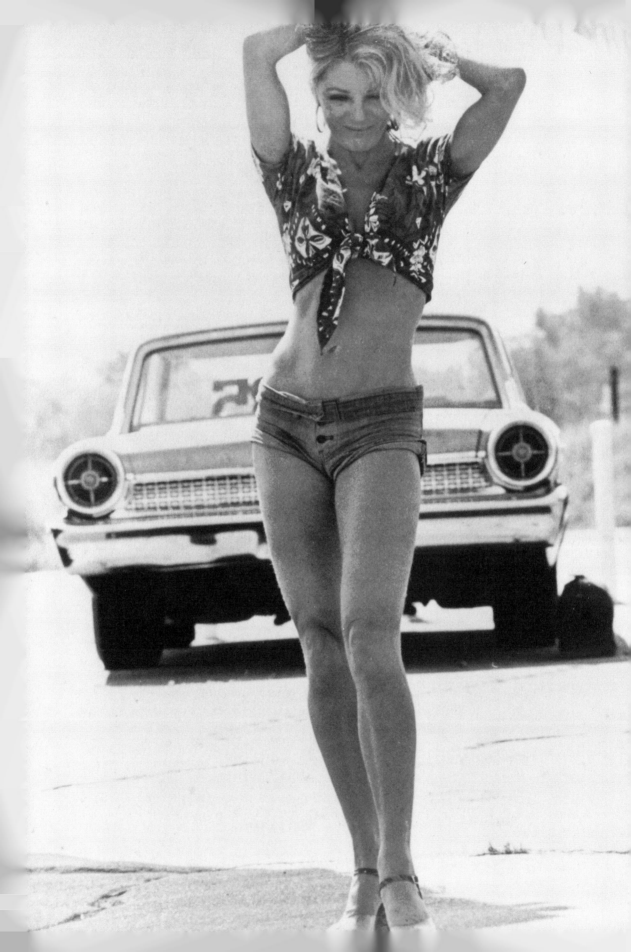

She recalls wistfully that "I almost had him talked into taking acting lessons and seeing a shrink. By that time, I was comfortable with acting, but Elvis was still very uncomfortable. Elvis would have to say something deprecating about himself before every scene, every take, because he was embarrassed about acting. I thought acting lessons would give him comfort and ease, and therapy might help with his depressions. Maybe it would have turned his life around. But then he started going on the road, and I think that's what did him in."

Even after returning to feature films, Sheree continued to work in the theater. In 1967 she gave an acclaimed performance in the play *Muzeeka*, portraying (as one account put it) "a gamy floozie wearily peddling her bizarre sexual specialty." The following year she was featured in *Enemy Enemy*, written by her ex-husband Bud Freeman. Sheree starred in the national company of *Your Own Thing* in 1969. In 1970 came a demanding role in another well-reviewed drama, *Rosebloom*.

Among Sheree's many feature films following her return, a few were particularly noteworthy. In *The Gypsy Moths* (1969), a fine John Frankenheimer drama starring Burt Lancaster and Gene Hackman as professional skydivers who come to perform at a small town in Kansas, Sheree plays a stripper who takes up with Hackman. She was teamed again with Lancaster in *Lawman* (1971), a strong Western in which she played an ex-hooker and old flame of marshal Lancaster, and they wind up in bed together in Sheree's first movie nude scene. *The Shootist* (1976), John Wayne's final film, was a poignant, memorable Western drama with Wayne a legendary gunfighter dying of cancer. Sheree is a dance-hall girl whom Wayne once loved, and after their happy reunion he learns that she wants to marry him in order to write his authorized biography.

As busy as Sheree's feature-film schedule was during the 1970s and early 1980s, it was more than matched by her full agenda of about fifteen made-for-TV movies. She got a chance to show her nasty side in *The Night They Took Miss Beautiful* (1977), playing the leader of a terrorist group that abducts five beauty pageant finalists; Stella Stevens was also featured. One of her most fascinating projects was *Legs* (1983), with Gwen Verdon featured with Sheree in network TV's first original musical in years, about the competition to become a Rockette at Radio City Music Hall.

One of Sheree's TV movies was particularly special: 1980's *Marilyn: The Untold Story*. For all the many efforts to dramatize the troubled life of Marilyn Monroe, none has been as successful in capturing her special qualities as this remarkable production. Sheree is memorable in her brief time on-screen as Marilyn's emotionally disturbed mother, and Catherine Hicks is poignant and touching in her portrayal of Marilyn. But Sheree's key

contribution to the success of this project was as acting coach to Catherine. The essential qualities of Marilyn may not have come across so powerfully without Sheree's knowledgeable counsel.

Making this film was an emotional and revealing experience for Sheree. **"All sorts of things emerged during the filming. For example, a girl that I had worked with at a supper club in the Valley resurfaced during the film, and it turned out that as a child she had been in the same orphanage as Marilyn. So I was able to learn more about Marilyn's childhood."**

Some of the things Sheree learned during the production never appeared in the finished film. **"I learned that there were needle marks in [Marilyn's] armpit that were never explained. There was no trace in her stomach of the Seconal gelatin capsules she was supposedly taking. And the ladies next door, who played bridge and watched all the comings and goings, saw a car pull in that night and go around to the back with three men, and one was carrying a doctor's bag. Something funny was going on.**

"Just look at what was going on in her life then. She'd never been trimmer, she looked fabulous, she was furnishing her home. She was doing everything that was positive and upbeat. This was just not someone who was going to take her own life. For the first time, she was taking charge of her life."

In addition to her telemovies, Sheree has done some of her most widely seen work during the last two decades on TV series. She was a regular on three short-lived programs. In *Big Eddie* (1975), she once again portrayed an ex-stripper, Honey Smith, the wife of former gangster Sheldon Leonard, who is trying to go straight. *I'm a Big Girl Now* in the 1980–81 season lasted a little bit longer, but the situation comedy starring Danny Thomas and Diana Canova was not renewed for a second season. *Bay City Blues*, a Steven Bochco creation that ran for several short weeks in the fall of 1983, deserved a better fate for its intriguing mix of characters surrounding a minor-league baseball team. Sheree was also offered the title role in the TV series *Alice* (which was taken by Linda Lavin) — a part for which she would have been perfect — but declined because she wanted to spend more time with her children.

During the early seventies she was seen on the likes of *Hawaii Five-O*, *Kojak*, *Cannon*, and *Barnaby Jones*. Every fan of *The Mary Tyler Moore Show* will vividly recall Sheree's portrayal of a steamy nightclub performer with a checkered past who entranced Lou Grant in a couple of episodes, beginning with

1974's "Lou and That Woman." Subsequently, Sheree turned up on *Magnum, P.I.*, *The Golden Girls* (in two episodes), and *Matlock*, among other programs. And most recently, she made a surprise appearance as Cosmo Kramer's mother in an episode of *Seinfeld*.

Looking back over her career, it's remarkable to see how far Sheree has come. The young dancer who shot to movie stardom with an utter lack of confidence in her acting has become a versatile, totally self-assured performer who adds a special dimension to virtually every part she plays. And her total body of work is an impressive one.

But still more impressive is the woman herself. After all Sheree has lived through, she remains an open, friendly personality; the hard-edged cynicism seen in many of the characters she portrays is alien to her. In the last few years, acting has taken a backseat to her activities in helping to run a small theater group in the L.A. area.

Sheree's enduring beauty is a tribute to years of exercise and a dedicated health-food regimen; the strength of character she has demonstrated across a remarkable life speaks to the deeper resources she possesses.

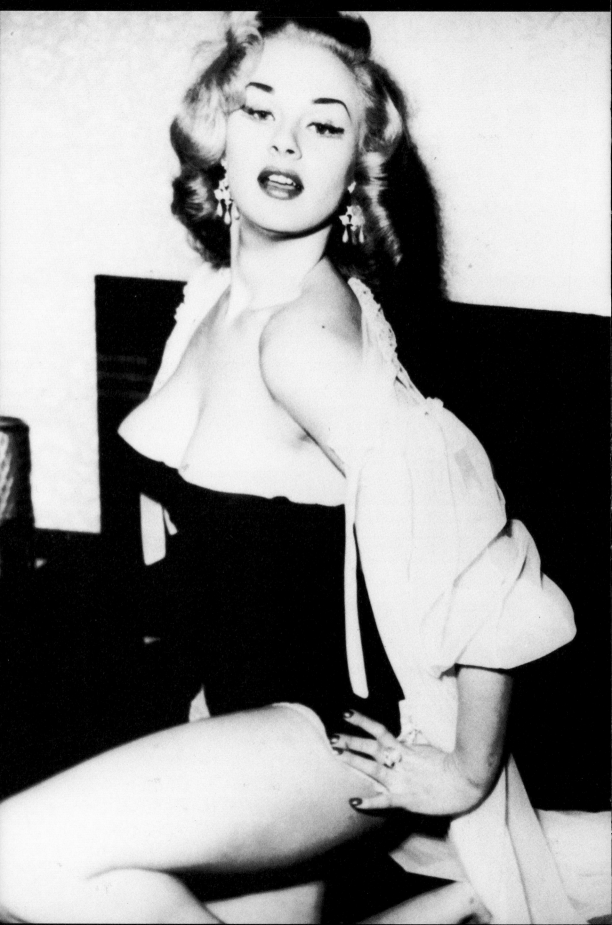

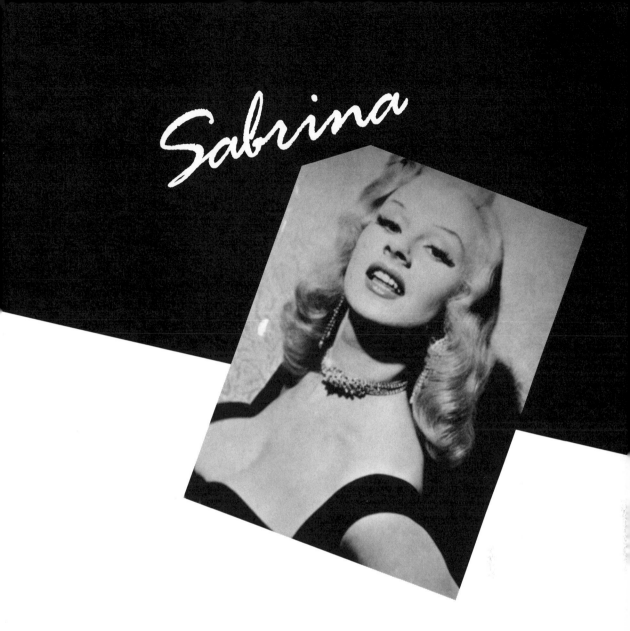

Sabrina

America gave birth to the popular
stereotype of the bosomy dumb blonde
through the likes of Marie Wilson and
Dagmar. But it was a British bombshell
known as Sabrina who carried the image
to its ultimate extension, and indeed
epitomized the absurd and wonderful sex
symbols of the 1950s.

Everything about Sabrina was manufactured — her heavy makeup, platinum hair, long eyelashes, and stop-at-nothing publicity. Everything, that is, except one of the most extraordinary figures (41-19-36) ever immortalized by pinup photographers. In the absence of any known ability other than a genius for self-promotion, she came to rely entirely upon these remarkable attributes for her fame and fortune. They proved sufficient to make her a phenomenon that could not have occurred in any other decade.

From Invalid to Blonde Bombshell

Norma Ann Sykes was born in approximately 1936 in the northern industrial town of Blackpool. A junior swimming champion at the age of twelve, young Norma was subsequently struck by polio and was hospitalized for two years in Manchester. A leg operation nearly proved serious enough to require amputation; doctors feared she would be crippled for life. But she gritted her teeth and embarked on a stringent regimen of exercise.

Once back on her feet, the newly blossomed sixteen-year-old set out for London. After working for a time as a waitress, Norma decided to give cheesecake modeling a try. Initially rejected by Britain's foremost glamour photographers for being too voluptuous, her fortunes changed after a diet that resulted in a wasplike waist. Very quickly, the teenager's curves, classically British peaches-and-cream complexion, and natural beauty made her a popular model for the pocket-sized men's magazines widely distributed in England during this period such as *Spick* and *Span*.

It was in January 1955 that the famous British comedian Arthur Askey opened the door to stardom for Norma. He needed a stunning girl to appear on his TV show *Before Your Very Eyes*, and later related the dream he had of an unbelievably voluptuous blonde who was destined to fulfill this role. When his press agent brought Norma to his attention on the cover of the magazine *Picture Post*, he quickly realized that she was the dream come to life. She was hired before even meeting the comedian. Askey dubbed her Sabrina — no last name — after a seventeenth-century poem by Milton and the Audrey Hepburn movie character of the same name.

Askey's gimmick for his new blonde was an old-time burlesque routine: Every time she would open her mouth to speak, the band would begin playing, the stagehands would start to loudly shift the scenery props, etc. The night before her debut, the press coverage of the new celebrity brought interest to a fever pitch. Never before had a girl been allowed to show cleavage on British television. It was a taboo that was now shattered with a vengeance.

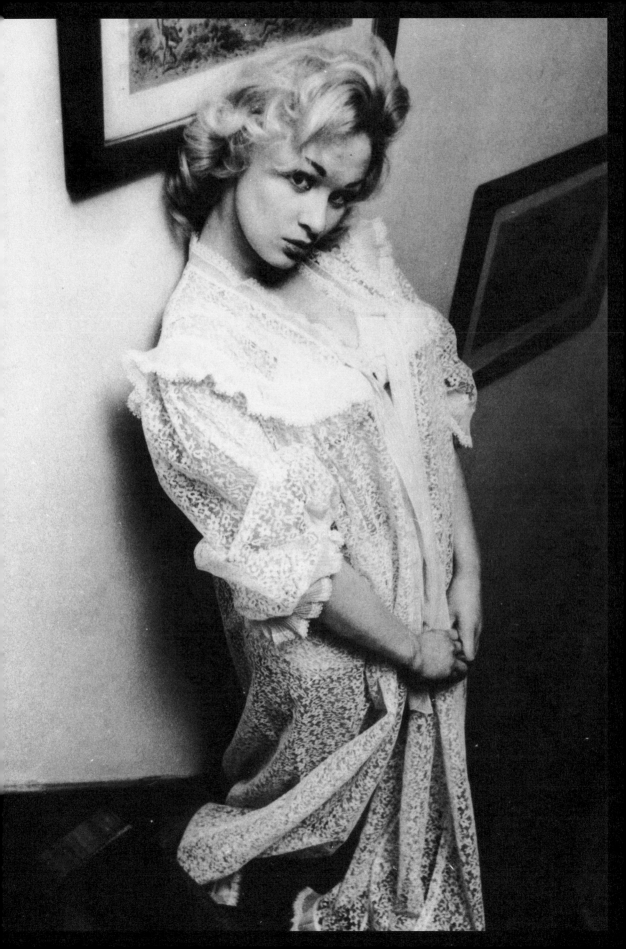

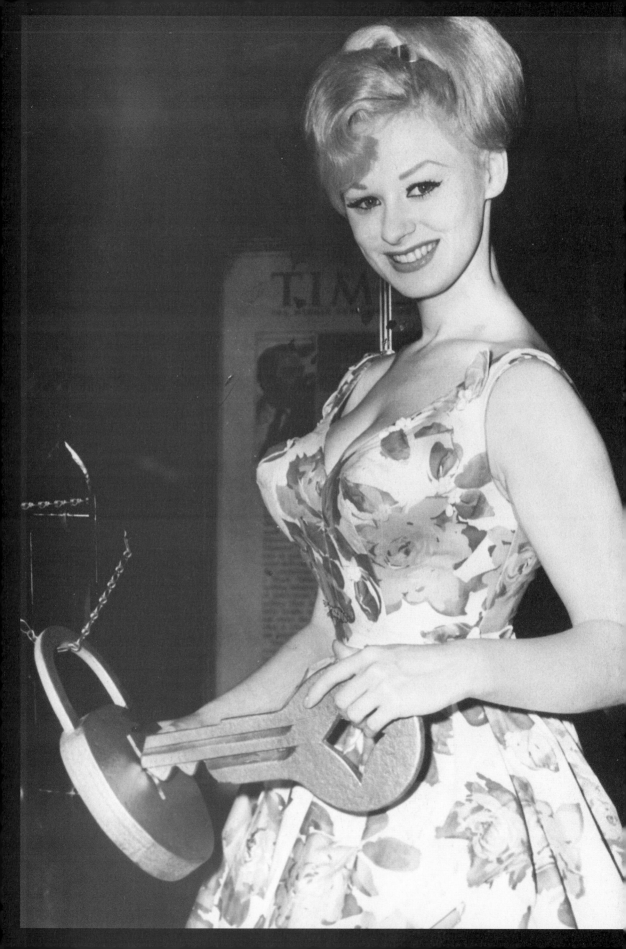

One magazine described her initial appearance: **"The cameras explored her development from neck to navel. What wasn't fully exposed was wrapped so tightly that every luscious line was displayed to best advantage."** The BBC was flooded with phone calls and letters in the next few days, and officials quickly **"began measuring her for even more revealing gowns."**

During a sixteen-week stint that proved to be a popular sensation, Sabrina never uttered a word on the television show; as she pouted innocently, the camera would zoom in on her mighty bosom, while Askey made subtle jokes about her none-too-subtle frame. For the British public, the name "Sabrina" would soon become synonymous with the word *bosom*.

Almost overnight, Sabrina was receiving a thousand fan letters a week. When she showed up to ceremonially open a Sheffield hardware store in February 1956, four thousand people turned out to see her, resulting in a massive traffic jam. It turned into a near-riot when her dress strap broke. Throughout 1955 and 1956, rarely did more than a few days go by in which Sabrina went unmentioned in the London press.

One of the subjects of media attention was the forty-thousand-pound insurance policy she took out with Lloyd's of London on her forty-one-inch bust. Specifically, the policy promised payment of roughly seven thousand dollars for every inch lost from her bosom — but stipulated that she could not claim for inches lost due to **"civil war, invasion or nationalization." "But I'll never collect,"** she confided to a newspaper columnist. Why not? She leaned forward and whispered: **"I'm growing bigger and bigger. You can tell the world I'm 42 inches now!"** Sabrina told another interviewer that **"I'm using my bosom to move on to bigger and better things."** As one wag commented, all of this served to prove that **"inches are a girl's best friend!"**

"inches are a girl's best friend"

A little scandal is always helpful in the making of a sex symbol, and Sabrina's came not long after her explosion on the national scene. It came to light that during her early struggling period, she had posed for a few nude stills that turned up on a set of sexy playing cards. The squatting nude profile that graced the five of spades in this series soon became a collector's item when Sabrina personally destroyed as many copies as she could find in London shops. **"I was only a kid of 16 when those photos were taken,"** she explained to a Scotland Yard investigator after her rampage. **"I was not going to admit defeat to my parents and ask them for train fare home."**

A bit exasperated by the overwhelming attention being attracted by the apparently talentless blonde, Askey gave Sabrina her release. **"It looks as though I'm stuck with a Frankenstein monster,"** he commented. Undaunted, she made the first in a series of motion picture appearances, most relatively brief and forgettable, and "performed" in London music halls. Her first stage appearances came in a sixteen-week variety tour right after the TV series ended, and despite the fact that Sabrina was topbilled she had little to do other than stand around decoratively while comedians hurled out jokes built around her. However, she soon had the opportunity to show off what she had learned in singing lessons. While her voice was nothing to write home about, she offered up mildly suggestive numbers like "Ready, Willing and Able" and "After You Get What You Want, You Don't Want It" in whispery Monroe fashion. When she was the guest of honor at the Savoy Luncheon at the Variety Club of Great Britain, it was announced: **"GREAT NEWS OF 1956 — SABRINA SPEAKS!"**

Her motion picture debut, *Stock Car*, was a bitter disappointment. **"I was furious,"** she told one publication. **"It was my first chance in British pictures and they dubbed a harsh Cockney voice in for my own. I really tried to get a part in this film and it just fell flat."** Sabrina's next film, *Rashbottom Rides Again*, reunited her with Arthur Askey, as did the 1957 movie comedy *Make Mine a Million*. The roles were small, and the pictures were not successful.

As **"Britain's answer to Jayne Mansfield,"** Sabrina never passed up an opportunity for publicity, and rarely turned away a photographer looking for cheesecake poses. Her automobile license plate — **"S 41"** — called attention to her most renowned attribute. After those teenaged nude poses, Sabrina was no longer willing to reveal all, but she was more than happy to pose in negligees with plunging necklines (**"She always suggests that she bend down,"** noted a photographer) and tight sweaters.

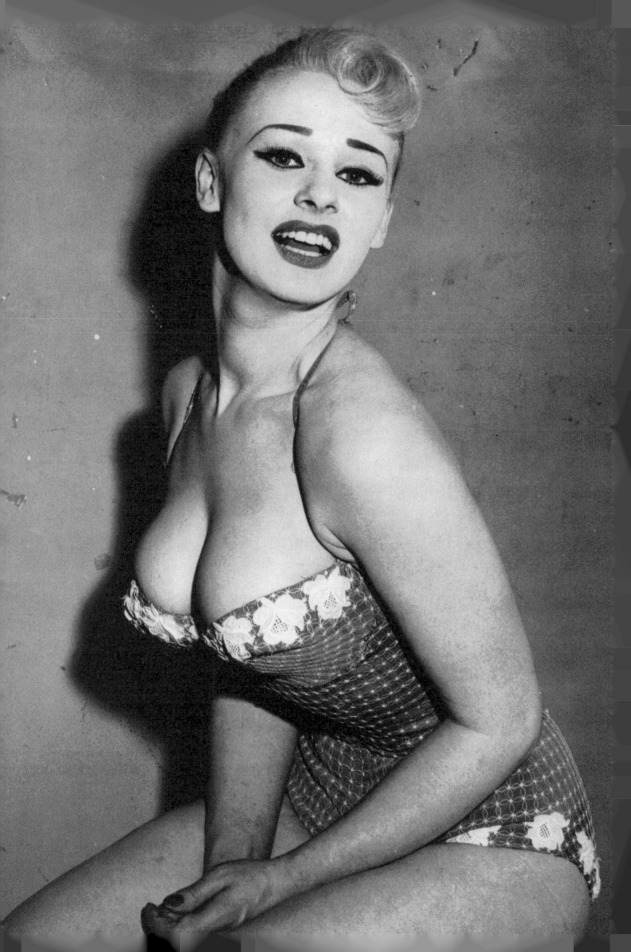

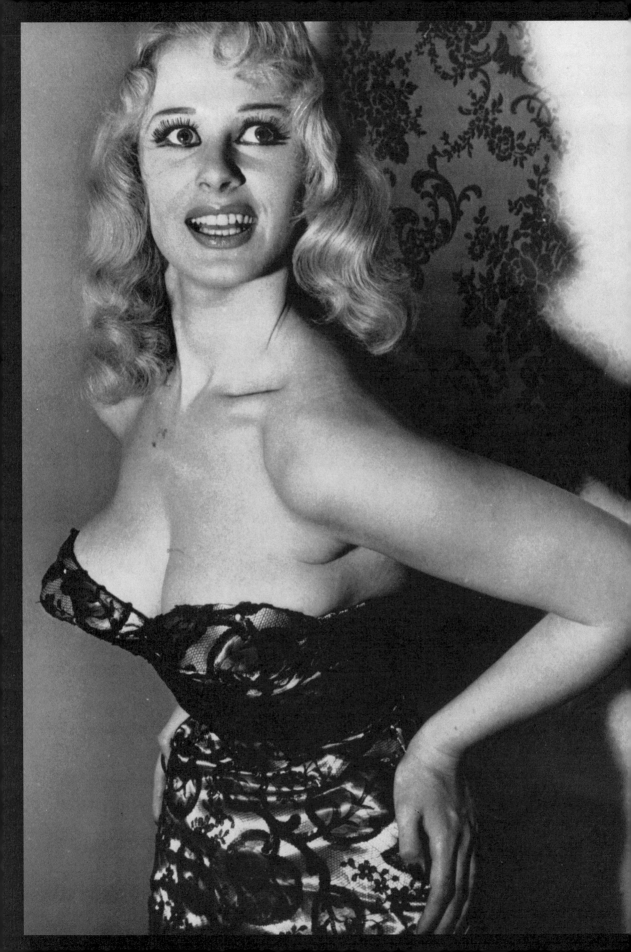

Russ Meyer was one of the photographers to capture her form for posterity on more than one occasion, and he says today he was never particularly impressed by her. Sabrina **"wasn't really a big girl,"** he recalls. **"She was concerned about Eve's [Russ's buxom blonde wife] bustline. She was a rather dull girl, very taken with her own importance."**

This is consistent with the recollection of pinup legend June Wilkinson, who was a friend of Sabrina's during those early days. **"I liked Sabrina, she was always nice to me,"** says June. **"I remember that she had a favorite trick of using a special tape measure. She had a tiny waist anyway, but this tape measure exaggerated her bust measurement and gave her a smaller waist because it had longer inches on one side and shorter on the other. Very clever!"**

Sabrina's feelings of frustration with her career in England were symbolized by her self-generated rivalry with Diana Dors. Sabrina made a point of driving a converted Cadillac that was a foot longer than Diana's, making it **"the longest vehicle on British roads."** Since Sabrina's bosom was allegedly some six inches larger than Diana's thirty-five-inch bust, she also took it upon herself to personally mail out eight-by-ten photos of her torso as compared to her rival's to prove the point to the press. One publication declared an appropriate epitaph for her campaign: **"Di Dors has more talent in her little finger than Sabrina does in her bra cups!"**

In 1958, Sabrina starred in the London revue *Pleasures of Paris*. It proved to be an excellent vehicle for her particular talents, and she went on to tour with the show for a year in Australia. By this time, Sabrina decided she had gone about as far as she could go in British show business. So she packed her bags and set out to conquer the world at large.

41

-19-

36

America and the World

Believing she had been discarded by the British press and show business as a cheap novelty, Sabrina made her way to America in late 1958, preceded by a number of girlie-mag appearances. The forty-minute cabaret show she performed in Manhattan's Latin Quarter drew a promising early response. She sang sexy ballads, joked about her famous anatomic assets, and took part in skits with stand-up comedians. Her cabaret show went on to tour in over thirty states. **"The people here respect me as a performer,"** she declared. **"I'm not just known as, you know — a bosom."**

Her most significant motion picture appearance came in 1958 with the British comedy hit *Blue Murder at St. Trinian's*, starring Terry Thomas and Alastair Sim. As one of the sexy madcap girls at St. Trinian's who wins a trip to Europe, she and her pals embark upon a fast-paced slapstick adventure involving a diamond heist. Her first American film, the memorably titled *Satan in High Heels*, featuring voluptuous U.S. star Meg Myles, was heavily publicized but failed commercially, although it has earned a cult audience in subsequent years. As usual, Sabrina appeared as herself, performing a song in a nightclub.

Sabrina headed south in 1960 and found a most receptive audience in Cuba. By press accounts, she apparently took the country by storm — including its new revolutionary leader, Fidel Castro, who found time to show her some of Havana's famed sights. The trip proved so successful that American promoters who had previously snubbed her were suddenly forwarding new offers. **"Who says I've gone bust?"** she proclaimed to reporters.

After having been away for four years, Sabrina — her measurements now improbably reported as 42-18-35 — made a widely heralded return to London in 1963. She made TV appearances (including a reunion with Askey) and performed in nightclubs, once again playing the breathy-voiced dumb blonde joking about her assets. She and Askey also performed a skit at the Royal Variety Show. In December 1964, a worldwide search for a bosomy successor to June Wilkinson (who was leaving to make a movie) in the bedroom-comedy stage hit *Pajama Tops* ended in the selection of Sabrina. But it soon became apparent that when it came to theatrical comedy talent, Sabrina did not quite measure up to her old friend and rival, and the show quickly closed.

Sabrina hit the road again, with a tour of Europe and Australia. She became a particular favorite Down Under, appearing regularly on television as the Caltex Oil girl. By the end of 1965, she had settled down to stay in the United States.

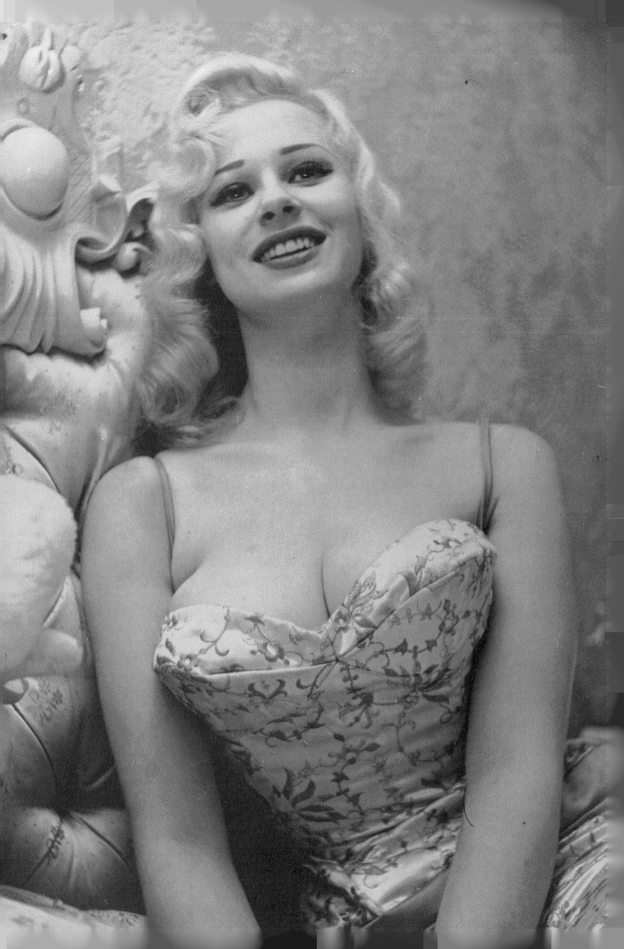

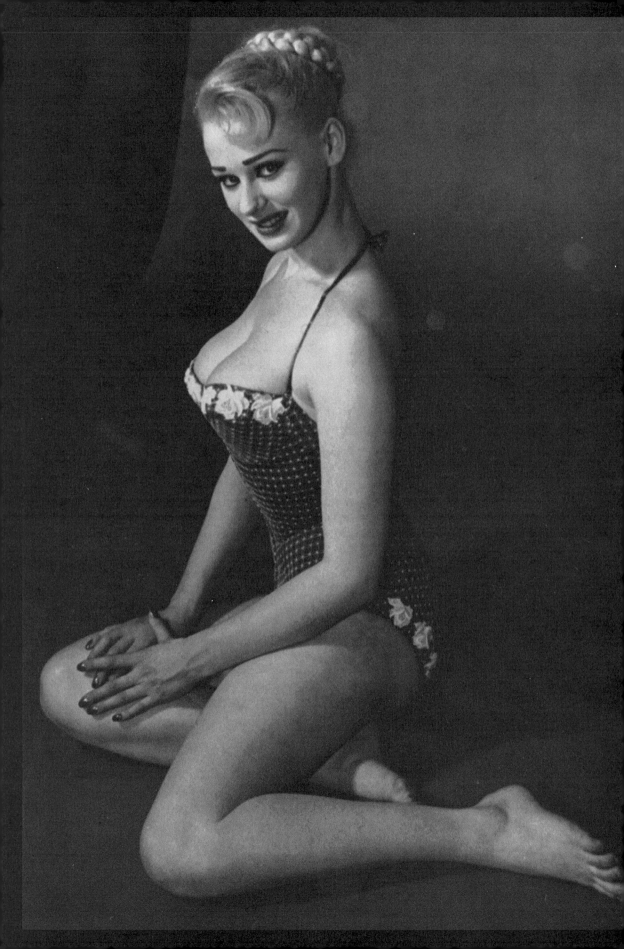

In August 1966, Sabrina starred in *Rattle of a Simple Man* at the Ivar Theater in Los Angeles. This play had been preceded by an eastern-U.S. tour with *The Loving Couch*. In an interview at the time, she showed her sense of perspective about a most unusual career. **"I've never taken myself seriously. I've always been content to be the dumb blonde of the BBC. It's a bit of a giggle for me to take on this part because I'm not an actress at all."**

The curtain did not close on one of the most curious of all show business careers until later that year, when Sabrina was top billed in a cheap exploitation movie called *The Ice House*. The film depicted a psycho killer who strangles a succession of beauties who gave him the cold shoulder, encasing them in a meat freezer. The picture was placed in cold storage for three years until a limited release in 1969.

In December 1967, Sabrina announced that she had married Dr. Harry Meilsheimer, a wealthy Hollywood plastic surgeon. **"He's tall, dark and handsome. . . . We're very much in love,"** she said happily. Sabrina and her new husband settled down in Encino, California. Looking back on her career in the 1970s, she remarked: **"I always enjoyed singing and dancing, but really I never took myself seriously as a performer. Neither did the public, not to mention producers and casting directors. They usually reviewed my figure and not the performance. I was frustrated and eventually got fed up with the whole thing."**

In one last hurrah as an entertainer, Sabrina made a special return appearance to England in 1974 for Arthur Askey's *This Is Your Life*. Unfortunately, married life back in California proved less enduring than her career, and the Meilsheimers divorced around 1980.

In the final analysis, it can fairly be said that Sabrina was **"all sizzle and no steak."** But for a time, that sizzle alone was oh so tantalizing. **"I can't dance. I can't sing. And I can't act,"** she once candidly admitted, shrugging her beautiful shoulders. Whatever Sabrina may have lacked in ability, she more than compensated for as a delightfully goofy symbol of a bosom-addled age.

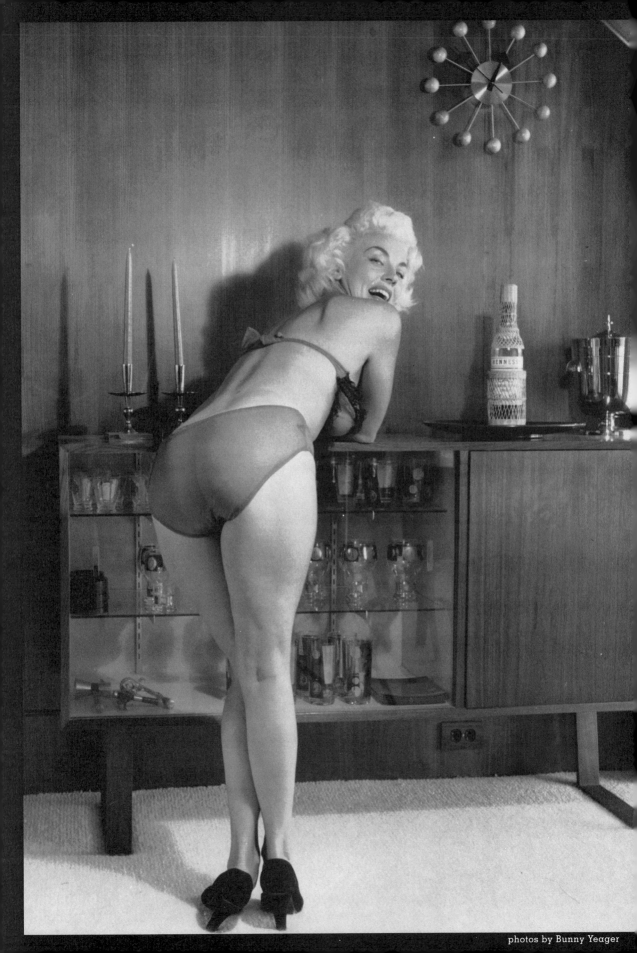

photos by Bunny Yeager

Maria Stinger

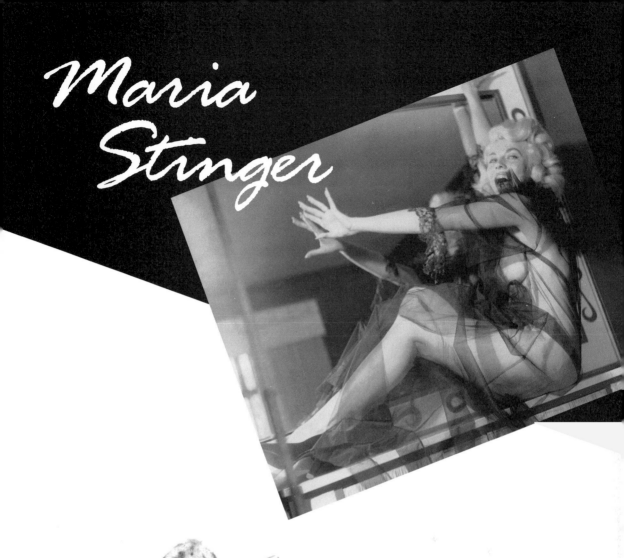

Like no glamour girl before or since, Marilyn Monroe inspired a generation of aspiring imitators who sought fame by trading on her golden tresses, little-girl wink and smile, and big-girl sensuality. Among the most popular of these "Marilyn wanna-be's" was Maria Stinger, who seemed to have the makings of one of the era's true glamour queens. It never happened because Maria would share at least one more trait with Marilyn: death long before her time had come.

"It's amazing how very much her life paralleled Marilyn's," remarks Maria's husband of sixteen years, Harry Stinger. "She was an illegitimate child like Marilyn. And, like Marilyn, she committed suicide at age thirty-six."

Maria was born in Philadelphia in 1931. Her father, who was not married to her mother, was an Irish-American policeman. Maria's mother later married another man, who drank heavily and apparently had a violent temper; the couple ultimately divorced after having two children.

In October 1948, Maria moved out and settled in Miami. "When I first met her, she was very shy, and would walk down the street with her head down," Harry recalls. "I was twenty-five, and had just gotten out of the military. . . . She was just seventeen. I was married at the time, but divorced soon after." They were married in 1949. During the next few years, they had three daughters — poetically named Spring, Autumn, and Summer.

At first, Maria was a housewife while Harry began his career as a painting contractor. After having Spring and Autumn, she began modeling around 1951. Her saucy brown-haired beauty and curvaceous five-foot-four, 37-25-36 form made her ideal for swimwear. "Big swimsuit companies like Jansen and Cole would send their salesmen down to Miami, set up in a hotel where buyers would come to see the latest suits, and Maria would model them. She probably got about twenty-five dollars a session."

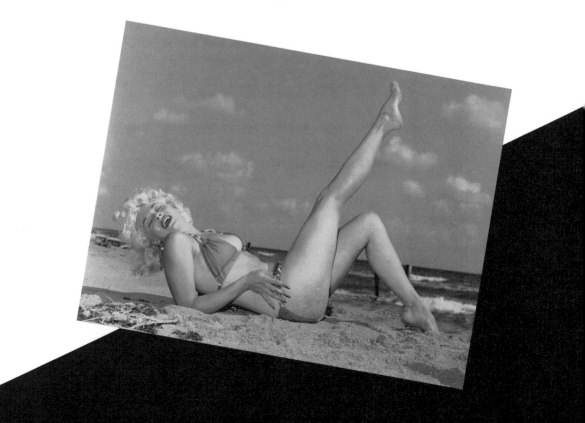

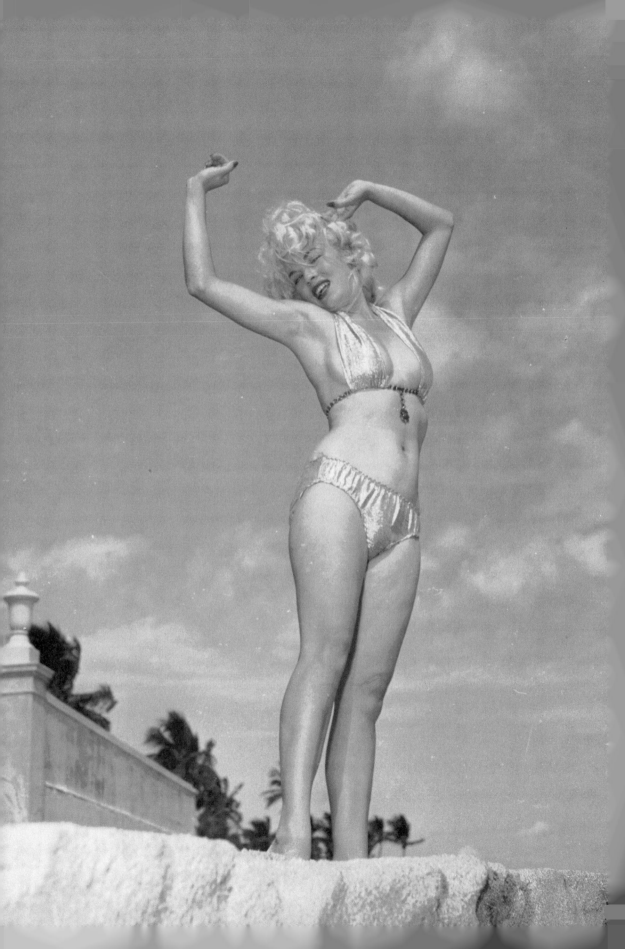

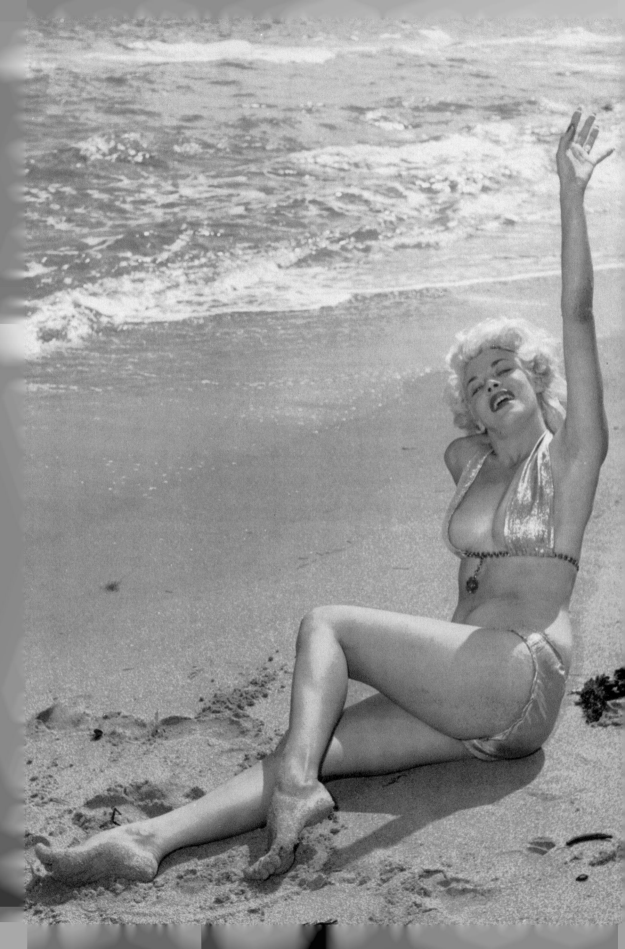

37

-25-

36

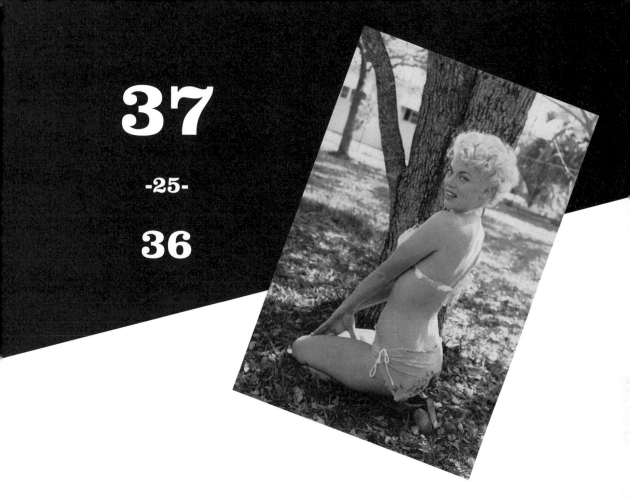

The first well-known glamour photographer to shoot Maria was Bill Hamilton, also known for his work with Bettie Page under the pseudonym Jan Caldwell. By this time, Maria was taking advantage of her resemblance to Marilyn Monroe by bleaching her hair blonde. Hamilton did some splendid early layouts on Maria (starting with the December 1953 issue of *Photo*), but the photographer who would become most closely associated with her was Bunny Yeager.

Bunny recalls that Hamilton **"came to me because he had this wonderful girl and he needed some bikini suits."** Hamilton then sent Harry Stinger to see Bunny. **"When he pulled out his wallet with pictures of Maria, I couldn't believe it. I mean, here was Marilyn Monroe, here was a movie star. I thought, how could anyone be married to this gorgeous creature? I was really enthralled with her beauty. So I made some bikinis for her to wear, but what I really wanted was to photograph her for myself. And eventually, I did."**

Nearly all magazine write-ups on Maria cite her victory in a Marilyn look-alike contest as the event that launched her to modeling stardom. But interestingly, this victory did not occur until late 1954 or early 1955, nearly a year after her Monroe-like photos began appearing in national magazines.

"It's fun when people do double takes over me," Maria confessed at the time. "I know they think they're seeing you-know-who." By the end of 1954, Maria was a hot pinup property. Among her hundreds of magazine appearances, the most noteworthy included four *Night & Day* covers (July 1954, April and July 1956, and October 1958) and a nude layout in *Fling Festival* issue 5 in 1960.

"I loved Maria as a model," says Bunny. "She was like Bettie Page — you just couldn't help but like photographing her and to be around her." In addition, Maria "probably became my best friend during that era. I had my first child right after she had her last child, and we'd share baby clothes. We'd go out together with our husbands. She was about the closest friend I had."

While her most famous layouts were photographed by Bunny, starting in late 1954 she did a number of bondage-type layouts for Irving Klaw that also created a stir. "Klaw got her name from Bunny, and every three months or so he'd come down to Miami with whips, six-inch spiked heels, and the like, and shoot Maria in S-M stuff," says Harry Stinger. "He paid about one hundred dollars a session. There was no nudity, just bra, underwear, and garter belt. I'm in some of those layouts, too! I'd put a grimace on my face, and Maria would threaten me with a whip. It was all just playacting."

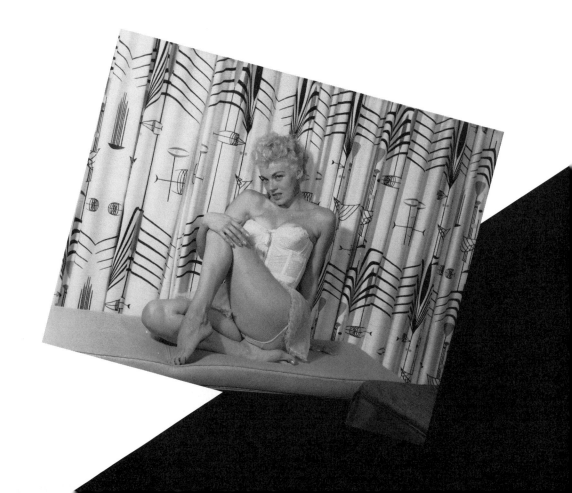

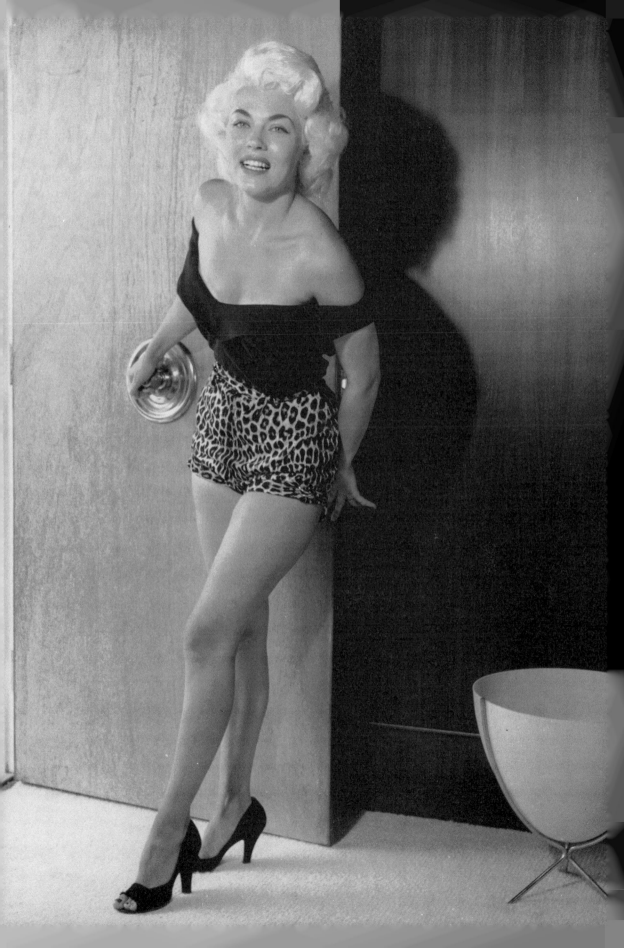

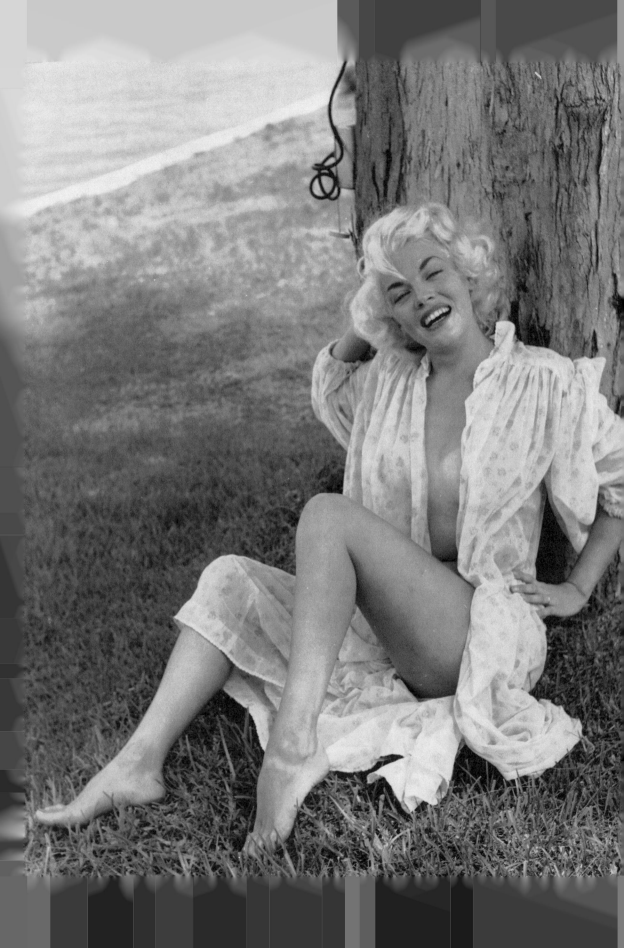

Maria in the Spotlight

The flush of success Maria experienced through modeling gave her a sense of confidence that she'd never known. "It was a great crutch for her," says Harry Stinger. "It gave her an outlet, some notoriety and recognition. She gloried in it."

Nothing gave Maria greater pleasure than the admiring male attention that would feed her fragile self-confidence. Bunny recalls: "Maria would come off as very shy at parties, and here she's dressed with these big boobs and everything hanging out. In the back of her mind, she knew she was turning everybody on. You could talk her into taking her clothes off at the drop of a hat, in a sweet, little-girl way. People would convince her to take off her top at a party or by a swimming pool. Because that was what she really wanted to do, but she had to be kind of talked into it, so everybody played that game with her." Harry Stinger recalls that she enjoyed receiving male attention in everyday life. "We'd go to a bowling alley with Maria wearing stretch pants, and every guy in all forty lanes would be watching her. She reveled in the attention."

"Maria could be so temperamental," Bunny recalls. "She was strange in that she would cut her hair, dye it different colors, and once she even shaved her head bald. It was hard for me to convince her to keep the Marilyn Monroe look. . . . With that look, she could have done anything. I tried so hard to get more pictures of her when she looked good. But when she went back to her natural color, Maria would say, 'I like it this way and I don't care if I never model again.' . . . I couldn't sell her as a brunette. She was never as pretty as she was when she looked like Marilyn."

Harry Stinger well remembers when he "came home one day and she had shaved her head bald. She didn't give any reason — she just felt like doing it. She said her hair would grow back fuller afterward, and it did." For the next few months, she wore wigs for modeling jobs.

In retrospect, he realizes that it was not the first sign of the demons in Maria's mind. "When we bought our first G.I. Bill house around 1953, I had a Prudential man come by to talk about life insurance. Out of the blue at one point, Maria suddenly asked him if they paid in case of suicide. Why in the world would she ask that?"

Perhaps due to her lack of self-confidence, Maria never actively pursued a show business career. Once, a studio flew her out to California to serve as a nude body double for an actress in a single scene. The only other "acting" she ever did (except for a 1963 nudist movie) was six weeks of Lanolin commercials during local studio cut-ins of Wednesday-night fights.

"She never mentioned wanting an acting career, and certainly never pursued it," Harry Stinger says. "And I don't think she would have been a good actress — she couldn't have handled the pressure." But Bunny believes Maria could have made it if she'd tried. "There was just something holding her back. She kept trying to destroy herself with all these crazy looks. She should have been a big star."

All things considered, says Bunny, "I would rate Maria Stinger and Bettie Page side-by-side [as exciting models]. They just exuded sex all over the place. . . . When you finally got Maria out there, she really enjoyed posing — it was just like Bettie. You hated it when you ran out of film, because she was still going! Maria was provocative without knowing it. But she kept saying, 'I just want to be a housewife.' I could never quite understand it."

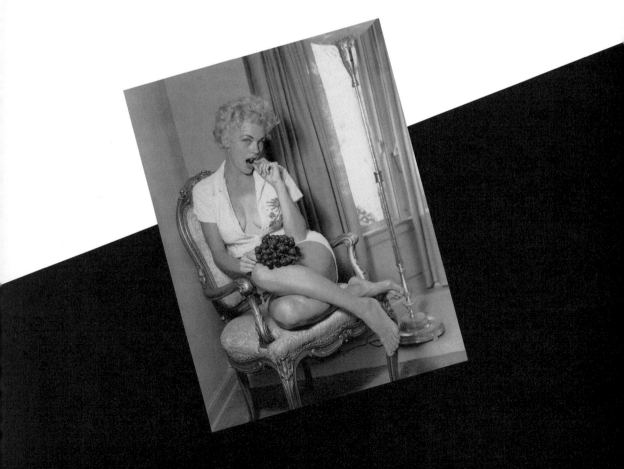

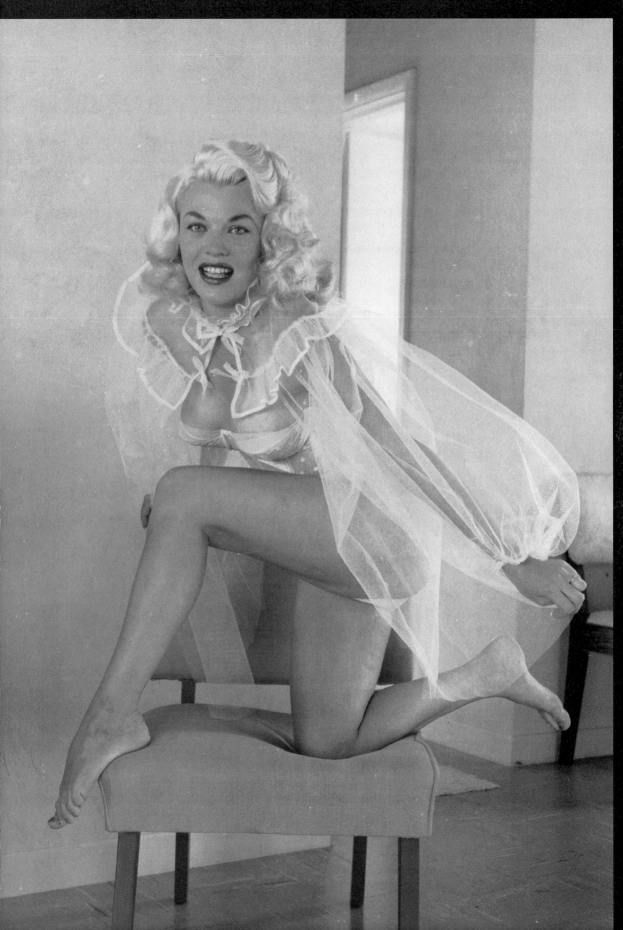

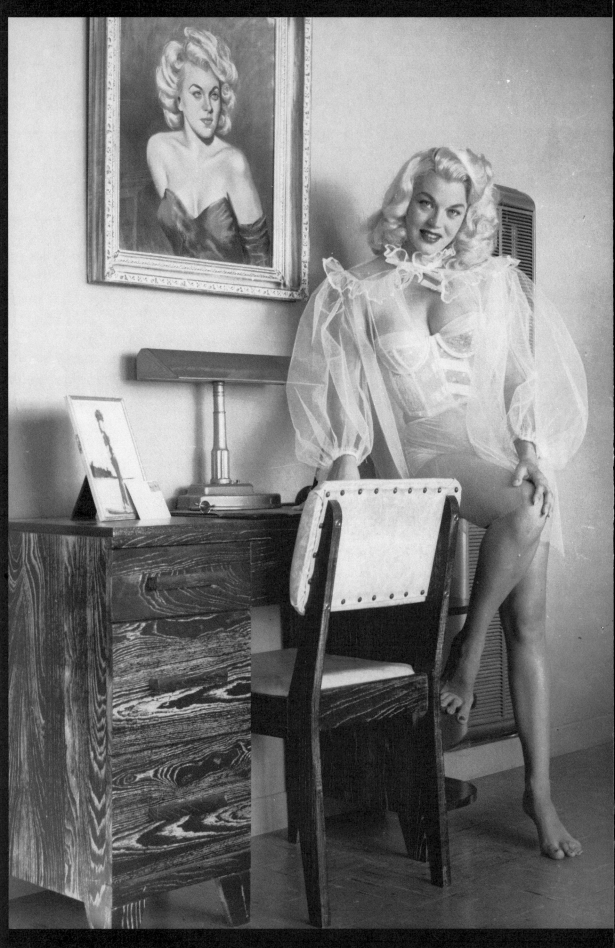

Even while avoiding show business itself, Maria stayed on
its fringes, including the long friendship she and Harry had with
Sammy Davis Jr., which began at a Miami club. **"Sammy sat with
us at the table after the show, and when Bunny introduced us,
he said to Maria, 'Your face is in all the magazines! Can I do a
shoot with you?'"** recalls Harry Stinger. **"So he shot Maria, and
it turned up on the cover of *People Today*."**

Maria's modeling income was crucial for the growing family.
When Harry began working as a restaurant general manager,
**"that had me working nights, so I didn't have time to give Maria
the counseling she needed. It was a time in her life when she
really needed someone. She couldn't be left alone. She needed
someone next to her, just for companionship."**

By the start of the 1960s, Maria was drinking during the day,
smoking more heavily than before, and going to bars at night.
She shed the Monroe image by modeling in her natural brunette
state — and occasionally under pseudonyms. Her face took on
a somewhat harder, puffier appearance, and her body seemed
more voluptuous than before. Some even suspected a bust job,
but Bunny says, **"It was just that she was putting on weight, and
she looked bigger all over."**

Maria's drinking did not go unnoticed. **"She'd call me on the phone and we'd have these strange conversations where she didn't seem like she was with it,"** Bunny recalls. The fun-loving Maria she had known now seemed sullen and distracted. Still, they kept in touch. In 1963, Bunny provided the photos for Maria's book, *Guide for the Amateur Photographers' Model*. It offered practical advice to aspiring models, with vintage and recent pinup poses.

Around late 1963, Maria starred in the nudie film *Girls Come, Too* (also known as *Nature's Sweethearts* and *How I Became a Nudist*). Using her own name, Maria opens the film describing her real-life career, showing a portfolio of her magazine covers and even mentioning her recent book. In typical nudie-film fashion, she goes on to relate her introduction to a nudist camp to escape the pressures of workaday life and to **"get out of those confining city clothes."**

"Being a photographer's model, you get used to being in the nude," she remarks. Once at the camp, we see plenty of Maria in all her latter-day glory: harder-looking than in the past — and in a preposterous platinum blonde wig — but impressively voluptuous. In addition to the usual nudist volleyball and shuffleboard scenes, there's also an enjoyable nude modeling sequence with Maria and several other girls on a yacht.

At the film's conclusion, Maria marries the fellow who initiated her into the nudist experience. **"I had come to Miami Beach on an ordinary modeling assignment, and it turned out to be the beginning of a richer, happier life for me,"** she proclaims. Sadly, in real life this was not to be the case.

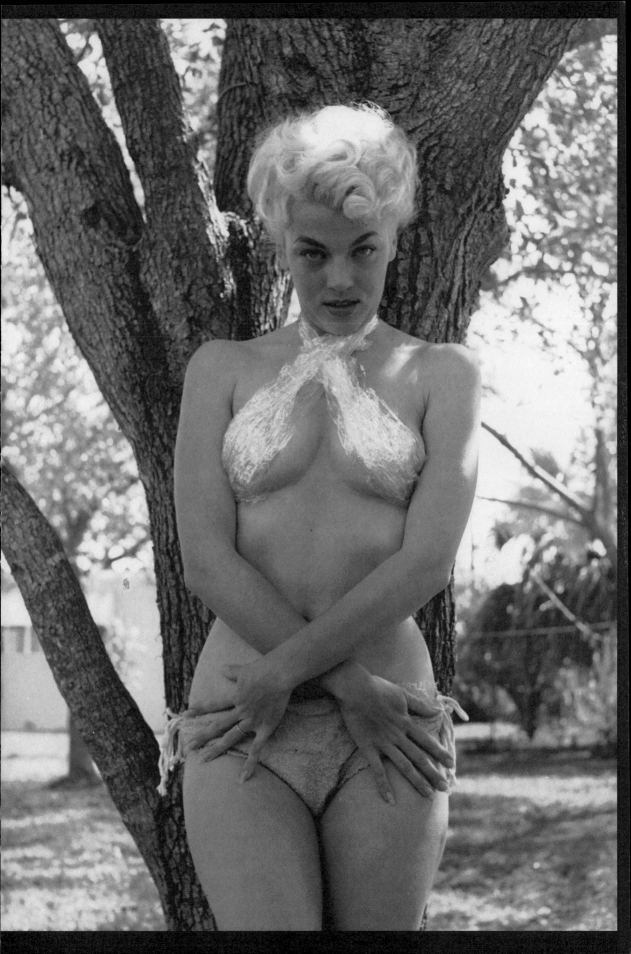

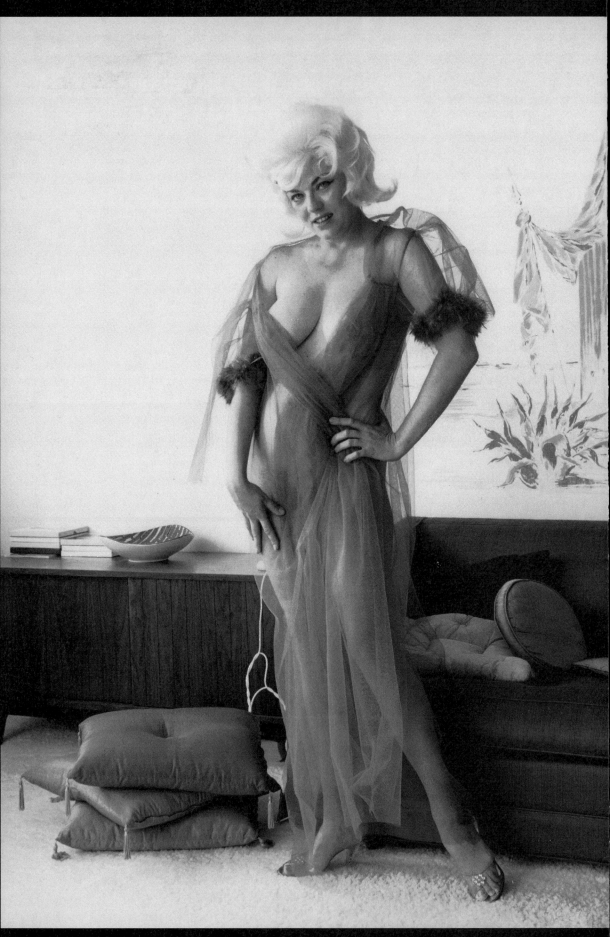

The End

In 1965, Maria and Harry Stinger were divorced. This came as a complete surprise to Bunny **"because they'd been through a lot together."** There had been financial difficulties, including a bankruptcy declaration when Harry's restaurant business folded. But the chief cause was Maria's steadily deteriorating mental and spiritual health.

Her modeling days now over, she was deprived of her sole source of self-esteem. **"She needed her career, it was essential for her ego,"** declares Harry Stinger. **"She had a husband who loved her, three children, and a nice home. But she couldn't seem to take solace in that. She felt her career was over, and she needed that adulation."** Despite her family, Maria seemed to feel alone. **"She was reaching out. She'd run up big phone bills calling Sammy Davis, just to talk."**

"The handwriting was on the wall" when Maria went out for a pizza one night and didn't return. **"The next morning, I broke down the door at a bar, and there she was,"** says Harry. Also, she was buying large amounts of patent drugs for various real and imagined ailments. About a year before the divorce, she had taken an overdose of pills and had to have her stomach pumped.

Following the divorce, Maria moved to Columbia, South Carolina, and began another romantic relationship, which didn't work out. **"I talked with her about two weeks before her death,"** says Harry, who had remarried by then. **"She said she would try to come down for Christmas. She had been working for the previous couple of months at a fabric shop, as a salesperson. She even mentioned getting together again, but I knew that wasn't possible."**

Bunny was in California working on a photo assignment for the *National Enquirer* in November 1967 when she received the shocking news from Harry Stinger that Maria had taken her own life by swallowing about fifty pills. After being discovered she was taken to intensive care, but died there. It was the day before Thanksgiving.

Despite all the episodes of odd behavior, there seemed to be no warning for Bunny that it would lead to this. **"She was such a nice person, really a lot of fun. It's a shame."**

The great glamour photographer Peter Gowland told me, in discussing another model with a tragic life, of his belief that **"it's a curse to be beautiful."** Could it be that the demands placed upon Maria to live up to the public's glamour-girl expectations became too much for her? Bunny Yeager rejects this theory. **"Being beautiful isn't a curse, it's a blessing,"** she declares. **"I just think Maria turned into a different person."**

Harry Stinger agrees. In her own troubled mind, Maria seemed to believe that being beautiful and admired by men was all she had. **"I tried to make her understand that with her family, there was life after modeling."** But that message was never taken to heart.

Reflecting on Maria today, he says that one quote about Marilyn Monroe from her former husband continues to resonate with meaning for the woman who built her career on the screen goddess's image. **"Arthur Miller said that emotionally, Marilyn was like an empty vessel — no matter how hard you tried, you could never fill it up."** Like Marilyn, every time Maria received approval through her career, the feeling would fade quickly and the emptiness would return. Finally, there was nothing left to fill the void.

Maria left a suicide note, addressed to her daughters. Nearly thirty years later, that letter has never been opened.

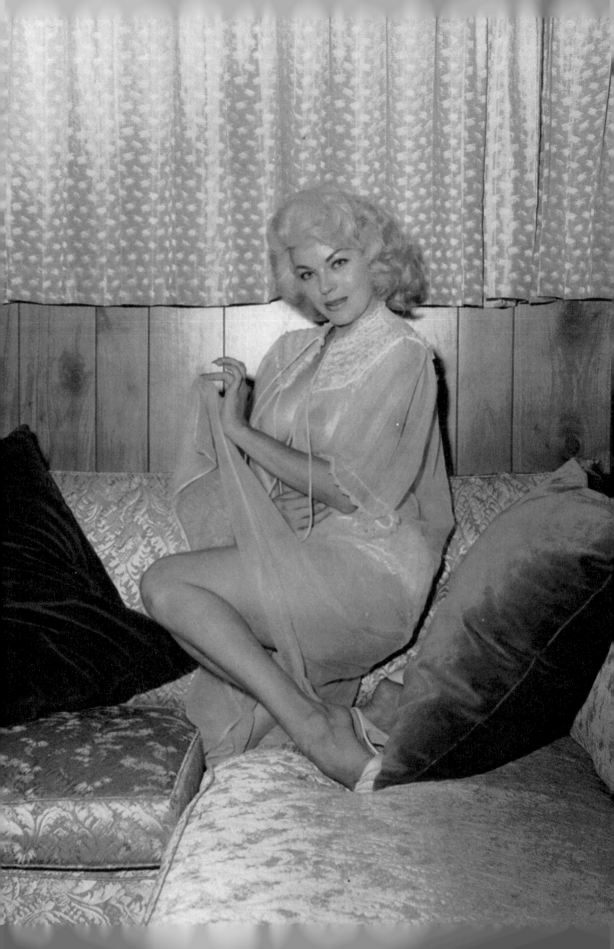

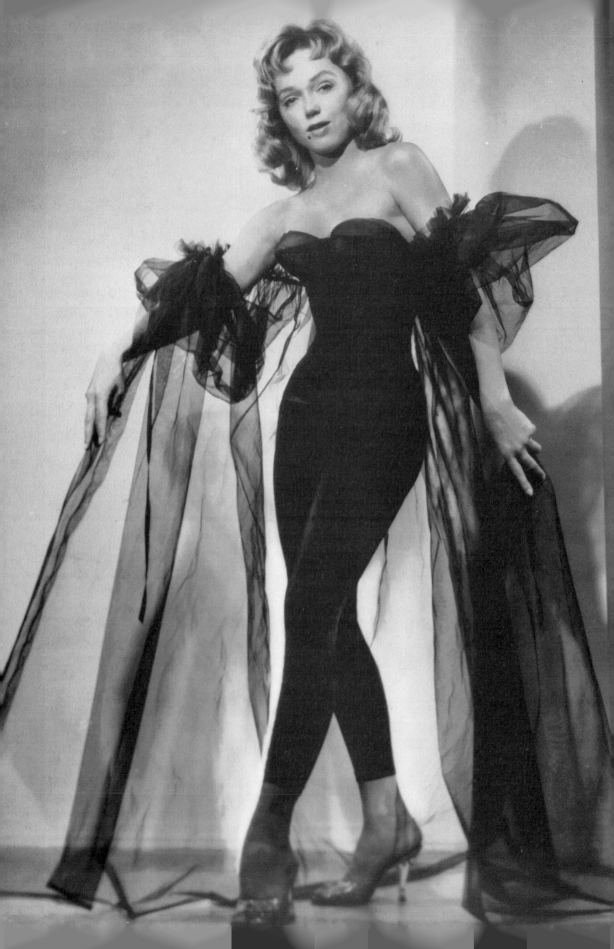

Yvette Vickers

A sultry blonde uncovered as *Playboy*'s Playmate of the Month, Yvette Vickers has become one of the definitive symbols to connoisseurs of the tarty **"bad girls"** who made the B movies of the 1950s beloved to a generation.

Yvette was born in Kansas City on August 26, 1935, the daughter of Chuck and Iola Vedder. The name of tenor saxophonist Chuck Vedder is well known to record collectors; after playing in the bands of Paul Whiteman (at age sixteen), Tommy Dorsey, and Harry James, he cranked out some hot small-combo instrumental singles in the 1950s. As a child, Yvette went on the road with her parents. Her mother was an adept pianist in her own right (originally a classical concert pianist), and when Chuck struck out on his own, Iola performed with his combo nightly at Danny's Hideaway, a club outside of Lancaster, California.

Some of Yvette's fondest childhood memories are of getting up onstage to sing with her parents. **"That really started it,"** she says of her desire to get into show business. Nevertheless, her original career objective was to become a writer; she was inspired by the example of her maternal grandfather, a renowned editor for the *Kansas City Star*.

She attended high school in Los Angeles, where she learned ballet and first got the acting bug. It was at her first little-theater job in San Francisco (at age fifteen) that she changed her last name for professional purposes — the producer decided that Yvette Vedder was not sufficiently mellifluous, and he picked the name **"Vickers"** out of a telephone book.

In 1950, the youngster was selected by Billy Wilder for a bit part in the classic Gloria Swanson–William Holden film *Sunset Boulevard*. She appeared as a giggly girl who won't get off the phone at a party. **"I was already socially active in L.A. — I'd bleached my hair, and pushed up my bra to look eighteen, so I could get into any bar,"** she recalls. **"I was with a girlfriend to see Bobby Short in a nightclub when someone sent a note to our table asking if I'd like to appear in a Billy Wilder film. I told them I had to go to school, but we worked it out so I could do the scene in between classes. I wasn't thinking of being an actress at the time, but I was curious and open to adventure."**

While attending Catholic high school, she performed in school plays. One of these was seen by a casting woman for Hal Roach Studios, which hired Yvette for a television commercial shot in New York. She became **"the White Rain girl"** in a shampoo commercial that was seen by millions, since it ran nationally for several years and was regularly aired during World Series games.

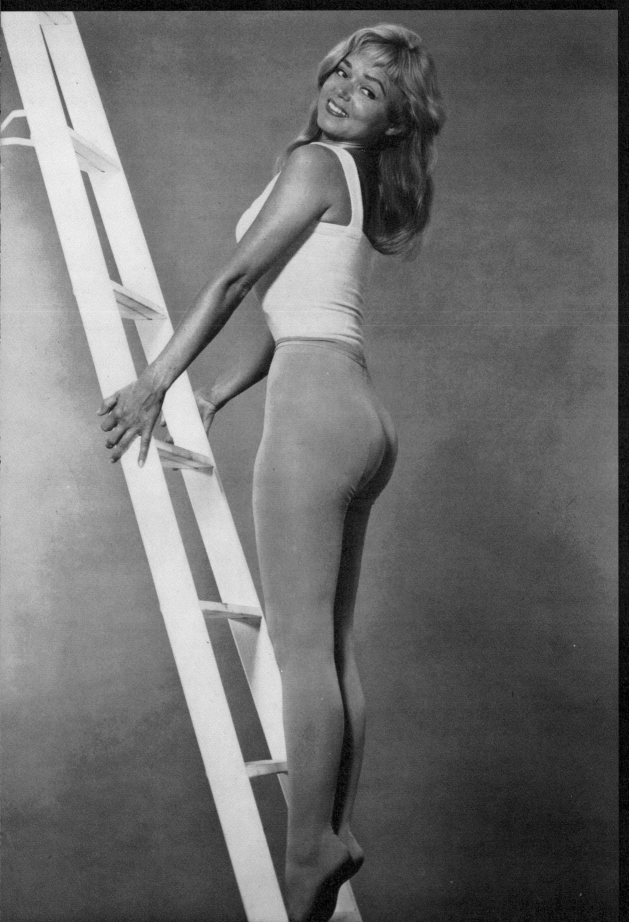

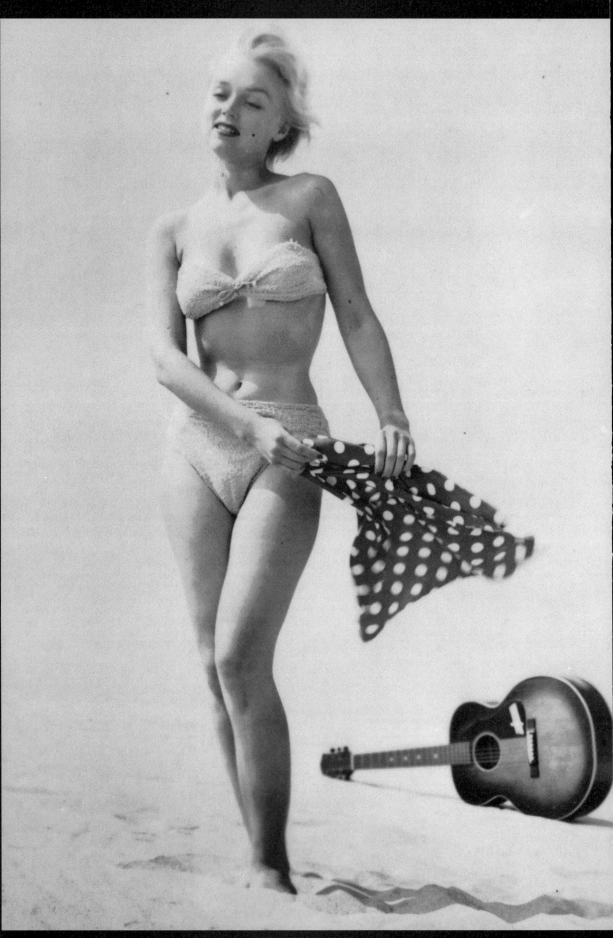

It was, however, as a dancer that she first began to make her name. With classical ballet training, she joined the Sonia Shaw dancers, which developed a crowd-pleasing style of modern ballet. She danced with the troupe for about six months. **"I was a bit of a wild child during this period — I was dating a lot, getting around, and was a little hard to handle. I didn't yet have the discipline to stay in one place for long."** By 1955, pictures of the svelte, shapely blonde were beginning to turn up in national magazines.

In 1955, Yvette made the decision to seriously pursue acting after playing the ingenue in a play called *The Man Who Stopped the City*. Before long, she was landing frequent television roles, including *Dragnet* (three episodes), *M Squad*, *Ford Theater*, *Alcoa Theatre*, and *Mike Hammer*, among others. While on occasion Yvette would play the sweet ingenue, most often she was already being cast as the juvenile-delinquent bad girl. In addition to the *Dragnet* episodes, she was hired by Jack Webb for the film *Pete Kelly's Blues* (as a 1920s flapper) and, years later, an episode of *Emergency!*

Meanwhile, her local theatrical roles continued, making Yvette a very busy young lady. One big thrill came when Marlon Brando came backstage to see her following a performance as Susan in *Finian's Rainbow* at the Hollywood Repertory Theater and chatted with her for thirty minutes. Brando told her, **"You have an erotic, animal quality like a wood-nymph. You bring so much excitement to the part."** Today, Yvette recalls Brando's visit as **"incredibly exciting — he walked directly to me, held both my hands, and looked into my eyes as he spoke. I just soaked it up, I was in shock."**

The quality Brando noticed in Yvette was one that casting directors and fans were beginning to appreciate. In 1957, Brigitte Bardot had emerged as the world's hottest sex symbol, and Yvette was seen by many as a potential American counterpart to Bardot with her lithe and compact five-foot-three, 35-22-35 figure, light blue eyes, and teasing appearance. The comparison was not accidental, for Yvette was a great Bardot fan. **"I adored her. I saw all her movies. I thought she was much more than just a body — there was something very spiritual I saw in her. Her independence appealed to me. I also had a look and style that was similar to hers, and people noticed."**

Yvette's first major film appearance was in *Short Cut to Hell* (1957), a remake of *This Gun for Hire* and the only film directed by the great James Cagney. She played Daisy, a "little tramp" who starts an affair with a man who turns out to be a hired killer; he decides that she knows too much, and tries to use her as a hostage. **"It was a very ballyhooed film with big studio backing. Unfortunately, it didn't quite have the magic in trying to recapture the film noir feeling."**

Also in 1957 came *Reform School Girl*, featuring Yvette as a teenage tramp in a genre classic from American International Pictures. Edd Byrnes (of later *77 Sunset Strip* fame) starred as a lowlife who is responsible for getting two girls packed off to reform school. The character of Roxy was even nastier than her usual bad-girl role — **"She was one mean little teenager,"** Yvette laughs. Roxy is tough, cynical, and boy-crazy; one rival cracks that **"if you were alone on a desert island with forty boys, there still wouldn't be enough!"** Offscreen, Yvette and Byrnes were romantic partners for about two years and remained friends long afterward.

Cult Movie Queen

Yvette's enduring place of affection in the hearts of B-movie lovers was ensured with her roles in the so-bad-they're-good cult classics *Attack of the 50 Foot Woman* and *Attack of the Giant Leeches*.

Attack of the 50 Foot Woman (1958) starred Allison Hayes as Nancy Archer, a troubled former asylum patient married to no-good philandering husband Harry (William Hudson). Harry at least has the good sense to select Yvette (as Honey Parker), the town's seductive good-time girl, to do his philandering with. Their affair is not subtle, as the couple go out drinking and dancing almost nightly, and he puts her up at a fleabag motel.

The couple's schemes to get Nancy institutionalized again so that he can get access to her considerable wealth appear to strike pay dirt when she begins raving about encountering a flying saucer in the desert. She brings Harry to see for himself and, when the UFO returns, winds up getting snatched by a hilariously phony giant alien hand. Authorities find Nancy unconscious and begin treating her; the remorseless Honey eggs Harry on to give her rival a lethal injection. But, overnight, Nancy grows to gargantuan proportions due to the outer-space radiation she absorbed. When Nancy regains consciousness, she decides that it's payback time. The fifty-foot woman, clad in sexy shorts and a halter top that just happen to fit snugly, stalks through the town and finds the conniving couple at their usual hangout. She attacks it, and in the ensuing fallout Honey is killed by the roof caving in. When the beautiful monsteress carries Harry off, police open fire with a riot gun and she dies in a blaze of glory.

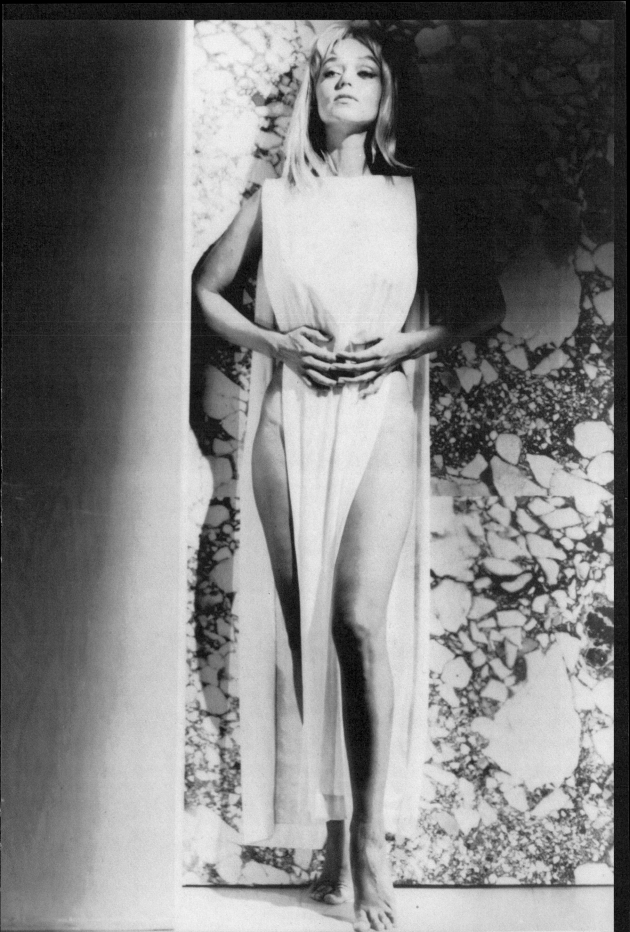

The special effects are grade Z, the acting (aside from Yvette's spirited performance) is wooden — and it's fun from start to finish for B-movie lovers, thanks to the delicious silliness of the story and the sultry charms of Yvette and Allison.

Yvette's role in *50 Foot Woman* came about because her agent also happened to represent Allison Hayes, and he told Yvette, **"You and Allison would bounce off each other perfectly in this film."** Even though the picture was to be a "quickie," Yvette would at least have a featured role. **"I was all for working, so I said fine. I had no idea [that it would become a cult phenomenon]. I was just praying it wouldn't ruin my career! But when I look at it now, I'm really delighted I did it. My Lady Macbeth scene in the car, telling [Hudson] how to inject her, is terrific — I really got into that."**

Almost immediately after *50 Foot Woman* was released, Yvette's agent called and said, **"Well, are you ready?"** She was already set to do a Broadway play (*The Gang's All Here*), **"but I was smokin' for work."** That work turned out to be her second cult classic:

In *Attack of the Giant Leeches* (1959), Yvette (as Liz Walker) is a sexy, Dixie-fried tease married to a meek, overweight older man, Dave Walker (played by Bruno Ve Sota), for whom she has only contempt. Showing off her legs while rubbing in skin lotion and displaying her lovely form in a low-cut casual outfit, she winds up making out in the grass with the handsome young local lech. But they're discovered by her husband, gun in hand. Dave forces them to wade into the ominous-looking swamp, and the two are suddenly dragged underneath by giant leeches. Police won't believe Dave's story, and he ends up killing himself.

The leeches (guys in preposterously cheesy rubber suits with suctions) subsequently claim two more victims, whereupon we learn that Liz and the others are not dead, but have been stashed in an underwater cave so the leeches can suck their blood. A dynamite blast releases all but Liz, their now-dead bodies floating to the surface with their blood sucked dry, and it's soon discovered that Liz is dead as well. They finally dynamite the swamp to finish off the creatures.

Making *Leeches* was "a strange experience, but exciting in a funny way. I have an adventurous, curious spirit." Yvette is quite aware that her fans' favorite scene is when she's putting lotion on her legs. "They love that scene! Most of that business was my own, and [director Bernie Kowalski] just let the cameras run." Her own favorite scene is when she explains to her handsome young lover the reason she married beer-bellied old Dave — "He had been nice to me when no one else was."

Still, she's quick to acknowledge that the film's flat ending was a disappointment. "I keep moaning and groaning, taking so long to die, and after that huge rescue effort my character dies and they barely comment on it." And, of course, there's that ever-present stigma of being associated with B movies. "Francis Ford Coppola once asked me what movies I had done, and I mentioned *Attack of the Giant Leeches*. I never heard from him again!" she laughs.

Among the several other films Yvette made during 1957–59, the most noteworthy was *I, Mobster* (1959), a well-done tale of a gang leader (played by Steve Cochran); Yvette has a supporting role as "the blonde." A well-known lothario, Cochran was also involved offscreen with Yvette for a time.

Playboy and Broadway

While making her way in Hollywood, Yvette was also becoming one of the favorite pinup models of the late fifties — most importantly for her *Playboy* Playmate layout shot by Russ Meyer for the July 1959 issue. "I loved working with Russ. I just thought of [the layout] as publicity — I didn't get paid, I just did it to promote my work. He brought me up to a little cottage wearing marine boots and a camouflage outfit. Russ had a powerful presence, but as a photographer he had a knack for disappearing into the background, letting you be yourself." The centerfold pictured a bottomless Yvette lying facedown on a sofa, her blue shirt pulled fetchingly above her waist as she smiles prettily for the camera. Yvette's only quibble with the layout was the look on her face in the centerfold. "Russ told me that Hefner wanted an Elvis-like sneer on my face. I thought it was a joke, so I said, 'Like this?' And that's the pose they used!"

Playboy called her **"the Beat Playmate,"** and indeed Yvette regarded herself as a beatnik. **"I loved jazz and Jack Kerouac, I went to the coffeehouses, and I would get into all these long intellectual discussions."** Many of these discussions were with comedian Mort Sahl. It was purely a platonic relationship, she says: **"He was one of the few men who really tried to get to know me without making a move on me."** Yvette has only positive memories about the *Playboy* experience, calling it **"a constructive career move."** The only drawback was that **"some people got the wrong idea that I would be an easy mark."** But when she went to New York after the magazine appeared, it brought needed attention to her Broadway play. **"I think it was all to the good."**

In 1959, Yvette's hard work took her to Broadway in *The Gang's All Here*, a satirical drama starring Melvyn Douglas as a fictional U.S. President resembling Warren Harding. The stellar cast also included E. G. Marshall and Arthur Hill. Yvette portrayed a dancer friend of the Douglas character. **"I was a wild flapper who was playing around with the president, and at first I don't know who he is. When I find out, it doesn't matter."** She also got to do some dancing in the show. The play, written by the author of *Inherit the Wind*, ran for ten months.

During the 1960s, Yvette continued to turn up regularly on television, with over one hundred programs, including *The Red Skelton Show, Bat Masterson, The Rebel*, and *Bus Stop*. She was also featured in a local theater production of *Bus Stop*. She loved playing Cherie and calls it one of her favorite roles.

Yvette was staying continually busy in theater, TV, and films, but still felt a sense of frustration. **"At this point I needed to break through and get leading roles, or just forget films and focus strictly on theater,"** she says. Then she received an offer to appear with Paul Newman in *Hud*. **"It was just a little part as his lover in town, but at least there were three decent scenes for me. Then the day before shooting, they told me my one long scene was cut. I wish I'd walked out, but I didn't. It was a terrible mistake. After everyone saw the film and saw me in that one little scene, I got all these offers for other bit parts, which I turned down."**

In the classic *Hud* (1963), a tough, gritty Western drama, Yvette is Lily Peters, whose affair with Newman is discovered by her husband, leading to a fistfight between the men. While her big scene with Newman at the beginning of the film was cut, she does have a scene with Melvyn Douglas, her Broadway costar.

Yvette's disappointment in *Hud* was soon forgotten with one of the highlights of her theatrical career in 1964. She made a big splash in Los Angeles's New Club starring in a series of stage adaptations of horror plays from Paris's Grand Guignol Theatre. In one, *A Day with Henry*, she was stabbed with a power drill and chopped up in a blood-filled bathtub. The shows ran for about a year, and she recalls that **"the Hollywood people came in droves to see it."**

Cary Grant, Jim Hutton, and Career Rebirth

One important element of Yvette's very full life has been her relationships with men. Her marriages were the least of it: In the mid-1950s she was married for four years to jazz bass player Don Prell (who played with the Bud Shank Quartet). A second marriage came and went quickly in 1959 to writer Leonard Burns (**"I knew immediately it was a very big mistake"**). And ten years later came another **"horrible mistake,"** a marriage annulled after just a few months to actor Tom Holland, whose credits included an appearance in the Russ Meyer film *Good Morning . . . and Goodbye.* Meyer had asked Yvette more than once to accept a role in his movies, but she declined each time. **"I loved his photography, and I thought his pictures were fun, but I just couldn't do it. I felt strongly about outright sexploitation."**

In between these marriages, Yvette was involved with a number of men. Soon after her two-year relationship with Edd Byrnes came an affair with Cary Grant. He was already in a serious relationship with Dyan Cannon, and Yvette had been warned by Mort Sahl and others about the legendary star's dalliances with multiple young ladies. But she was totally charmed by Grant, who for a time helped to choose her roles. **"It was mainly a social and intellectual relationship that became romantic."** It ended when he learned that Dyan was pregnant and decided to marry her.

There were a number of other romances, but, Yvette emphasizes, not as many as some have suggested. **"It got tiresome with men wanting to go to bed with me as soon as they met me,"** she remarks. **"If I'd actually gone to bed with all the men who said I did, I'd never have had the time to do anything else! I've always been attracted to men, but the feeling has to be mutual."**

But the most important romantic relationship of Yvette's life was with Jim Hutton, the tall, youthful-looking actor best known for his good-natured romantic comedy roles in *Where the Boys Are, Bachelor in Paradise,* and *Walk, Don't Run.* They met in 1964, about a year after his divorce, and hit it off immediately. **"We'd talk for hours on end, and the waiters would practically have to drag us out of the restaurant. We were inseparable twenty-four hours a day."** After the two had a spat in 1969, Yvette impulsively flew to Las Vegas the next day to marry Holland; after the quick divorce she and Hutton reunited.

Walk, Don't Run, which costarred Grant and Hutton in a comedy set at the 1964 Tokyo Olympics, presented a delicate situation — particularly because Grant's character served as Hutton's mentor in wooing the film's female lead, Samantha Eggar. **"But they were both sophisticated gentlemen,"** says Yvette. **"Jimmy would call from Tokyo and say, 'You know, Cary really likes you.' There was no trouble at all, since Cary was married to Dyan, and he was happy for us."**

Marriage was a subject that came up often. But Hutton was haunted by the failure of his previous marriage, and the three-times-burned Yvette acknowledges that **"I was scared, too. We were happy, romantic, and in love. Why do anything to ruin it?"** By 1979, they were thinking about the possibility again when Hutton received the stunning news that he had terminal cancer. Doctors operated immediately, but it was too late and he died a month later. **"It was the most serious relationship of my life. I'm lucky to have had that with someone I cared so much about."**

During the 1970s, Yvette scaled back her acting schedule except for three small film parts (including the 1976 Kris Kristofferson picture *Vigilante Force*) and an occasional local theater role. She had already gotten into real estate investment, including buying thirty acres in Malibu, and during the early eighties **"really concentrated on it to make money for my retirement years."**

It was in 1987 that a remarkable new phase of Yvette's life opened up. A feature on her in *Filmfax* magazine reminded cult-film fans that one of their favorite stars was still **"alive and well."** (This status was reaffirmed a few years later when she was featured in Jewel Shepard's popular book *Attack of the B-Movie Queens*.) Suddenly, the mail started pouring in — **"intelligent, sweet, caring letters."** So did offers to make guest appearances at conventions around the country. **"It was astonishing to me — it all seemed to come from out of nowhere,"** she reflects glowingly. Some of these special events included screenings of *50 Foot Woman* and *Giant Leeches*, and **"there would be lines around the block at theaters that seated 1,200 people. I had no idea there were so many fans!"**

One particularly memorable convention was the FanEx Fantasy/Sci-Fi Convention in Baltimore in 1991. She sang the R & B classic "Fever" with a small combo, and then performed "The Ballad of Honey Parker" about her character in *50 Foot Woman*. **"I acted out the story while I sang, and people just loved it. There was pandemonium."**

Encouraged by such responses, Yvette resumed her career, including her first movie role in fifteen years, *Evil Spirits* (1991), a horror cheapie enhanced by a fascinating cast. In December 1991 she had a leading role in a local theater production of *The Bones of Joaquin*, playing **"a beat-up broad in a circus sideshow."** She also put together a cabaret act that includes not only her singing but also impressions of Marilyn Monroe, Marlene Dietrich, and other movie blondes.

Yvette also pursued her childhood aspiration of writing by starting two projects: a history of both sides of her family, and a novella about her relationship with Hutton. A proposed play she has been developing for a decade, on the life of Zelda Fitzgerald, is currently on the back burner, although she still has hopes for it. And most enticing of all for her devoted fans is that Yvette has written *Attack of the Leeches II* in which her character survives and **"becomes Ivana to Donald Trump."**

During the early nineties, she began singing in local clubs, performing some of the enduring Gershwin and other standards she learned through her parents and also some original compositions. Following the death of her father, for whom she had been caring during his final months, Yvette refocused her attention on music in 1996–97. A talented jazz performer with a warm vocal style, she cowrote new songs and recorded two dozen tracks (and even a music video) for a prospective album containing elements of jazz, pop, Latin, reggae, and country.

Looking back, Yvette has no regrets that she became identified as the queen of the B-movie bad girls. **"I loved doing that kind of role. They were better written and more interesting than other roles because you're the cause of conflict, things are centered around you.**

"It's a marvelous thing in my life that all this has happened," Yvette says happily. **"I've got more creative energy now than I've had in years. It's really a kind of miracle. I'm still here, and I still have a lot of things I want to accomplish."**